Design For Society

Design For Society

NIGEL WHITELEY

REAKTION BOOKS

For Daniel and Ella

Published by Reaktion Books Ltd
1–5 Midford Place, Tottenham Court Road
London W1P 9HH, UK

First published 1993

Distributed in USA and Canada
by the University of Washington Press,
PO Box 50096, Seattle,
Washington 98145–5096, USA

Designed by Ron Costley

Photoset by Wilmaset Ltd
Birkenhead, Wirral
Printed and bound in Great Britain
by Redwood Books, Trowbridge,
Wiltshire

This book is printed on Arctic Natura Matt 115gsm, a new sulphate-
based double-coated printing paper, which is completely chlorine-free and
wood-free. It is produced from hydrogen-peroxide bleached sulphate pulp
which means that there are no chlorine waste products involved in its
manufacture.

British Library Cataloguing in Publication Data
Whiteley, Nigel
Design for Society
I. Title
745.2
ISBN 0–948462–47–7

Contents

Photographic Acknowledgements

The author and publishers wish to express their thanks to the following for their permission to reproduce illustrations:
Anti-Consumerism Campaign, p. 129; The Ark Environmental Foundation, p. 87; Baby Milk Action, p. 127; The Body Shop International PLC, p. 50; British Telecom, p. 8 (photos © BT); DesignWeek, p. 65; Dulas Engineering Ltd, p. 64, top; Ergonomi Design Gruppen, Sweden, p. 117; Grammer AG, p. 84; IDEO Product Development, pp. 74, 78; Indes Design Consultants, p. 102; IN.form, p. 64 bottom; LN Industries SA, p. 41; London Innovations, pp. 111, 112; Media Foundation, p. 128; Media Natura Trust Ltd, p. 105; National Institute Of Design, India, pp. 120, 121; National Motor Museum Trust, Beaulieu, Hants, p. 12; Ross Consumer Electronics (UK) Ltd, p. 27; Gary Rowland Associates, pp. 82, 88, 89; Sharp Electronics (UK) Ltd, p. 36; Sony (UK) Ltd, p. 22; Zanussi Ltd, p. 77.

Preface

The motivation for writing this book arose from a dissatisfaction with the existing literature about design, the vast majority of which deals only with the surface of the subject. It is all too rare for a design book to look directly at values and how they might relate to a value system, and to look at the implications – human and ecological – of those values. This is not to deny the importance of the aesthetics of objects and images, or their place in the history of design, but in the end we learn little about the role that design plays in society, and why it has come to acquire its current status. *Design For Society* seeks to examine the ideology of design in our society.

Design For Society can arguably be placed within a tradition of criticism that was once memorably described by Reyner Banham as the 'tradition of art worry', and which dates back to the writings of A. W. N. Pugin and John Ruskin in the mid-nineteenth century. Its best-known exponent of recent years is Victor Papanek, whose *Design for the Real World*, first published in 1970, was revised and reissued in the mid-1980s. The core of the tradition is that there is a direct (and inevitable) link between a society's design and its social health: design is a manifestation of the social, political and economic situation (or, most importantly for Ruskin and Pugin, the religious situation). The strength of the tradition is that design is firmly grounded in a relationship to society rather than being presented as an area of study which feeds only on itself; its weakness has been that, in both the nineteenth and twentieth centuries, design reform writing has been on occasions little more than a cover for professional middle-class taste masquerading as ethically superior – 'good' – design. I hope to have avoided that particular weakness in the current book.

The title of this book may appear misleadingly simple, but it has been chosen after careful deliberations. All three words of the title have significance. As the subject area of the book, *Design* needs little justification or explanation, other than to state that the type of design under discussion is consumer goods and not capital goods. It is the type of design so widely (and uncritically) written about during the 'designer years' of the later 1980s. Prepositions and conjunctions in book titles are usually relegated to a lower-case first letter, but on this occasion *For* merits a capital one. The reason is that one of the central issues raised in the book is whether consumer-led design is, essentially, to the benefit or detriment of society as a whole:

whether it is *for* as opposed to *against* society. And the nature and character of *Society* was, of course, one of the main political battlegrounds in the politics of the 1980s: whether society was anything more than the sum of individual parts or whether – to recall a notorious political claim – *society* exists at all. The book's title is, therefore, as much a declaration of the author's standpoint as a description of the book's content.

The title is also closely related to two other titles. First, it relates most directly to, and is in line of descent from, Papanek's *Design for the Real World*. Second, it is indirectly related to a book which is little known, but which enters the discussion in the first chapter – *Design for Business* by J. Gordon Lippincott, published in 1947. Lippincott's book is a eulogy for consumerist values. Thus it promotes and upholds the values that *Design For Society* attempts to question and criticize.

Design For Society has drawn on historical texts, academic books, ephemeral journalism, personal interviews and correspondence. I am grateful to all those who gave their time, shared their thoughts, or furnished me with information about either their own work, or the work of their organization. They include The Anti-Consumerism Campaign, Ark Trust, Margaret Bruce, The Chartered Society of Designers, Ashoke Chatterjee, Anne Chick, Roger Coleman (London Innovation Limited), Chris Cox (AWARE), Les J. Curtis (The Society of Typographical Designers), Disabled Living Foundation, Friends of the Earth, Greenpeace, John Grieves (Ergonomi Design Gruppen), Paul Griffiths, Robin Grove White, Luiz Eduardo Cid Guimares (Laboratorio de Desenho Industrial-UFPB), He Jintang (South China University of Technology), Homecraft, Industrial Designers Society of America, Cathy Lauzon, London Ecology Centre, Lois Love, Brian Lowe and Hazel Potter (Unit for the Development of Alternative Products), Karen Lyons, Dorothy MacKenzie, Ross Marks (Ross Consumer Electronics UK Ltd), Rosy Martin, Nottingham Rehab, o2, Victor Papanek, David Pearson (Ecological Design Association), Tapio Periäinen (Design Forum Finland), Birgit Pohlmann-Rohr (Feministische Organisation von Planerinnen und Architektinnen), David Poston (Intermediate Technology Development Group), Mark Renkin (Ecover), Chris Rose (MediaNatura), The Sheffield Centre for Product Development and Technological Resources), David Huw Stephens (Practical Alternatives), Simon Stoker (AWARE), SustainAbility Ltd, Sue Taylor-Horrex, The Transnational Network for Appropriate and Alternative Technologies, Alice Unander-Scharin (Svensk Form), Ludo Vandendriessche (International Council of Societies of Industrial Design), the Women's Design Service, and Gaynor Williams. To those whose names are omitted through error, oversight or incompetence, I offer my apologies.

I would also like to acknowledge Oxford University Press for permission

to use extracts from my article entitled 'Toward a Throw-Away Culture: Consumerism, "Style Obsolescence" and Cultural Theory in the 1950s and 1960s', which appeared in the *Oxford Art Journal*, x/2 (1987), pp. 3–27. Acknowledgements are also due to Thames and Hudson for extracts from Victor Papanek's *Design for the Real World*.

Finally, I would like to thank Diane Hill for her constant support and encouragement on this lengthy project. I now look forward, in sentiments which have become politically fashionable, to spending more time with our family, to whom this book is dedicated.

Introduction

We witnessed a frantic period of design in the 1980s. In Britain, for example, the design industry grew by about 35 per cent a year for most of the decade. Turnover and profits trebled in the same period. 'Design' as a noun or verb was daily intoned – usually hopefully rather than purposefully – as a solution that was going to deliver us from all economic evils. 'Designer' as an adjective connoted prestige and desirability, sometimes desperately so; and 'designer' as a noun was the new celebrity profession, with the deeds and lives of the stars appearing in endless magazine features, gossip columns and television chat shows. If the 1960s merit the epithet 'swinging' then the 1980s must be the 'designer decade'. It is this type of design – and the values it implies – that is the subject of this book.

Much has now changed. A sharp economic recession is one reason why the design-bubble burst. By the turn of the decade the same designers were more likely to be featured on the financial pages as their consultancies and practices ran into 'severe cashflow difficulties', or even dramatically crashed into oblivion. But there is more to design's decline than the short-term economic situation: the design boom became its own worst enemy and choked on the froth of its own hype. Far from being the basis of the *solution* to society's problems, it became increasingly apparent that design – that is, 'market-led' or 'consumer-led' design (as it is commonly called) – was one of society's *problems*. Two angry young designers, disenchanted with the profession to which they had committed themselves, asked the following rhetorical question in the early 1990s. If design were a person would it be a 'mature adult taking responsibility for its actions or a whining adolescent, insecure and struggling to come to terms with the outside world?'[1]

The mood is now right for a reassessment of the role and status of design in society. The design writer Jeremy Myerson has bemoaned the fact that design is 'fast becoming a weapon of exclusivity, of segmentation – the means by which many desirable goods and services are put out of reach of large sections of the community'.[2] Its role needed urgently to be reconsidered. The designer F. H. K. Henrion attacked the prevalent notion of design as 'the yuppy fun of a moneyed minority', arguing that 'the designer's place in the economy is of crucial importance but his place in society is no less so.'[3] Henrion cited the economist-philosopher E. F. Schumacher who was, he believed, particularly relevant to the current

situation: 'What is at stake is not economics but culture; not the standard of living but the quality of life.' *Creative Review* noted that 'many designers are asking where their profession is heading . . . Should they be the willing agents of a manufacturing process that makes products obsolescent before their time?'[4] An editorial in *Blueprint* in 1990 called for designers to contemplate their values: 'After a period of enormously rapid change, in which form has played more of a part than content, it is time to re-address the meaning of design.'[5] And the design educationalist John Wood made the following accusation:

. . . 'style' and 'image' provide a more immediate and compelling rhetoric than durability and efficiency. But the creation of beautiful packaging for ugly or dangerous technologies should now be seen as an unacceptable task for the responsible designer. There are deep questions regarding the relationship between consumerism, democracy and technology which must be addressed by everyone if we are to avoid the abyss.[6]

These sentiments were echoed by David Chipperfield, principal of David Chipperfield Architects:

Like the US and Japan [Britain] enthusiastically pursued an uncritical free market system and abandoned its broader responsibilities. When designers do likewise, operating solely as a tool of consumerism, their status becomes questionable. The current recession has given architects and designers an opportunity to reconsider their role.[7]

The mood for reassessment is particularly strong amongst a new generation of designers who are more able (or willing) to grasp the connection between their own professional activities, and the problems facing society at large. The first step in the reassessment might be to impose a moratorium on the word 'creative', which has become as abused a term as 'design' and 'designer'. In the 1980s the most trivial change of detail on the package of a product would be hailed by its designer and – far from free of guilt – the design press as 'a creative redesign'; the 'creative professions' seemed to be those that successfully designed new designer-clothes for vain emperors; and 'creative accounting' seemed simply to be a euphemism for legally getting away with financial murder. But the assessment needs to go deeper than the surface irritations, which are merely manifestations of a system that has intrinsic faults.

Any system that one lives within is liable to seem normal, if not 'natural', because one's values and expectations are largely conditioned by it. Michael Wolff, vice-chairman of Addison Design Consultants and a designer of long experience, has likened the value system of design to a 'transparent bubble that we can't see'. In the 1990s, he continued, addressing the design profession:

. . . we need to re-invent what we do. We can take responsibility for the
environmental and social effects of our work. We can grasp new information,
educate ourselves, develop new creative ways. The nineties are the biggest
opportunity for imagination and boldness our species, and our profession, have
ever had. With the highest make-or-break stakes.[8]

The design profession needs to be both introspective and outward-looking.
It must look at its practices and values, and their implications; and it must
look at the condition of society and the world. Designers can no longer take
refuge from responsibility for their own actions and continually repackage
the same old type of consumer goods at a time when issues about consuming
and its relationship to the world's resources and energy need urgently to be
acted upon.

Repackaging and redesigning are – as we shall see – part of a socio-
economic system that assumes limitless growth and a continual state of
desire. Consumer-led design in a market economy goes far beyond the idea
of meeting human needs: it seeks to create and constantly to stimulate
human *desires*. The modern consumer's condition is characterized by
dissatisfaction and a consequent state of longing. A continual stream of 'new'
goods is produced to satisfy temporarily the desires which the market has, if
not created, then certainly kindled. We must never forget that this system is
part of a global context in which between 50 and 75 per cent of human beings
have an inadequate supply of the basic necessities of life – a situation made
worse by the rapid growth in world population. Quite apart from our sense of
justice, we are now being forced to recognize the finite character of some of
the resources required to meet those rapidly growing human needs, and we
are beginning to see that the consumption of energy needed to produce the
basic goods and services demanded by the growing world population, and to
meet the expanding markets of the developed countries, will destroy our
environment through the 'greenhouse' and other effects.

This raises questions about the morality of consumer-led design and the
ethical responsibility of the designer. Is it morally acceptable to maintain a
system in which (as one designer puts it), 'Advertising and, more impor-
tantly perhaps, the desire to mass-manipulate people for financial gain has
become perfectly acceptable, and in many ways downright desirable'?[9]
Many would argue that consumer-led design not only manipulates people
and makes them dissatisfied, but encourages them to be excessively
materialistic as well. Life becomes a matter of what you consume, and more
public and altruistic values are diminished in importance. The needs of
individuals and social groups who have little power in the market-place are
simply ignored.

One matter that is beyond doubt is the influence of the consumer system
worldwide. Most newsworthy in recent years has been the beginning of the

export of the system to what was the Eastern bloc. State-controlled centrist systems have been, understandably, overthrown in one country after another in Eastern Europe as the 'globalization' of design (which, as we shall see, can also be described as the 'Americanization' of design) has taken hold. The Marshall Plan for the economic recovery of Western Europe after the end of the Second World War has its modern-day equivalent in a kind of 'McDonald's plan' as fast-food outlets announce the arrival of Western consumerist values.

While few would retain any affection for a system as inefficient, corrupt and intolerant as state communism, there is a growing fear that the imported system may be far from desirable. A conflict of, if not cultures, then at least value systems in design has been witnessed in many Third World countries. In the sub-continent of India the conflict has been evident for over a decade. The adviser to India's National Institute of Design, Ashoke Chatterjee, bemoaning the 'glossy images of design pouring in from richer lands', points to the pressures placed on the design profession in his country. With the consumerist value system:

The common denominator is one of affluence and obsolescence, the catering to inconsistent whims which spell high profit. The vigour with which this new understanding of design is insinuating itself into the consciousness of the elite mocks every modest step that designers have taken over the past two decades. The concept of real need is sought to be replaced with the image of design as the five-star life-style.[10]

The desirability and seductiveness of consumer-led design does not justify it as a system. In the opinion of Romesh Thapar, one-time chair of the Review Committee on the National Institute of Design, 'too much of our social and cultural-aesthetic future is at stake to permit the free play of the market.' The main problem is, however, that the system's values are seldom made visible and openly debated. The *ideology* of our system of society and design's role in it needs to be more widely understood. This is the conclusion also reached by Romesh Thapar: 'A comprehensive view has to be nurtured about the society we are designing – or, to put it another way, about the value system which must underpin it. An ideology for a designer? Well, yes – in a way. You cannot escape it.'[11]

And this statement is equally applicable to design in *our* society. The design writer John Thackara admitted that he was surprised at how design:

. . . has managed somehow to evade blame for the negative consequences of its role in our thoroughly modern lives: the de-aestheticization of environments and products in the name of marketing and economic manufacture . . . at the same time as production is unable to meet the most basic of human needs in non-industrial countries.[12]

Indeed, the question of the ideology of design – design's explicit and implicit values and priorities and what they tell us about ourselves and our society – is seldom raised in design magazines or books. This does not imply a conspiracy, it is merely that the surface activity of redesign, repackaging and revamping, and the seductive desirability of the latest designer goodies, are far more newsworthy and exciting. The design press can be justly accused of complacency in creating such little space for debate about the nature, role and status of design, but publishers would no doubt respond with reminders about market forces which necessitate giving the consumer what s/he appears to want – and debate about the ideology of design does not seem to rate very highly. The majority of books on design implicitly condone our current system by concentrating on the history of design as style, or on star designers. Design publishers (whose output is increasingly market-led) and other bodies operate *within* the market, and so are seldom able to step back from that market and analyse it. This is what *Design For Society* will attempt to do.

It should be stressed that *Design For Society* is not an anti-design book. It undertakes a critical examination of the consumerist system of design, but it will become apparent that it is also not simply anti-consumerist. Neither is it committed to some form of direct centrist control. Nor is the text informed by any religious or anti-materialistic system of belief, whether Christian, Buddhist or whatever. It *is* written from a perspective of what might be called 'secular liberal pluralism'. This is stated both because the book is one in which values are intended to be made explicit; and because the statement accounts for the particular selection of critiques. A different book could have taken a 'truth-orientated', transhistorical, absolutist perspective. The following critiques of 'Green' design, socially responsible design and feminist design are, at least as I have presented them, socio-political and not spiritual.

The first chapter deals with the origins and development of consumer-led design in order to allow us to focus on its ideology, values and implications. The second chapter presents the Green critique, because its newsworthiness since the later 1980s has made it the most accessible and widely understood of all critiques of consumerist design. It leads logically on to 'responsible design and ethical consuming'. This critique broadens the terms of reference from what are often particular products and their effects to a wide range of ethical and political concerns such as work conditions, labour relations, animal testing, Third World workforce exploitation, or investments in armaments or undemocratic regimes. This politicization of design is brought into the sharpest focus in the final critique – the feminist critique. In the words of one commentator:

Women need to gain knowledge of the means to effect the decisions that control their material and social environment. Then designers would be better able to

serve them, rather than perpetuating the power imbalances. This requires a
political change . . . Design in its broadest sense is power, control and defining
new possibilities to aim for.[13]

The feminist critique makes us uncomfortably aware of the ideology and
values of consumer-led design, their implicit social and gender relations, and
the gloomy future of the unchecked consumerism of our capitalist society.

Design For Society is not a blueprint for the future of design – a future
which presupposes a drastic reconstruction of society – but a questioning of
current values. An awareness of current values and how they have historically
developed is the prerequisite for considered future action. To recall, not for
the first time in my own writing, words written by the artist Richard Hamilton
over thirty years ago: 'An ideal culture, in my terms, is one in which
awareness of its condition is universal.'[14] This seems to me an entirely sane,
defensible and, indeed, necessary aim for a book about design – a book
which seeks to be about design *for* society.

1 Consumer-led Design

We are so much surrounded by examples of 'consumer-led' or 'market-led' design in our everyday lives that it now appears to be a natural and inevitable aspect of our society. But we need to stand back from this type of design to understand its values – both explicit and implicit – and its implications. This chapter, therefore, examines the historical, social and cultural context of consumer-led design from the early years of this century in the United States, the country in which its prophets have been most uncompromising in singing its praises and most direct in spelling out its value system and ideology. The basic system, whether – in the vocabulary of consumerist designers – 'revamped', 'updated' or even 'cleaned up', has been adopted by the Western European countries and is now being courted by the countries which used to comprise the Eastern European bloc.

Any colour so long as it's white

'We all have the same telephone without longing for an individual design. We wear similar clothes and are satisfied with a small degree of difference within this restriction.' So wrote Anni Albers in 1924. Albers was, at the time of writing, a student at the Bauhaus and she went on to become a weaver of international repute, extolling the Modernist virtues of the Bauhaus through her books on weaving, her teaching in Europe and the USA, and – perhaps most influentially – her textile and fabric designs. 'The good object', she wrote in the same statement, 'can offer only one unambiguous solution: the type.'[1]

Albers's sentiments help to define the opposite to a design which is consumer- or market-led. The notions of choice and variety in the design and styling of products which we now take for granted were considered unnecessary, outdated and socially divisive by those committed to the Modernist vision of technological progressivism. Choice and variety were unnecessary because Modernists would be inventing the type-form – the perfect or, at least, optimum solution to a functional problem – for every product; they were outdated because unnecessary diversity and profusion were characteristics of the Victorian age of pompous individualism with its 'romantic gloss and wasteful frivolity'.[2] They were also outdated because the new spirit of progressivism called for egalitarian collectivism, and each

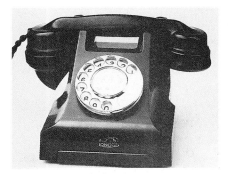

Siemens telephone, 1931
Jean Heiberg's design for Siemens became an object type for the telephone; it was adopted (with minor modifications) internationally, and remained in use until the 1960s.

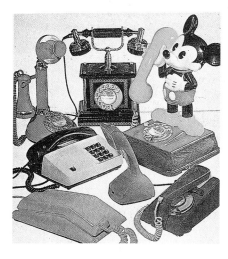

Telephones, late 1970s
With the advent of consumerism, choice was manifested in visual variety and novelty. The object type is superseded by the 'impactful' and fashionable product.

product would thus be available to all. There was no longer any need for choice and variety in product design because science, technology and the dynamics of the 20th-century condition would provide people with choice and variety in their daily lives.

Walter Gropius, the director of the Bauhaus while Albers was a student there, rallied designers for 'the creation of type-forms for all practical commodities of everyday use'.[3] Thus, the search for the type-form became, in the words of one Modernist writer, 'the paramount task of the modern designer'.[4] A type-form would remain unchanged unless or until new materials or new processes of manufacture could improve it. Albers believed that the design of telephones had, in the mid-1920s, arrived at their type-form: had become standardized, simple, mass-produced and – in keeping with the new age – impersonal.

Marcel Breuer, the designer of such Modernist 'classics' as the B33 chair and a contemporary of Albers at the Bauhaus, expanded on the idea of

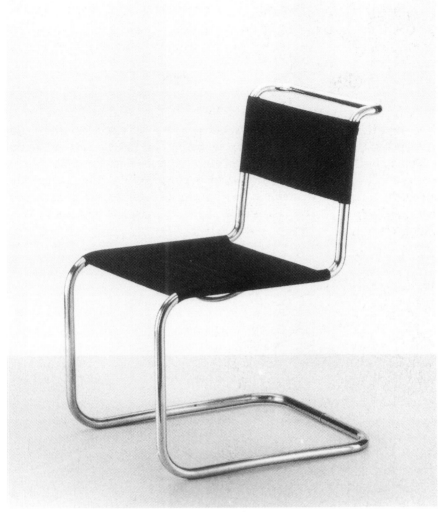

Marcel Breuer, Chair B33, 1927–28
The B33 is as close to the Modernist idea of a 'clear and logical form based on rational principles' as any design of the period. Such designs, Modernists hoped, would transcend their period and become 'styleless' and timeless.

impersonality in design. In language that was as precise and unemotional as the objects he designed, Breuer called for 'clear and logical forms, based on rational principles'.[5] The 'logic' of the forms would be determined from the object's primary function and ergonomic requirements. The primary function of a teapot, for example, is to hold tea satisfactorily; and its ergonomic considerations include a spout which pours rather than gushes or dribbles, and a handle which is comfortable to hold. 'Rational principles'

would include such supposedly timeless dicta as 'economy of means', 'truth to materials', 'integrity of surface' and – a favourite at the Bauhaus – 'a resolute affirmation of the living environment of machines and vehicles.'[6] Breuer described Modernist design as ' "styleless", for it is expected not to express any particular styling beyond its purpose and the construction necessary therefore.'[7]

Moreover, for Breuer and other Modernists, it was not just each object that should appear impersonal, standardized and styleless, but the total environment in which they were contained, even if it was a house or an apartment: 'The new living space should not be a self-portrait of the architect, nor should it immediately convey the individual personality of its occupant.'[8] The idea that a living space ought not to reflect or express the personality, taste or aspirations of its occupant is, by today's consumerist norms and expectations, a denial of the very function of design. Most Modernists of the 1920s and 1930s abhorred pattern; Breuer also rejected strong colour. In a lecture and article of 1931 on 'The House Interior', he wrote:

There has seldom been a more misunderstood concept than colourfulness or 'joy in colour' . . . Following in the steps of the modern movement came a shocking brightness, a substitute for arts and crafts, which offended anyone who did not look at colours with his eyes closed . . . I consider 'white' a very versatile and beautiful colour; at the same time it is the brightest colour – there is seldom a reason to replace it with any other colour. Living things appear more intense in bright monochromatic rooms, and this is important to me.[9]

What this uncompromising Modernist approach to design in the 1920s and 1930s reveals to us is the total absence of consideration for the consumer in terms of the consumer's tastes or desires. Modernist designers rejected any notion of design being dictated by 'the market' as a debasement of standards. The stylistic free-for-all of nineteenth-century design was, in the 'living environment of machines and vehicles', as outmoded as the 'penny farthing' and the bustle. The consumer had a responsibility to improve her or his taste and to live up to the progressive, unsentimental and rational design solutions and type-forms that resulted from the 'systematic practical and theoretical research in the formal, technical and economic' aspects of an object; these aspects were themselves underpinned by the 'resolute consideration of modern production methods, constructions, and materials'.[10]

If the design process – in the very simplest and broadest terms – comprises creation, production and consumption, then Modernist designers placed an overwhelming emphasis on their own creativity (which they claimed was based on objective systems of analysis rather than subjective caprice) and the demands arising from the processes of mass production. Consumption was a

presumed end-result as, indeed, was manufacture; in fact, most Modernist designs reached only the prototype stage, and were produced by craft techniques or manufactured in very small quantities. The consumer's subjective response to an object – such tertiary functions as the object's social or cultural associations, or its status or prestige – were ignored in Modernist design. Design in the Modernist world – supposedly rational, unsentimental, functional and serious – was about how architects and designers felt people *should* live; it did not grow out of the way people *do* live. The psychological role of material culture was not acknowledged in this rational world with its rational aesthetic.

Writing about the Bauhaus in 1930, one critic sceptically claimed that Bauhaus products 'were for the most part conceived out of a taste-orientated arbitrariness decked out in new clothes, and out of a *bel-esprit* propensity for elementary geometric configurations and for the formal characteristics of technical contrivances.'[11] That critic's claim is, for the most part, reasonable, but whether or not Modernist designers were as rational as they claimed matters less to us than their attitude to the consumer, which was, like their designs, clear and unambiguous. An approach which altered the relationship with the consumer was, however, developing at the same time. Not surprisingly, given its political and social ideology, the approach was being developed in the United States.

Any colour so long as it's black

The new approach replaced a system that, in some ways, was similar to the Modernists' quest for the type-form. In the United States, up until the late 1920s, car design was dominated by Henry Ford, and was based on a concept of scarcity and needs. Ford had introduced the Model T – the 'tin Lizzie' – in 1908. Its cheapness, due to quantity production facilitated by specialized production-line techniques, put it within the financial reach of middle-income Americans. As sales grew, unit costs and sale-price decreased, so expanding the market for the car. However, cheapness was possible only while the car remained essentially unchanged, because any mechanical or styling alterations were bound to increase costs. Henry Ford was well aware of this, and he presumed an uninterrupted production of the Model T, if not for ever, then until it was technologically superseded. A variety of models, or even colours, was not available unless the purchaser was willing to have the car customized: the reductivist approach to the basic model gave rise to the line about the customer being able to choose 'any colour so long as it was black'.

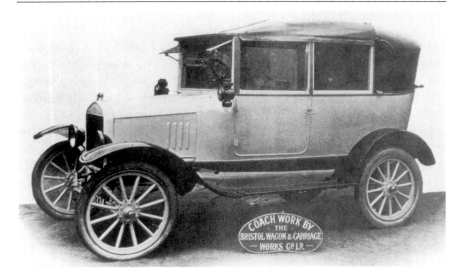

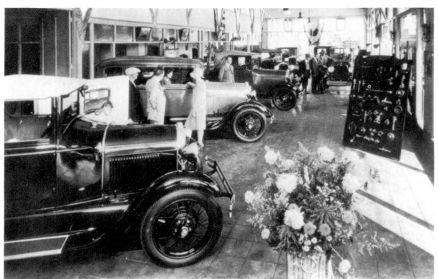

Ford, Model T, 1919
The 'tin Lizzie' epitomized the notion of standardization and mass-production. The illustration shows a 1919 model with a British-produced body.

Ford Model As, in a showroom, 1928–29
The Model A may have delivered less than it promised in terms of innovation and styling features, but it represented a break with the ideas underpinning the Model T, and helped to change Ford's outlook in favour of innovation and change.

Engineering consumers and obsolescence

However, in the later 1920s the ground rules of car design began to change. Styling became an important factor in consumer choice, and in 1932 Roy Sheldon and Egmont Arens wrote in their influential *Consumer Engineering: A New Technique for Prosperity* that 'the tin Lizzie had obsolescence thrust upon her . . . And neither lower prices nor proved ability to stand up under hard use could save the Ford when the American woman began to buy and drive the automobile.'[12] Whether the authors were right to (dis)credit women with the change is controversial, but it is clear that the strategy of gradual but constant improvement towards technical perfection – which, in this context, can be seen as relating to some extent to the type-form approach – was replaced by the policy of continual styling changes to stimulate sales. Previously, styling had been confined to expensive, hand-produced cars for the rich and famous, but from 1927, Ford, with their Model A, and General Motors (GM), under the styling leadership of Harley J. Earl, introduced it into their mass-produced cars.

In America in the later 1920s and during the time of the Depression, manufacturers found that a designer or, more commonly, a stylist could give a product what is now called 'added value', but what was then termed 'eye appeal'. In other words the stylist could make a product more appealing, and so more likely to be purchased. To achieve this, the American designer took as a starting-point symbols that were understood – and enjoyed – by the consumer. In the 1930s those symbols were derived from transport and fast travel: hence the vogue for streamlining with its connotations of speed, dynamism, efficiency and modernity. The craze stimulated a wealth of streamlined products for which the style was functionally unnecessary or even wildly inappropriate: radios, electric heaters, vacuum cleaners, irons, toasters, jugs, pans, light fittings, cash registers, even stapler guns and pencil sharpeners. In each case streamlining was, according to Sheldon and Martha Cheney in their 1936 book on *Art and the Machine*, used as a language, 'as a sign and a symbol of efficient precision.'[13] The advantage to manufacturers was pinpointed by an astute businessman: 'streamlining a product and its method of merchandising is bound to propel it quicker and more profitably through the channels of sales resistance.'[14]

Consumers were now able to purchase products which were more appealing and desirable; their tastes were being addressed and even catered for. Yet design could not yet be described as 'consumer-led' because it was the manufacturers who were determining what should be produced; they were employing designers to make more attractive what they – the manufacturers – decided to produce. Consumers – to return to the title of Sheldon and Arens's book – were being 'engineered' to fit the product rather

than the other way round. But what is significant about this inter-war stage of design in the United States is that it develops the ideology of the market economy, and this ideology forms the very basis from which our contemporary design emerges. Understanding the basic ideology that underlies design is crucial to a full understanding of our present condition.

The first generation of American industrial designers such as Norman Bel Geddes, Henry Dreyfuss, Walter Dorwin Teague and Raymond Loewy often sought to justify their activities in terms of creating a better world by making products more efficient, easier to operate and more (in today's language) 'user friendly'. Ultimately, however, styling was about sales and profit. When asked for his thoughts about aesthetics in product design, Loewy outlined his simple but unambiguous view which 'consists of a beautiful sales curve shooting upwards.'[15]

Moreover, by giving a product a fashionable appearance, the designer was virtually guaranteeing that it would look old-fashioned in two or three years time, and so was building-in style obsolescence. In *Consumer Engineering*, Sheldon and Arens presented the case for a positive acceptance of style obsolescence by manufacturers. Rather than fearing it as the 'creeping death to his business', the manufacturer was beginning:

. . . to understand that [obsolescence] had also a positive value; that it opens up as many fields as ever it closed; that for every superseded article there must be a new one which is eagerly accepted. He sees all of us throwing razors away every day instead of using the same one for years. He turns in his motor car for a new one when there is no mechanical reason for so doing. He realizes that many things become decrepit in appearance before the works wear out.[16]

The same sentiments are immediately recognizable in today's design magazines, although they are less frequently stated because they are now taken for granted by the majority of designers. It is true that 'obsolescence' may now be becoming an unacceptable word amongst designers, as it threatens to tweak their social and environmental conscience; but then, even in the 1930s euphemisms were sometimes thought preferable – Sheldon and Arens suggested 'progressive waste' or 'creative waste'.[17]

The American economic system was becoming increasingly dependent on high consumption as the means of creating wealth. Sheldon and Arens employed not only economic but also cultural defences for this system, which they described as 'The American Way':

Europe, without our enormous natural resources, whose land has been tilled for centuries and whose forests are hand-planted state parks, is naturally conservative in its philosophy of living. But on this side of the Atlantic the whole set-up is different. Not only are our resources greater; they are unsounded, unmeasured, many of them almost untouched . . . In America today we believe that our

progress and our chances of better living are in positive earning rather than in negative saving.[18]

They admitted that the justification for their preferred system was not absolute but temporal: 'In time we may approach the European point of view, but that time is not yet . . . We still have tree-covered slopes to deforest and subterranean lakes of oil to tap with our gushers.' They further admitted 'We are perhaps unwise and enormously wasteful, as our conservation experts tell us.' But concluded, in a rationalized way which actually avoided the ecological issue, 'we are concerned with our psychological attitude as an actuality.'[19] Consumer design, Sheldon and Arens rightly realized, was not just an economic system, but a cultural one too.

The 'dynamic economy' and consumerist values

In the 1930s the sales of most products, whether refrigerators or cars, were still far from saturation level, and many middle-income families were saving for their first one. But in the post-War period America moved into what has been called the 'high mass-consumption stage': the era of the advanced consumer society when saturation levels for many goods within middle-income markets were achieved. The increasing prosperity of the burgeoning middle class meant an expanded market for homes, cars, appliances and services – boosting, in the words of Harley Earl, the '*dynamic* economy'.[20] The production of cars rocketed from two million in 1946 to eight million in 1955. Registrations followed suit, increasing from 25 million in 1945 to 40 million in 1950, 51 million in 1955, and 62 million in 1960. High and frequent consumption was encouraged by the ready availability of credit. From 1946 to 1958, short-term consumer credit, most commonly used for buying cars, rose from $8.4 billion to almost $45 billion; and in 1950 the credit card was introduced.

In less than a quarter of a century the American economic system had shifted from one based on scarcity and need to one based on abundance and desire. One critic, noting how the high consumption/'dynamic economy' approach underlay auto-design, stated approvingly that the 1950s' car had:

. . . taught its owners to consume and its makers to produce, for an economy in which the strictures of historical scarcity no longer apply. It has made waste through overconsumption one of the indispensable gears of that economy, and has made it socially acceptable as well.[21]

Moreover, what was taking place in the United States in the 1950s was seen as the model for other societies as soon as they could afford it. The internationally respected designer George Nelson put forward the view that, 'What we need is more obsolescence, not less.'[22] Nelson, like Sheldon and

Arens, saw obsolescence as part of the 'American Way' of design, but 'only in a relatively temporary and accidental sense. As other societies reach a comparable level [of consuming], similar attitudes will emerge.'[23]

The implications for design were profound. The consumer society was now being superseded by what I would term the *consumerist* society. The former term is predicated on a market economy and so has been in existence for some centuries; consumerist society signifies an advanced state of consumer society and the market economy, in which private affluence on a mass scale is the dominant force in the marketplace.

The keynote of the system of consumerist design was, of course, high consumption. In the case of automobile design, style obsolescence was integral to the system. The underlying reason was economic: in 1955 Harley Earl unashamedly pronounced that 'our job is to hasten obsolescence. In 1934 the average car ownership span was five years; now it is two years. When it is one year, we will have a perfect score.'[24] The justification offered by manufacturers for style obsolescence was that it was consumer-led: 'the public demands it, [so] there must be born new ideas, new designs, new methods of making the automobiles of a coming year more beautiful than those of yesterday and today.'[25]

The major problem for manufacturers and designers of today is essentially no different from that described by J. Gordon Lippincott in his forthright book *Design for Business*, published in 1947. The major problem, he wrote, was of continually 'stimulating the urge to buy' now that the market was becoming saturated.[26] The new situation was arising because we were now 'entering a period where we will accept an economy of abundance rather than an economy of scarcity'.[27] Lippincott justified high consumption in a way which became standard in a market economy: 'Any method that can motivate the flow of merchandise to new buyers will create jobs and work for industry, and hence national prosperity . . . Our custom of trading in our automobiles every year, of having a new refrigerator, vacuum cleaner or electric iron every three or four years is economically sound.' But tied to this economic justification for obsolescence was a social one: 'Surely in no other country in the world can a worker earning $45 a week drive to his job in his own automobile. He enjoys this privilege only because of the aggressive selling methods of the American automobile industry.'[28] High consumption and obsolescence were essentially democratic, because the prosperous middle-class consumer traded in last year's model, so passing down the line his 'style-obsolete' product, which continued a useful life with poorer owners 'until it finally hits the graveyard and becomes scrap metal for re-use in industry.'[29] This prevented a stark 'have'/'have not' demarcation which would have been socially and politically unstable: the majority of the population were able to own and to aspire.

Lippincott envisaged the designer as working alongside researchers and advertisers with the common purpose of the 'breaking down of *new sales* resistance to accelerate the flow of goods and services'. Significantly, Lippincott realized that this had to take place at a psychological level: 'This is chiefly mental conditioning – largely a job of convincing the consumer that he *needs* a new product before his old one is worn out. It is a case of bucking age-old habits of thrift.'[30] Lippincott, totally committed to a 'free enterprise', 'capitalist' system, was not in the least coy in unequivocally stating that, 'There is only one reason for hiring an industrial designer, and that is to increase the sales of a product.' He explained:

. . . no product, however well its aesthetic functions are fulfilled, may be termed a good example of industrial design unless it meets the acid test of high sales through public acceptance. *Good industrial design means mass acceptance. No matter how beautiful a product may be, if it does not meet this test, the designer has failed of his purpose.*[31]

Given the values and ideology of consumerist design, Lippincott is surely right. If we substitute 'mass' for 'niche' it is likely that the majority of designers practising today in our 'property-owning democracy' would accept his definition of 'good design'. (This is an issue that we will return to in the concluding chapter.) Lippincott's opinions were echoed by other industrial designers in the post-war years. Henry Dreyfuss, for example, sought to avoid any misunderstanding about the designer's primary role: 'One cardinal point which should be made unmistakably clear . . . is that industrial designers are employed primarily for one simple reason: to increase the profits of the client company.'[32]

It should be remembered that not everyone felt enthusiasm for the growing consumerization of design, especially in Britain where there was a tradition of viewing design as a socially and morally improving force. Increasing profits might be all very well, but they should not be at the expense of this wider role. However, given the ideological and political complexion of society at a time of growing private affluence and social mobility, the design 'reactionaries' and reformers were clearly going to be overwhelmed.

The social language of lifestyle

The establishment of consumerist design with its hallmarks of abundance and desire – in the United States in the 1950s and in Western Europe in the 1960s – brought about two other significant aspects of design which we now take for granted: that design is a social language; and that design expresses lifestyle. In the 1950s, unlike today, the language of design was largely unchronicled, but this did not mean that connoted meanings and nuances of

status were opaque or esoteric. For example, as post-war affluence enabled widespread ownership, the American automobile of the 1950s became a richly-loaded carrier of messages that made it the *objet sans pareil* of American consumerism. A gleaming new car may have been a sign of financial success, but the make, model and age of the car was what really mattered because this announced to his or her peers the owner's position on the social ladder. The magazine *Industrial Design* summed it up neatly, describing the 1950s American car as a 'kind of motorized magic carpet on which social egos could ascend.'[33] In the GM stable the range was spread between Cadillac at the top end of the market, through Pontiac, Oldsmobile and Buick, to Chevrolet at the bottom. Each make had its own identity – expressed through styling features – so that it could be immediately recognized. Social mobility and status could be gauged by what a consumer owned from one year to the next.

Design as lifestyle in the consumerist society is demonstrated in Britain by the arrival of the style-conscious Habitat stores; the first was opened in 1964, during the era in which Britain evolved from being a 'consumer' to a 'consumerist' society. Terence Conran recalls that, 'There was a strange moment around the mid-60s when people stopped needing and need changed to want . . . Designers became more important in producing "want" products rather than "need" products, because you have to create desire.'[34] Habitat was a symptom of the new society of the socially mobile, young middle-classes: Conran described Habitat as a shop 'for switched-on people selling not only our own furniture and textiles but other people's too. It's functional and beautiful.'[35] A second Habitat outlet was opened in October 1966, and by the end of the decade there were five branches and a mail-order service. Habitat exploited the aspirations of young, upwardly-mobile buyers for moderately cheap, reasonably fashionable furniture and design that was displayed in a lively and 'young' manner. Conran expressed his hope of taking 'the foot-slogging out of shopping by assembling a wide selection of unusual and top-quality goods under one roof.'[36] As well as its own designs, the store sold bentwood furniture; chairs by Le Corbusier and Vico Magistretti; lighting equipment; toys; bright enamelled tinware; fabrics; kitchen utensils (especially of the 'French farmhouse' variety); and general reproductions of 'below stairs' Victoriana: an eclectic mixture of styles and periods.

The total mix may have been eclectic, but the success of Habitat is partly accounted for by Conran's approach of offering a 'pre-digested shopping programme'.[37] Basically, the Habitat range was selected so that everything 'went' with everything else. This approach anticipated the 'total wardrobe' co-ordinated approach of companies such as Next in the 1980s, whose clothing approach was applied to home furnishings so that 'selecting a

decorating scheme is as easy as choosing a co-ordinated outfit'. The Habitat style in the 1960s and 1970s appealed to the young and 'switched-on' because it not only countered the prevailing British taste for the 'repro', but because it expressed and confirmed a lifestyle. Habitat was not just a store to shop in, but a sort of lifestyle club where one purchased a kind of social confirmation. Conran recognized this: 'You don't go to Habitat to buy so-and-so's products, you just go to Habitat.'[38] A Habitat designer underlined the point: 'Although it is a furniture company selling furniture, furnishing and decorating bits and pieces, it's actually all about a style of life.'[39]

It would seem to be an inevitable consequence of a consumerist society that the increasing competition leads to greater group differentiation in market targeting, and greater product differentiation. A product broadly aimed at an undefined mass is likely to fail because it does not satisfy any particular group or segment of the market. Research, therefore, is carried out to establish a consumer profile to try to ensure that a new product socially and emotionally 'fits' its particular market target group. Market research and motivational research are the tools frequently used by manufacturers to gain such information and, predictably, it was in America – the country with the most developed consumerist society – in the 1950s that such tools were used widely for the first time.

The impact of marketing

However, market research in the 1950s was, compared to today's relatively refined models, often unsophisticated and of limited value. The American automobile manufacturers, for example, tended to ask consumers for their preferences from within a range of pre-determined options. Consumers' choices were limited by their expectations, which in turn were based on previous experience. Market research tended to suggest small and predictable refinements on the existing design – a sleeker look or a different combination of colours – along a linear trajectory. It was not until market research was subsumed within a total marketing approach that consumer-led design could be regularly and successfully achieved. This was certainly the view of Theodore Levitt who could, with justification, be called the godfather of contemporary marketing. Asking why the automobile manufacturers did not anticipate the consumer's need for a compact-sized car at the end of the 1950s (with subsequent major financial losses), Levitt wrote:

The answer is that Detroit never really researched the customer's wants. It only researched his preferences between the kinds of things which it had already decided to offer him. For Detroit is mainly product-orientated, not customer-orientated. To the extent that the customer is recognized as having needs that the

manufacturer should try to satisfy, Detroit usually acts as if the job can be done entirely by product changes.[40]

The real needs, Levitt suggested, were at point-of-sale, repair and maintenance. The type of market research Detroit was carrying out at the time would probably never have revealed these needs.

Levitt's thesis, which he expounded in 1960 in the *Harvard Business Review*, was to place the consumer centrally in the company's thinking. This might involve the company completely redefining how it thought of itself. He gave as an example the Hollywood movie industry, which had been ravaged when television came along. Hollywood's problem was that it:

> . . . defined its business incorrectly. It thought it was in the movie business when it was actually in the entertainment business. 'Movies' implied a specific, limited product. This produced a fatuous contentment which from the beginning led producers to view TV as a threat. Hollywood scorned and rejected TV when it should have welcomed it as an opportunity – an opportunity to expand the entertainment business.[41]

So, Levitt continued, 'had Hollywood been customer-orientated (providing entertainment), rather than product-orientated (making movies)', it would not only have avoided its near terminal demise, but would have flourished.[42] And the aim for a company, Levitt exclaimed, was not merely to survive but 'to survive gallantly, to feel the surging impulse of commercial mastery; not just to experience the sweet smell of success, but to have the visceral feel of entrepreneurial greatness.'[43] Such heroic rhetoric served to embellish and elevate the raw profit motive. A thorough-going marketing-orientated company, in Levitt's words:

> . . . tries to create value-satisfying goods and services that consumers will want to buy. What it offers for sale includes not only the generic product or service, but also how it is made available to the customer, in what form, when, under what conditions, and at what terms of trade. Most important, what it offers for sale is determined not by the seller but by the buyer. The seller takes his cues from the buyer in such a way that the product becomes a consequence of the marketing effort, not vice versa.[44]

Design thus becomes part of a company's strategic business plan, and the type of product it produces must change with the perceived needs of the consumer. This can be easily understood if one thinks of leisure products: a company that has produced television sets might have to start producing portable compact-disc players or computer games that are available at supermarkets if it is to remain successful. The company will have to think of itself as a 'leisure-satisfying' company rather than simply a manufacturer of televisions.

The lifestyle of the consumer becomes a key ingredient of the 'marketing mix'. Other ingredients include price, promotion, distribution and after-sales service. Lifestyle is, of course, closely tied to market segmentation, and the product or service is tailored to fit it. Product features and styling help to determine the product's identity and to differentiate it from its competition.

It took two decades before Levitt's ideas were accepted and acted upon by most companies. In the intervening years companies had to change not only their outlook but their whole business and organizational culture; in effect, they had to reposition their thinking and values. In *The Design Dimension* Christopher Lorenz discusses some of the companies – Sony, Philips, Ford, John Deere and Baker Perkins – who have most enthusiastically embraced the Levitt total-marketing philosophy, and the reader is directed to that excellent book for illustrations of how the companies put the theory into practice. What concerns us here is how marketing has contributed to the idea of consumer-led design.

Strategic lifestyle and desire

Much of the strategic thinking of the hugely successful Sony company has focussed on lifestyle as the key determinant of a product. Following their commitment to the small-screen, portable television set in the early 1960s, Sony acknowledged the need constantly to re-evaluate the company's scope in consumer electronics, and this philosophy led to the development of the Walkman personal stereo, introduced in 1979, the Watchman and portable CD player, and eventually to the Discman and 'personal digital assistant'. In the 1970s, Sony became aware of the importance of understanding changing social attitudes and behaviour in order to develop more of what the company's executives called 'software thinking'. Culture and lifestyle as determinants of new types of products are the springboard for Sony's product development. Sony protest that market research has limited value in 'software thinking' because the consumer is not aware of what new products s/he may desire. Market research in the late 1950s for the small-screen portable television gave a negative response to the product. The same was true of personal stereos. But by studying social trends in relation to lifestyle, Sony has been successful in anticipating desires before consumers are even the slightest bit aware that they might want the new product.

Sony has demonstrated that 'to feel the surging impulse of commercial mastery . . . to have the visceral feel of entrepreneurial greatness', a company has to get ahead of the game – and this means not only anticipating consumer demands but creating them. Terence Conran described the process when he directed the Storehouse Group: 'The market was studied, the target customer identified, and the designers used their skills to create exclusive

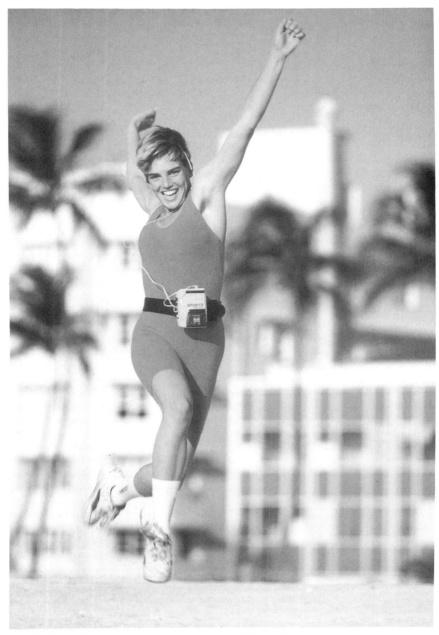

Sony Walkman Sports
'Lifestyle' has become the principal
determinant of many consumer goods. The

Walkman Sports, in its various guises, is a
prime example of Sony's 'software' thinking.

new products and shopping environments aimed specifically at these customers.'[45] But, because the marketplace is a dynamic institution, a company needs to shape products, services *and* consumers:

. . . the marketplace is continually evolving and competitors are always snapping at each other's heels; to be successful, constant fine tuning is required to meet the mood of the consumer or, better still, to tell him what that mood will be before he has realised it.[46]

These sentiments were more vigorously stated by John Butcher, one-time government minister at the Department of Trade and Industry (where he was responsible for design). It is no good designing something, Butcher warned, 'that responds to what the customer thinks he wants now – you have to aim for what he will discover he wants in the future.'[47]

The most commonly cited example of creating a desire – and the one described enthusiastically by the National Economic Development Council in their *Design for Corporate Culture* report (1987) – is the Sony waterproof Walkman with its distinctive bright yellow colour. The number of consumers who actually *needed* a waterproof Walkman would not have justified its manufacture and production but, as the report remarks, that is to miss the point about creating a demand:

The initial purchasers, no doubt, were those who are particularly concerned to express the fact that they are 'sporty', 'outdoor' or 'healthy', perhaps even 'sexy', certainly 'fashionable' and perhaps also 'progressive' . . . With allowances for age, they are probably the same sort of people who buy a 'mountain bike' to get to the shops.[48]

The emphasis on actively creating new desires in consumers rather than responding to identifiable and recognized desires has been the major development in consumer-led design during and since the 1980s. The changing emphasis can be seen in a company such as Philips. Until the early 1980s, Philips had always been technology-led: its engineers developed new and innovative ideas based on the belief that consumers would respond enthusiastically to them. But changes in management priorities have led to a fully 'consumer-led' approach because, reputedly, the company became preoccupied with the desire to match Sony, JVC and its other Japanese competitors in creating consumer demand for new products. Design is seen as playing a crucial role in shaping likely consumer preferences: not only for colours, shapes and styles, but also for entire product concepts.

Design as a lifestyle accessory

One of the great success stories of consumer-led design in the 1980s was the Swatch watch. Swatch watches were launched in 1983, a new product

development created to ensure a viable future for the Swiss company Eta. In the 1970s, the Swiss watch industry was threatened with collapse under the weight of cheap, accurate quartz digital watches that were manufactured in the Far East and sold as impulse purchases outside the normal retail outlets, in places such as garages. Swiss companies, with higher labour and production costs, could not compete on price; instead, Swatch was marketed as a lifestyle product – a fashion accessory for the young, design-conscious consumer across the world. The variety of appearances we have come to associate with the Swatch belies the standardization of the underlying modular construction by an automated production process which reduces the normal 90 parts for a quartz watch down to only 51. The new precision tooling processes, which included ultrasonic welding and riveting, presented Eta with new skills which – remembering the Levitt approach of being customer-orientated rather than product-orientated – enabled the company to develop itself as a precision toolmaker, and so fulfil a demand from other industries for electronics-based measuring and control equipment.

But it was with the design concept of the Swatch that Eta was most innovative. The company started by identifying a market that lay between cheap digital watches and the expensive brand names. The pricing was crucial: too cheap and the Swatch would not be taken seriously; too dear and it would not be bought in the way that was planned. The Swatch was, from the first collection in 1983, marketed as a fashion accessory: you choose your watch to suit what you are wearing and where you are going. Swatch's chairman put it this way in 1987: 'Everyone needs more than one Swatch. They need two, three, four because it is not so much a watch as a fashion accessory. There is always a new generation coming up who will need one and an older generation is finally getting round to the idea of wearing a Swatch.'[49] As in the fashion industry, every six months a new collection was launched with up to twenty-four designs in each collection. Lifestyle is central to the selection of face designs, which are targeted at four main groups: the sports market; the trend-conscious; the design and technology market; and the more conservative and 'sophisticated' young market seeking the classical or traditional in design. Information leading to new designs is gathered less through conventional market research than through the more subjective speculations of designers with their ears to the ground. At one time a fashion consultant in New York provided advice on fashion and colour trends.

Once a new stylistic trend has been spotted and the decision to produce a particular design of Swatch has been made, the new product can be brought out in only six weeks, which allows the company to keep pace with fashion. The marketing of the Swatch has also been innovative in the way in which it has moved selling-points away from specialist watch retailers and jewellers to design-conscious department stores or shops such as Top Shop, in order to

position the product as a fashion accessory. The marketing manager of Swatch described his company's business approach as a 'demand marketing strategy' and, in the words of one design commentator, 'No other mass market product, with the possible exception of the Sony Walkman, has interpreted consumer psychology with such consistent skill.'[50]

The globalization of design

The Swatch sells across the world in millions, demonstrating that lifestyle in the consumer-led age is a greater determinant of taste than any national or regional characteristics. The affluent urban young of London have more in common with their counterparts in Paris, New York and Tokyo than they have with other market segments in their own country. The Swatch is often referred to as a 'global' product and much has been written about this phenomenon in recent years. The internationalization of culture through television and other media; the increasing growth of world trade and the development of new, unexploited markets; and economies of scale in production, have given rise to companies whose products are consumed in most countries on the planet. Theodore Levitt enthusiastically predicts an advance to a unified global culture or, in his words, a 'single converging commonality'. Technological development has 'proletarianized commun-ication, transport, and travel, making them easily and cheaply accessible to the world's most isolated places and impoverished multitudes'. As a result, 'no place and nobody is insulated from the alluring attractions of modernity . . . and everybody everywhere wants all the things they have heard about, seen, or experienced.' Levitt awaits the demise of the multinational corporation that 'knows a lot about a great many countries, and congenially adapts itself to their supposed differences' to be replaced by a 'global corporation' that 'knows one great thing about all countries, and lures them to its custom by capitalizing on the one great thing they all have in common'.[51] Local traditions and customs are replaced by a global condition in which pizzas, Chinese food, Coca Cola, Wrangler jeans and rock music become a language as universal (and as unrooted) as Esperanto. The apparent desire of the Eastern bloc to acquire the trappings of this global culture seems to add weight to Levitt's thesis.

Some commentators see in globalization a threat of anonymous standard-ization; like an international hotel chain, the globalized product would deny national variety and cultural difference. Others argue that the basic product may be global but that the producer will have to take account of national and regional taste cultures if it is going to satisfy its geographical market. Even Coca Cola, the supposed paradigm of global products, has distinctive regional variations as well as a range of options (such as 'Diet Coke' or 'Coke

Classic'). And Philips and Braun became the leading suppliers of electric shavers in Japan only after reducing their size to fit smaller Asian hands. In the case of a standardized global product – such as a home computer – the marketing may have to vary considerably from country to country, depending on cultural habits and expectations. Even a global fast-food pizza will have to be marketed differently in different places, depending on whether pizzas are perceived as standard or exotic fare.

Whatever the product, it is certain that marketing will play a crucial role in these consumer-led design products, and that marketing will help to position a product in a cultural or market niche. It has become standard practice to differentiate consumers by lifestyle rather than socio-economic factors (type of work and income). We can all be fitted into one of four main lifestyle categories: 'traditionalists' or 'mainstreamers' (those who seek the predictable and reliable, such as branded baked beans and major High Street chain-stores); 'achievers' (those with wealth and the desire to surround themselves with objects which reflect their status); 'aspirers' (consumers who are highly status conscious and who seek the latest fashionable products); and reformers (consumers with a conscience who buy recycled paper products and avoid aerosols). The categories are, of course, not discrete and a consumer may 'inhabit' one lifestyle in some purchases, and another one with others. Furthermore, the consuming preferences of a group may change because of environmental or health factors: ozone-friendly products are now being bought by 'mainstreamers' as well as 'reformers'. Nevertheless, the categories are useful enough to form a broad 'lifestyle' approach to marketing. A target group within the category then has to be identified by the producer. One market-research company identified 'avant guardians', 'pointificators', 'chameleons', 'self-admirers', 'self-exploiters', 'token triers', 'sleepwalkers', 'passive endurers', 'Lady Righteous', 'hopeful seekers', 'lively ladies', 'new unromantics', 'lack-a-daisy', 'blinkered', and 'downtrodden' as useful sub-groups.

As competition increases – whether because of the heat of the marketplace or the damp of a recession – niche groups become ever more carefully distinguished and targeted. The ultimate and scarcely believable aim, according to Stan Rapp and Tom Collins in their book *The Great Marketing Turnabout* (1990), is targeting individuals rather than niches.[52]

Within the target group's price boundary, appearance continues to be the most important selling factor. This is borne out by a recent Henley Centre report:

Whereas 30 years ago consumers were more concerned with a product's function – efficiency, reliability, value-for-money, durability and convenience – today's customers are prepared to pay more for a stylish product as they become more

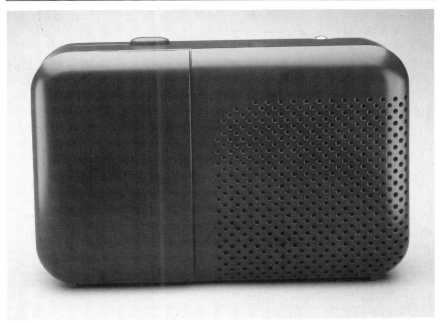

Ross Consumer Electronics Ltd, RE5050 radio, 1985
In consumerist design, 'quality' and 'value-added' appeal are crucial to a product's identity and status. The RE5050 is a product which perfectly captures the mood and values of consumerist design in the mid to late 1980s.

affluent and visually sophisticated . . . Aesthetics now play a greater part in portraying the perceived status of a particular product as functional differences between models are reduced . . . The visual aspects of design have come to predominate as a means of attracting the consumer.[53]

Designing designer-products

An example of this shift towards the importance and careful calculation of visual appeal is the Ross RE5050 radio, introduced in 1985. Ross Consumer Electronics are committed to a consumer-led approach to design. Their 'design philosophy', as defined in the company's 1987 prospectus, states that, 'The company seeks to identify gaps in the market, to conceive the type of product (within predetermined price ranges) to fill those gaps and to design them for cost efficient production, impact in the market place and customer appeal.'[54] This clear thinking has led Ross to alter their marketing strategy from one based on price to one based on style, 'quality' and 'value-added' appeal in which appearance and styling are, arguably, the most important factors.

Research carried out for Ross revealed that, unlike television viewers,

radio listeners had regular and fixed listening routines, so that particular stations were tuned into at particular times in particular locations (bathroom, bedroom, kitchen etc.). The implication of these types of listening habits is that each family, couple or individual owns several radios which will be located in particular places rather than moved around with the listener. From this conclusion, which was based on behaviour patterns, the designers decided that, so long as the on/off switch was easily accessible, other controls including tuning and volume could be sited out of view behind a flap. This had the advantage of turning the radio into a sleek, unfussy object of designer-desire for the market segment Ross aimed for – the style-conscious professional 20–35 year old. Market image was very important: the RE5050 had the same sophisticated, minimal appearance as a shaver or toaster by Braun, and thus might be displayed in the home as a designer product. The radio was produced in colours that were fashionable in the mid-decade – white, red, black or the ubiquitous grey – and it was widely illustrated in design magazines and sold at design-conscious shops as well as hi-fi outlets.

Ross introduced a new radio – the RE5500 – about 18 months after the RE5050. It housed, more-or-less, the same innards (most of the controls were tucked away) but was upright and had six pre-set station buttons as well as the on/off switch. The rationale for the development of new products was that:

> Ross continually introduces new ranges of products and redesigns earlier lines in order to maintain their popularity in the market. The Directors consider that, for example, a headphone range has a selling life in the region of two years before it requires updating and, after about eighteen months into the product's life, a new version is introduced in order to maintain demand. Design is also used to expand the sale of existing products by encouraging consumers who already have headphones to purchase a further pair through the use of fashion input.[55]

Maintaining demand or increasing sales through restyling or redesigning is, of course, the same aim that Lippincott described as 'stimulating the urge to buy'. The most successful way of doing this, as Ross realized, was the consumerist method of making the product more fashionable than its predecessor. Ross, like other consumer-led companies in the 1980s, were putting into practice the more sophisticated version of this marketing rule by relating each fashionable product to lifestyle.

Ross applied this approach to the product that they had originally become known for in the 1970s: headphones. In 1986 they announced a range of lightweight headphones: 'Movers', in '3 stunning colours' (red, blue and yellow), were aimed at teenagers; 'Stylers' – 'music with style for the girl on the move' – were targeted at the Swatch fashion-product market. One journalist described them as 'fashion-accessorising headphones for women

... The product fits into a make-up style compact case and has four sets of interchangeable plastic earpiece covers (in pink, blue, green and yellow). The idea is that you can change the colour of your personal hi-fi headphones to match the outfit you're wearing.' The designer conceived them as 'a pair of giant earrings with speakers inside'.[56] The concept was centred on the headphone as a fashion accessory, and the redesign included new packaging 'to suit a "lifestyle" image, incorporating colours and mood to match today's fashions.'[57] This 'consumer-led' approach was even applied to the company's heavyweight headphones, which were redesigned and relaunched with 'new details, in a darker shade of grey, and with revamped packaging'.[58]

Ross Consumer Electronics is a British company and the RE5050 was marketed as a British radio but, symptomatic of Britain's recent economic plight, it was designed and assembled in Britain, but manufactured abroad. The consumer-led design approach is, however, a typical global trend and it paid dividends to Ross as a company. In the four years following 1982, a loss of £31,000 was turned into a surplus of over half a million pounds.

The audit of design

One of the chief claims for consumer-led design is that it generates wealth through high consumption – the classic argument put forward by the Cheneys and Lippincott in the 1930s and 1940s respectively. If the *raison d'être* of design is financial – as uncompromising marketers would doubtless argue – then the bottom-line of consumer-led design's account sheet is all that we need to study. But, now that we are becoming aware of wider costs through environmental audits, as well as the social and cultural costs of a particular value system, it would be simplistic to judge consumer-led design in this limited and self-justifying way. The criteria by which one judges design are, needless to say, of fundamental importance to the present study.

We have seen in the first part of this chapter that consumer-led design has not emerged spontaneously from our 'enterprise culture', but has evolved as an almost inevitable consequence of an advanced consumer society and a market economy. We have seen how it operates and we have analysed some of its values – both those that are explicit and those that are apparently natural to our culture and thus implicit. The real issue is whether consumer-led design is part of the solution to society's problems, or whether it is a cause of those problems. What are the arguments against it?

Performance, in a primary functional sense, should still surely be the first criterion by which most products are assessed. Some consumer-led design, hailed as 'successful' and 'good' design, has significant shortcomings in this area. The Ross RE5050 radio, for example, was found to be sub-standard in sound level, FM and long-wave reception by *Which?* in a report which tested

thirty-eight portable radios.[59] I can confirm these shortcomings from personal experience: the maximum volume level is poor and meant that the radio could not be used for the purpose I had intended. The reader may think it significant that I had purchased a Ross radio – s/he may be right – although, in my own defence, I would argue that, being both professionally interested in design and being a sometime collector of radios, I may not be a *typical* consumer. Although I may have bought it because, in styling terms, it was 'significant', I would admit that I would not have purchased some of *Which?*'s 'best' or recommended buys because I find them unattractive or not to my taste.

This raises the question of the extent to which consuming choices are made on rational grounds. My (or, in general, the consumer's) choice was not 'rational' in that it was not based on measurable and quantifiable criteria: I did not, for example, test the radio for volume level before I bought it. My choice was determined by some objective factors (price, reasonable expectation of acceptable performance) and some subjective factors (style and associations). The point here is that consumer-led design cannot be rejected merely because it does not promote 'rational' criteria. Proponents of socially responsible design can often be accused of assuming that the consumer is entirely rational or, at least, would be if all products were 'rational'. Equally, however, I would not suggest that the fact that the consumer is not wholly rational, means that any form of design which appeals to her or his taste is therefore justified on expressive or emotional grounds. This defence – if a product is bought it must be satisfying a functional or emotional need and therefore is justified – ignores wider issues which we will be examining later in this chapter, and at greater length in subsequent chapters.

In the 1950s and 1960s, Vance Packard brought out a series of books – including *The Hidden Persuaders* (1957), *The Status Seekers* (1959) and *The Waste Makers* (1960) – which amongst other things claimed to expose the exploitative techniques used by advertisers on a naïve and eternally gullible public. Some would criticize consumer-led design as equally exploitative: sophisticated means are used to bedazzle and seduce an easily manipulated public. The public, this argument goes, does not really want the types of design being foisted on it, but is made to believe it does. This argument presumes the public to be passive and easily manipulated; and, implicitly, that they would be wholly rational consumers if given a fair chance. Manipulation is a loaded word, and it would be indefensible to claim there was *no* manipulation in consumer-led design. Obviously there is a great deal if we use the word more neutrally – as a way of 'treating with skill' or 'shaping responses'. Yet in our society we often happily accept and willingly participate in manipulation, for example, by watching a movie at the cinema or a drama on television, and this factor also affects us when we make

purchases. There is a need for playfulness and desire in our lives which consumer-led design helps to meet. What we might object to is not that consumer-led design is immoral because it caters for desires rather than just needs, but the *extent* to which a value system attuned to desires has become a predominant cultural and social norm with values that are very largely implicit rather than explicit.

Longing for design

In *The Romantic Ethic and the Spirit of Modern Consumerism* (1987), Colin Campbell identifies 'longing' as the characteristic cultural condition of consumer society. Longing is manifested in daydreaming, advertising, marketing, the design of products we buy and the places we both purchase and consume them. Campbell underlines the importance of understanding the difference between concepts of need and satisfaction on the one hand, and those of desire and pleasure – which give rise to longing – on the other. 'The former relate to a state of being and its disturbance, followed by action to restore the original equilibrium.'[60] Need is, therefore, essentially a state of deprivation: the need for food arises from hunger:

By contrast, pleasure is not a state of being so much as a quality of experience. Not properly itself a type of sensation, pleasure is a term used to identify our favourable reaction to certain patterns of sensation. Desire is the term used to refer to a motivational disposition to experience such patterns.[61]

For Campbell, a fundamental difference between the two is that needs relate to a state of being, while pleasure relates to a quality of experience and, 'although interrelated these cannot be directly equated'.[62]

Campbell's thesis is that the shift from a concern with needs to one which focuses on pleasure is the effect of not only affluence and abundance (although these are prerequisites), but also of the Romantic emphasis on the nature of individual experience and sensations (which replaced the classical and aristocratic modes of ordained and ordered responses), and of industrialization. The broad historical condition Campbell describes is particularly pertinent to a study of the contemporary consumer. The spirit of the modern consumer is, posits Campbell, 'an apparently endless pursuit of wants; the most characteristic feature of modern consumption being this instability'.[63] The modern consumer has to realize that her or his wants will never be satisfied 'because of the apparently endless process of replacement which ensures that when one want is fulfilled, several more usually pop up to take its place'.[64] This is different to an addiction which has a sharply defined single focus, such as the physical addiction to alcohol or drugs. By contrast, the modern consumer:

. . . is characterized by an instability which arises out of a basic inexhaustability of wants themselves, which forever arise, phoenix-like, from the ashes of their predecessors. Hence no sooner is one satisfied than another is waiting in line clamouring to be satisfied; when this one is attended to, a third appears, then subsequently a fourth, and so on, apparently without end. The process is ceaseless and unbroken; rarely can an inhabitant of modern society, no matter how privileged or wealthy, declare that there is nothing that they want.[65]

As soon as a want is fulfilled, it seems to die or become obsolete. Campbell goes so far as to say that 'the desiring mode constitutes a state of enjoyable discomfort, and that wanting rather than having is the main focus of pleasure-seeking.'[66]

Campbell has described accurately and well the consumer's frequent mood of longing in today's consumerist society. One could argue that Campbell overplays cultural forces to the detriment of economic forces – the political and social effects of the 'high consumption' economy – in the creation of the modern consumer, but his emphasis on cultural factors is an antidote to the more orthodox economic determinist arguments. As regards consumer-led design, it follows from the 'longing' thesis that the consumer will opt for a novel rather than a familiar product 'because this enables him to believe that its acquisition and use can supply experience which he has not so far encountered in reality'.[67] This suggests a rather adventurous consumer, whereas some consumers seem to seek nothing more than the tried-and-tested, the familiar, the reassuring. It is the very absence of apparent change that makes Hovis bread, a Mars bar, and a Burberry raincoat so appealing to those who respond to (respectively) 'tradition', 'goodness' or 'the timeless-ness of classics'. Lifestyle groupings respond differently to change and novelty: 'aspirers' will be the most favourably disposed, with other groups attracted to lesser degrees depending on the type of product or service – 'reformers' would, for example, respond positively to what they perceive as socially beneficial change. Furthermore, if the product itself stays unchanged, the advertising and marketing surrounding it can change and give the product what appears to be a new identity – as in the case of Hovis developing their self-conscious image of a nostalgic past.

Revamping the world

Far from it being the novel product which most appeals to consumers, as Campbell suggests, it is often the familiar product with a 'freshened up' image. A balance has to be achieved between newness and reassurance, hence the constant news in the design press about graphic identities and images, packaging and even products and interiors being 'revamped', 'updated', 'tweaked' or 'cleaned up'. The intention, to quote the publicity

surrounding the updating of the package for a well-known crisp, is to give the product a 'facelift, but not a new face'. A few examples taken from the design press over the last couple of years will make the point. The quotations often contain some rather euphemistic language that tends to give the impression that significant and profound and certainly *creative* (the design world's favourite word) designing has taken place. A major brewer has 'revamped the look of [its] major lager brand . . . to give the beer more onshelf impact and clearer branding. "The shape of the logo has been altered from a race-track to oval form,"' announced the brewer's marketing manager for lagers. Other alterations included a larger black bar printed across the centre of the logo and the name in larger type. The manager defended the fact that the new design is only slightly different from the old: 'I don't think big brands should be changed radically', he said.

An ageing branded aftershave also needed to generate more 'on-shelf impact' because, its manager lamented, 'its on-shelf image was incongruous with the brand's quality'. Although the original aftershave bottle was retained, the rest of the range – from talc to splash-on lotion – was repackaged in high-gloss plastic bottles which 'use the heritage of the glass aftershave bottle' (surely the most bizarre use of 'heritage' since the establishment of the industry!). The packaging graphics were 'tweaked slightly' for a 'cleaner image' in an overall 'facelift' operation. A cosmetics group decided to 'revamp' its brand-name shampoo because 'market research showed that [its] image as a natural, frequent-wash shampoo was still relevant, but the packaging was becoming too familiar'. A 'more modern' bottle was introduced and the herb illustration was retained but 'redesigned' because it was part of the 'brand's identity [and] intended to "reassure" the consumer'. The consultancy director announced it was a 'cleaning-up exercise'.

'On-shelf appeal' seems to be not only a fashionable phrase but a selling strategy and a professional obsession. A chocolate and cake manufacturer used 'mouth-watering' photographic images on their redesigned cakes packages because the shots of sliced cake were intended to give 'extra "eat me" impact on-shelf'. Determined not to be left *on* the shelf, its rival has 'updated' the packaging of one of its best-known brands for the 'first time in seven years' – a time-span which seemed to invite audience incredulity. The 'fairly straight' old design was given a 'bouncy' hand-drawn logo that tried 'to reflect the personality of the product in the packaging, to make it more fun and dynamic', according to the senior brand manager. The consultancy manager said that his aim was to give the new pack a more 'youthful and contemporary look and at the same time retain the loyal brand consumer'.

These seemingly trivial changes result from companies trying to maintain or expand their market segments. The brand leader for matches had their

box redesigned because, 'We wanted to make it appeal more to women, without effeminising the product, and to a younger audience of 18 to 24 year olds, who tend to use disposable lighters.' Consumer testing showed the redesign to be popular with the new segments 'because it looked more expensive'. These changes are examples, according to the management director of the chocolate and cake manufacturer, of the company taking 'a leadership stance'.

The American designer and stylist Raymond Loewy entitled his auto-biography *Never Leave Well Enough Alone* (1951) because he realized that the designer was assured a regular income if the appearance of products was continually updated. Updating is an integral feature of the consumer-led design approach. Companies which traded with the same graphics, packaging and 'retail environments' for years, and sometimes decades, now find that once they embark – and embark they usually must if they are to retain their market share in the face of the competition's attractive revamp – on a redesign of their image, style obsolescence soon takes over and another update or redesign is required. An example is provided by a chain of shops selling children's clothing. The shops were 'revamped' only five years after they had been 'thoroughly overhauled' by another consultancy. Neverthe-less, the shops' existing look was deemed to have become 'outdated'. The new look, we were promised, would be 'cleaner and simpler'. Just as a new hairdresser, plumber or dentist habitually blames their predecessor for the unmentionable state of dereliction your hair, pipes or teeth have fallen into, so the designer can often be heard to lament the visual clutter and creative mediocrity of the former designer, while promising to provide the image that modern consumers long for.

Accelerating product development

Throughout the 1980s the frequency of redesigning increased as compe-tition became sharper. Although there will be occasional slow-downs caused by economic downturns and recessions, the frequency of redesigns over a longer period – rather like an international share index – will continue to speed up. The same is true for product development. In 1990 the CBI (Confederation of British Industry) acknowledged this tendency and hosted a conference in London on 'Accelerating Product Development'. The conference brochure stated the case:

Fierce competition and increased customer expectation mean the rules of the game in new product development are changing. Companies are increasingly realising that the sequential approach to new product development simply won't get the job done. Effective product development can reduce lead times by as much as 50% . . . The company who can bring out products faster than their

competitors enjoys a huge advantage. Failure to implement successful product development systems can spell disaster!

The motivation slogan for the conference was pure 1950s Levitt: 'Don't just survive in the future – excel!'

One of the 'vital issues' covered at the conference was 'methods for shortening your lead time and fast-tracking product development': an issue that had concerned Sony, Philips and other major consumer electronics companies for some time. The general manager of one global electronics company did not feel that speedier product development was to the consumer's advantage. In the mid-1980s a Japanese firm took, on average, three years of development to bring a consumer-electronics product to market (compared to a 5–7 year average in the West),

. . . once it has cracked the technology and the product concept. This used to leave 12 months for design. However, the demands of marketing have cut design time further. Designers are now lucky to get more than a couple of months, and to add styling only . . . As a result, the production cycle only allows for real innovation once or twice in a decade.[68]

By 1991 Sony were offering fifty new Walkmans a year. Most, obviously, incorporated minor changes of technology (referred to as 'creeping feature syndrome') or styling, but the sheer volume of 'innovation' drags a vast marketing baggage in its wake. By 1992 the Japanese Ministry of International Trade was exhorting manufacturers like Sony not to make changes to their products for at least a year after they are first introduced!

New versions principally make use of styling to stimulate demand. A manager who had had personal experience of Sharp's QT50 radio-cassette player, with its 1950s styling and fashionable colours, remembered that it became an overnight success, but 'was in and out so fast' when a newer model came along. The QT50 was, however, a landmark in consumer technology as a fashion commodity.

Consumer-led design obviously relies heavily on a new product being fashionable. Light years away from the Modernists' quest for the unchanging type-form, the designer in the consumer-led age seeks the immediate and 'impactful' which, almost inevitably, are also the transitory and the ephemeral. Generally speaking, the greater the initial impact, the smaller the sustaining power. It seems at times as if design has become merely an offshoot of the fashion industry: the product as a fashion accessory to the decorated self. The importance of on-shelf appeal is replaced, after purchase, by on-self appeal. 'Lifestyle' is presumed to be the only desirable state of being in the late-twentieth century, the ultimate antidote to the existentialist dilemma.

The authors of the National Economic Development Council's 'Design

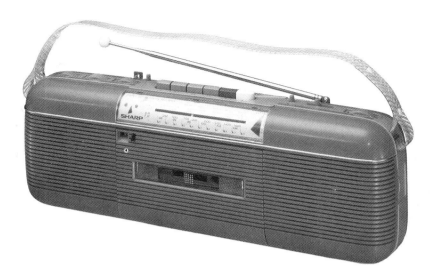

Sharp QT50, 1984
The QT50, with its conscious 1950s 'retro' styling and 1980s fashion colours, was a

landmark in consumer technology as a fashion commodity.

For a Corporate Culture' report seem to confirm this presumption. In the section of the report which deals with 'Designing "Lifestyle" Products', the authors pronounce that 'many designers believe that product design has become more of a profound activity' than the words connote:

It is not so much a question of fashion (which suggests that design is about colour and styling) but of *lifestyle*. Designers today need more than ever to understand the more complex motivations that prompt consumer purchase decisions, such as the development of a distinctive self-image.[69]

However, whether fashion is a subdivision of lifestyle or vice versa matters less than the implications of continual redesigning as a way of stimulating desire, as a way of creating longing and increasing consumption.

The NEDC authors admit that this situation is far from satisfactory, and even acknowledge that some designers have grave reservations:

Some designers bitterly condemn this competitive emphasis on shortening product lifespans, since it is viewed as wasteful, distasteful and 'exploitative'. Whatever the rights and wrongs of the matter, for most companies it is now a fact of company life that can't be made to go away by refusing to play the game.[70]

But, having made a gesture at salving its conscience with this half-raised issue, the NEDC report then goes back to talking about design without questioning its ideology or challenging its assumptions. As the Green and

ethical consuming movements have demonstrated, change *is* possible; but an essential precondition is an awareness of the current situation.

Consumer-led design?

The question of whether consumer-led design is wasteful will be discussed in a future chapter; the reader will, by now, probably have formed an opinion as to whether it is 'distasteful and exploitative'. Whether, more particularly, the increasing frequency of product replacement and the continual updating or revamping of style are genuinely to the consumer's advantage must also be judged by the reader. Is today's shopper at the children's clothing store mentioned above really dissatisfied with the apparently dated image? And can that change of image be described as consumer-led? But having scrambled onto a merry-go-round that is whirling faster and faster, manufacturers have found that it is very hard to get off. Many designers have moral qualms about the seductive pleasure the merry-go-round promises, but manufacturers and companies are inviting them on board and, if they say no, other designers will jump at the chance. Finally, the consumer climbs aboard. But only to the extent that the consumer is paying for the ride (as well as for the manufacturer's and designer's tickets) can s/he be said to be *controlling* the merry-go-round.

'Consumer-led' design is, therefore, a misleading term. It implies that companies are following where consumers are leading; but its proponents admit that consumers have to be enticed to want to go to a place that they did not even know existed. A more honest term for this sort of design would be 'marketing-led', because it is marketing, not the consumer, which is the driving force. The much vaunted claim that consumer-led design as a system facilitates 'freedom of choice' should be regarded with much scepticism. Looking back at the era of the Model T Ford, J. Gordon Lippincott in *Design for Business* recalled that nine cars out of ten were black, but soon 'nine cars out of ten will be any colour *but* black'.[71] Thereby spoke a committed consumerist apologist for whom 'choice' referred to the colour of the paintwork or, in today's terms, the styling and graphics of the packaging. The argument turns upon the *level* of choice that one believes to be significant: alternative colour schemes merely to differentiate the same product; or genuinely alternative products. The choice that consumer-led design offers may be attractive, but often it is phoney.

The material world and 'self-seeking vulgarity'

The effect that consumer-led design has on people is, not surprisingly, a matter of controversy. Since mass production began in the nineteenth

century, design moralists have warned of the dangers of materialism and selfishness. In Britain in the 1950s, when prosperity was beginning to usher in consumerist society, the fear was expressed that traditional British puritan values were being destroyed by a crass American materialism. Against a background of loathing for the 'American Way' of Lippincott, Loewy and (eventually) Levitt, the cultural critic Richard Hoggart in *The Uses of Literacy* (1957) attacked the American mass media:

> Most mass-entertainments . . . are full of a corrupt brightness, of improper appeals and moral evasions . . . they tend towards a view of the world in which progress is conceived as a seeking of material possessions . . . and freedom as the ground for endless irresponsible pleasure.[72]

He believed that we were guilty of allowing 'cultural developments as dangerous in their own way as those we are shocked at in totalitarian societies'.[73] The writer and cultural theorist Raymond Williams espoused similar views in *The Long Revolution* (1961), and unambiguously stated his viewpoint: 'We should be much clearer about these cultural questions if we saw them as a consequence of a basically capitalist organisation and I at least know no better reason for capitalism to be ended.'[74] Many on the British Left blamed the country's journey into consumerism on the Right and rejected consumerism as a symptom of the 'affluent society brought in by the Tories . . . with its refrigerators, motor cars and washing machines, [which] had corrupted the British people into self-seeking vulgarity.'[75] Vulgarity was also apparently evident in American design. The architectural historian Nikolaus Pevsner, for example, abhorred the post-war American automobile because, 'it symbolises riches and power . . . grossly . . . That sort of noisy show comes off in the United States where it is at least in accordance with its people . . . [but] they are in contradiction to qualities of the British character. To be gross and flamboyant has never been typical of British art and design.'[76]

The manifestations of gross 'self-seeking vulgarity' may have become less flamboyant and brash, but many would claim to see plenty of vulgarity in modern consumer-led design – primarily amongst 'aspirers' such as the so-called 'yuppies' of the 1980s. An example is the way that the watch became a status object. This was conspicuously manifested not only through the wearing of a Rolex, but through the playing of the status game which might be called 'watch me and my wardrobe'. It was described by Anne Inglis in *DesignWeek* in 1988.[77] In pre-consumerist days, Inglis started, watches were bought principally to tell the time; they were worn discretely and replaced only when they terminally broke down. A watch was often a present for a special occasion like a twenty-first birthday. Whereas now, watches are worn as a badge of conspicuous consumption: 'After all, it seems a pity to hide this

arbiter of status from view when it means so much: more subtle than a tie, more interesting than designed jewellery (real or false), and more convenient than the car that is parked out of sight . . . Indeed, there is a view now that the watch has replaced the car as the sign of who or what you are.'

In a saturated market, owning two watches became the norm: one for the day and one for the evening. Inglis thought that this shift in attitude was caused by the marketing of the Swatch, which encouraged the notion of the short-lived, replaceable, attractive timepiece – although the Swatch itself was 'no longer considered to be the right sort of object to own up to'. By 1988:

The average watchperson owns five or six watches. Generally one of these is smart and expensive, and is worn to impress clients and instil the idea that business is going well. Currently, this tends to be a Rolex Oyster, which performs the happy trick of combining a classic design with Swiss reliability.

The market in the late 1980s was such that a number of specialist watch retailers opened in London for the market Inglis was writing about. The 'London designer store' Fast FWD offered a tiered (in marketing terms) range of watches as an aid to developing 'the total look, which is taken a step further by fashion arbiters such as Paul Smith'. Many of the watches at the stores emphasized 'the look rather than the efficiency of the time-keeping'. In fact, a lot of the cheaper fashion watches hardly worked at all but, as Inglis reminded us, 'it's the look that counts, not what the minute hand says'. And, in May 1988, it was 'the *macho* look [that was] hot currency for both men and women'. But early signs were visible of a move back to 'the single classic, more expensive item, made out of quality materials (lots of gold), which will retain its value'.

No doubt there was an element of fun-poking in Inglis's piece, but the piece does illustrate well the role of design in a consumerist society. Does it validate those who have argued that consumerist tendencies are to do with status, and make people more materialistic and greedy? An interesting and somewhat unpredictable answer comes from Colin Campbell, who writes that:

. . . the spirit of modern consumerism is anything but materialistic. The idea that contemporary consumers have an insatiable desire to acquire objects represents a serious misunderstanding of the mechanism which impels people to want goods. Their basic motivation is the desire to experience in reality the pleasurable dramas which they have already enjoyed in imagination, and each 'new' product is seen as offering a possibility of realizing this ambition. However, since reality can never provide the perfected pleasures encountered in day-dreams . . . each purchase leads to literal disillusionment, something which explains how wanting is extinguished so quickly, and why people disacquire goods as rapidly as they acquire them.[78]

Yet Campbell makes the mistake of equating materialism with the *quantity* of goods one owns. For most people materialism is more an attitude and a belief. The objects that one possesses or lusts after are important because they make a social statement about status: how you see yourself and who you are. Materialism, therefore, is likely to combine possessing *and* longing. Indeed, a materialistic attitude may be manifested in a minimalist way: a bare room housing only one or two crucial objects of exquisite taste or social prestige.

Social priorities and design

Consumer-led design – virtually by definition – promotes the production of anything that can be fitted into a market. Its proponents would claim that it is amoral in terms of what is produced. For the designer to make moral judgements (the argument goes) is to interfere with the consumer's right to choose for her- or himself in a 'free' society: a denial of consumer sovereignty and an indefensible reduction in the choice that the market-place best facilitates. When priorities are determined by the market, products which are socially or ecologically desirable but have no immediate or significant consumer appeal may not be produced unless a central body with power in the marketplace intervenes – normally the state or its agent. This raises issues about priorities and socially responsible design which are examined in chapter 3. More to the point now is the socially unnecessary (and, arguably, socially divisive) products that consumer-led design produces.

An example is the Ikari 'ignitor', essentially a cigarette lighter based on a technology spin-off from the Ariane space programme and fuelled by rocket propellant. Its research, development and investment over a four-year period exceeded £1 million. LN, the Geneva-based company that manufactured the Ikari – a name resulting from meticulous research into international linguistics and word association – offered the justification that the lighter's rigid flame would be a boon when lighting barbecues and unfreezing car locks. The sleekly-styled object was awarded the French Institute of Industrial Design's label of good design, was voted 'Object of the Year' at a major Paris design exhibition, and received the International Press Award at the 'Salon des Inventions' in Geneva. Some consumers may rationalize paying about £45 for an up-market lighter in terms of its functionality, but the company's marketing director predicted that the value-added appeal and cult status would compensate for the price; he hoped that 'the desire to own one is such that people buy first and find a use for it later'.[79] As one outraged letter writer asked, 'how many useful objects such as irrigation pumps, alternative agriculture implements or power-generating devices for use in developing countries might have been created with the same resources?'[80]

Ikari International, Ikari all-purpose lighter
The publicity material gives examples of its functions, 'which will only increase with use . . . Lighting a barbecue or a camp stove; cutting a boating rope; lighting a work-site brazier; defrosting a frozen car door lock; lighting the candles on a birthday cake without the user being burned; eliminating sludge from a bicycle chain; destroying a nest of insects in the hollow of a plant . . .'

Comparisons of this sort may be over-simple. Nevertheless, they do make us aware that society makes certain choices, and pursues certain interests and values.

Private affluence and public squalor

The materialism of consumer-led design testifies to private affluence on a substantial scale. Moreover, by identifying a taste culture, referring to aspects of it through emotive images in advertising and marketing, and by creating lifestyle products, a consumer-led company appeals directly to an individual – even though that individual is seen by them as typical of and undifferentiated from others in a market segment. Thus *individualism* rather than individuality pervades our consumerist society. This leads to another criticism of consumer-led design. Its vision is one of affluent and fulfilled individualism in which the individual is respected, admired and lusted after by envious or wishful acolytes. With individualism, society is no greater than the sum of its individualistic parts, and so consumer-led design offers us no social vision – no vision of society. The hard Right in Britain – to recall a notorious statement by the ex-prime minister Margaret Thatcher – does not seem to believe that 'society' in any collective sense even exists. 'Society' – their preferred phrase is probably 'nation state' – is a collection of individuals, most of whom have families, and all of whom should be striving to 'look after themselves' by 'feathering their own nests'. After all, it's only

human nature. And individuals should think of themselves not as 'citizens' but as 'consumers' – not only in the marketplace (where such a distinction is valid), but also in relation to the state-funded sector (such as the health service or education) and the professions.

Market(ing) segmentation is not synonymous with social pluralism. You have power in the marketplace only if you have sufficient money; many groups in society – from disabled groups and elderly people, through to a significant percentage of ethnic minorities, to the growing 'underclass' – have a minimal income (let alone any disposable income) and so are excluded from the marketplace. Consumer-led design does not – and cannot – deal with the needs of these people because there is no profit in them. If we seek a harmonious, socially plural and tolerant society, a structure has to be in place effectively to cater for the sick, the homeless, the unemployed and the other disadvantaged. A number of feminists also argue – as we shall see in chapter 4 – that marketing-led design is inadequate for many women. It seems to work best for the affluent, white, male – and probably childless – middle classes.

Designers: politics and creativity

So it is not surprising to find that most designers are white, middle-class males. Marketing-led designers seem not to be troubled by any feelings of responsibility to society: these designers feel they owe their allegiances to the companies who commission their services. One typical design consultancy, a consortium of people with skills in marketing and design, offer 'applied business development', and describe themselves as 'very, very market-led'. For them, 'design is just a branch of marketing', and so, inevitably, the company serves the interest of the commissioning client: 'We're actually rooting for the client, we sit at the client's side of the table and think, now, what kind of product do we need to further the company's interests?'

By and large, designers are not coy about aligning themselves. Interviews with designers from consultancies, and the letters pages of the design press, are full of unselfconscious and unthought-through ideological statements about design and its role in society. A common argument from designers is that the interests of their clients and the client's customers are identical: a successful product or service satisfies the user who buys it, and this satisfies the company because it keeps it profitable. This is the unconvincing argument of the amoral designer who caters for desires but asks no further questions about how those desires are formed, whether they are socially beneficial, whether resources are wasted . . . and so on. Many designers are deeply suspicious when they hear talk about such notions as 'the designer's

social responsibility' and 'socially useful products'. First, because it may harm their own financial prospects: a continual process of revamping products and packaging means continual employment. Second, they find such notions anathema, politically and ideologically. Instead, a two-dimensional view prevails, and this is encapsulated in a letter that was published in the design press:

> Designing for the public good . . . often means design by committee, and then shoving it down an unwilling public's throat. Eastern socialists tried that and produced the Trabant. We did the same, and produced tower blocks for hapless workers to exist in. With all its faults, our system, where design is the hand-maiden of capitalism, beats the alternative hands down.

This polarization is often accompanied by an inflated view of the designer's own creativity. The design writer Jeremy Myerson regrets that designers can seldom resist claiming that every job – however mundane and run-of-the-mill – is somehow a 'breakthrough, a radical departure'. As Myerson remarks, 'I can't imagine a firm of solicitors completing a conveyance and saying "we really subverted the context on that one". Or an accountancy practice submitting your audit with the explanation: "We really stretched the envelope this time." '[81] As the two disillusioned design graduates put it, if industrial design were a person it would be a 'whining and insecure adolescent . . . or perhaps a boastful drunk in a pub'.

Occasionally, the profession sees its own creativity in grandiose terms. In his company's heyday, Michael Peters remembers, 'I was in Venice, looking at paintings in churches, and I thought to myself, "I am no different from those blokes: if I lie on my back and paint this I am exactly the same." '[82] Peters's point was that Michelangelo was fulfilling a commission for a client, and therefore felt an obligation to that client. Given the profession's own hype about its value and special skills, it does not take an ungenerous mind to read this comment as implying that designers are on a par with artists such as Michelangelo because of their mutual creativity.

Legal, decent, honest and truthful

Readers might feel that this is twisting Peters's words – and they may be right – but this chapter has not attempted to be entirely dispassionate and impartial. It has simplified the values of 'consumer-led', that is, 'marketing-led' design by emphasizing its more dubious side. This dubious side certainly exists, and it serves to expose the fundamental ideology which underlies all marketing-led design. There are countless examples of marketing-led design which are attractive – even seductive – and which make the world a more personally satisfying (as Campbell might use the

term), lively and convenient place in which to live. However, to discuss marketing-led design at the level of personal likes and dislikes would be to miss the point about its implicit ideology, implications and wider effects on society. Every piece of marketing-led design is part of a *system*, a system which has some undoubted appeal but which is also socially divisive and environmentally destructive. Marketing-led design, as I hope this chapter has clarified, is part of an economic, social and political ideology.

Readers will not, I hope, think of the criticisms in this book as just 'do-gooder' or 'spoilsport' sentiments: the arguments are not the 'anti-pleasure' or 'anti-material possessions' stances of a puritan who believes that everyone should act rationally and in earnest all the time. Nor should the criticisms be seen as dated. It is true that – perhaps because of the economic recession – the 1980s were all about hype and image, whereas the 1990s are about 'smart' design and 'integrity'. But one should be deeply suspicious that 'smart' design and 'integrity' are anything more than the emperor's new designer-clothes; they are more likely to be this year's life-style image, intended to allow consumers (and designers) to feel that they have a social conscience and care about the world and its problems. The imagery of car advertisements may have moved from the car being depicted as a thrilling and rather dangerous experience, to the car as a stylish accessory to the caring life of an adoring father; and the image of products may have increasingly embraced a superficial environmental friendliness. But the underlying system has changed little, if at all.

It would appear that, every so often, a backlash to the more blatant manifestations of consumerism takes place. For example, in the USA at the beginning of the 1960s there was a reaction to the more extreme aspects of built-in obsolescence. The principal counterforce emanated from the consumer protection movement which, like its British counterpart, attempted to distinguish between the promised and real performance of a product. None other than J. Gordon Lippincott, author of *Design for Business*, declared that he was disenchanted with the emotional intensity of a high-consumption society, and fed up with products whose performance had been sacrificed to appearance and which could not be repaired.[83] The result was that American manufacturers, retailers and advertisers in the 1960s had to begin to give an impression of integrity and maturity in order to regain the respect of the consumer. However, while in polite professional circles, talk of 'planned obsolescence' may have been discretely discarded, the ideology of the high consumption economy was neither fundamentally questioned nor seriously revised. The graph may have levelled out for a while; it may even have dipped occasionally, but its ultimate and purposeful direction remained the same. In 1989 *Business Week* devoted a major cover story to 'Smart Design: Quality is the New Style'. 'Smart design', it claimed, comprised a

'timeless style, simple elegance and a sensation that makes people feel comfortable and satisfied to be near it'.[84] But the fact that this development was announced as a *style* indicated that 'smart design' and 'integrity' were little more than that year's marketing hype.

Plus ça change

The differences between American design in the 1950s and global products in the 1990s may seem enormous, but they are enormous only at the level of style and sophistication. Lippincott's words of 1947 could just as easily emanate from today's design press or from a Henley Centre-type report: 'Today as never before the consumer is design-conscious, and the appearance of a product has become an integral feature in its success or failure. Hence the growing need for attention to style.' And, the role of the designer is 'to imbue the consumer with the desire of ownership'.[85] Design may have become a strategic tool within a company, carefully calculated and finely tuned, but the basic economic systems and ideologies of the two periods are essentially the same: the latter is a logical development from the former. The American design historian Jeffrey Meikle makes much the same point when discussing the globalization of markets which, he argues, is more accurately the 'Americanization of markets':

> . . . from a cultural perspective, [globalization] actually represents Americanization, as the rest of the world learns from the United States how to live in a consumer society. Although many of the products – Japanese VCR's, Dutch shavers, German coffee makers – are not made in America, the lifestyles they nourish ultimately follow American models. Back during the 1930s . . . American industrial designers were already pioneering techniques for differentiating products, segmenting markets and adding emotional value to products. If markets now seem global, it is because businessmen and designers of other nations have successfully learned from the American experience.[86]

What we have been witnessing since the arrival of affluence and saturated markets is the triumph of the American Way, both ideologically and practically. Meikle's point reminds us that, if we are to understand the value system of design, we need to consider its historical, social, economic and political contexts.

Cultural habits are as difficult to change as an economic system because they are, in part, formed by that system. The marketing-led design boom in the 1980s placed an exaggerated emphasis on design both because a designer lifestyle was presented as if it were the ultimate state of psycho-physical being, and because it was thought to be the panacea for society's economic problems. During the same period, the cracks in the edifice of marketing-led design became increasingly visible, and critiques were

developed which exposed the values and ideology of our consumerist society. We will now turn to look at the most established and well understood of those positions – the Green critique.

2 Green Design

Stephen Bayley, erstwhile Director of the Design Museum and one of the pundits of consumerist design, wrote as recently as 1991: 'Green design is a foolish idea, something created for and by journalists.'[1] It is undeniably true that the epithet 'Green' has become one of the keywords of the late twentieth century. One journal monitored the use of the word 'Green' in newspapers and magazines 3,617 times in one month in the mid-1980s. By the end of the decade the rate was up to 30,777. Is the Green design critique a significant one?; or is it, as Bayley seems to maintain, the emperor's new theory? 'Sensible design' has, he believes, always used materials economically and safely, and is in accord with nature and natural principles. 'Green design', Bayley concludes, 'is as much a tautology as walking shoes, or drinking water.'[2] Yet can today's consumer be sure that a pair of shoes are constructed for serious walking, or that the water from his tap can safely be drunk? Far from being tautologies, Bayley's examples remind us that we can take little for granted in design, and that includes not only the relationship between form and function, but also the relationship – in an era in which the discourse of advertising has coloured our values – between adjectives and nouns.

It is also sadly wrong to imagine that Green design has always been a part of 'sensible design'. As this chapter sets out to show, Green design is a radical critique not only of consumerist design, but of the type of design Bayley describes as 'sensible'.

Bayley is, however, right in emphasizing the dangers of the overuse and loose usage of the word Green. This applies particularly to design, where Green-ness has often been incorporated as little more than a marketing ploy to appeal to the relatively affluent middle classes. While the media interest in Green issues has clearly been beneficial in raising people's awareness about the exploitation of natural resources, or the effect of noxious substances on the earth's environment, there is a danger that, once the initial impact and novelty value subsides and the issues become repetitive, the Green agenda will be relegated to the occasional magazine feature. This would not be for the first time.

Green beginnings

Following the political unrest and social upheavals of the late 1960s across Europe and the United States, there emerged the first mass stirrings of the ecological movement. This was in part a reaction to the values of technological progressivism that were prevalent in the 1960s (in which bigger or faster was always better); and in part a rejection of the consumerist attitudes that promoted a 'you are what you consume' mentality. Rachel Carson's *Silent Spring* converted many people to the ecological cause. First published in the United States in 1962, and in Europe a year later, its influence can be gauged by the fact that it was reprinted six times between 1965 and 1972. Carson exposed the persistent and continuous poisoning of the whole human environment by pesticides, fungicides and herbicides and warned of their effect on the planet's ecology. With the circulation of books such as *Silent Spring*, the previously overlooked side-effects of industrialization and advanced technology started to become matters of concern for an increasingly vocal lobby, who protested about not only the technological pollution of air and water, but also the noise pollution from air transport.

The design profession came in for public criticism too. Town planners and architects were held responsible for creating the high density, high-rise 'concrete jungles' that fuelled inner-city tensions and social unhappiness. The new agenda filtered into the profession's debates: the International Council of the Society of Industrial Designers (ICSID) selected 'Design, Society and the Future' as the consciousness-raising theme of their sixth annual conference, held in London in the summer of 1969. Planners and designers were urged to shift their viewpoint from quantification to the quality of life in the 'post-industrial' society. According to Hasan Ozbekhan, director of planning at Santa Monica, 'The problem is to redirect our energies and all the technology which is at our service toward renewed human ends – ends which are not given, as was survival amid scarcity, but are now in need of being invented.'[3] A similar point was made in an editorial in *Design*, which was reviewing the conference proceedings:

If we are to avoid mistakes similar to those of the first industrial revolution, then we have to make sure that modern technology is geared to take us where we want to go, and not just where the next step happens to place us.[4]

Both statements testify to the healthy realization that technology was not neutral, but part of an integrated economic, political and social system. An advanced chemical plant might mean employment for a local community, but it might also mean the pollution of air and water around it, long-term ill health for some employees and local residents, and increasing power for a multi-national corporation. Designers were being encouraged, at a time

when the very values of consumerist society itself were under attack in some quarters, to consider carefully their professional actions, and to contribute to the wider debate on the sort of society they were helping to create.

Public concern reached a peak in 1972 following the publicity surrounding the United Nations Conference on the Human Environment held at Stockholm in June. A 152-member committee of scientific experts and social commentators from 58 countries served as consultants in preparing a report commissioned by the Secretary-General for the conference, and this was published world-wide as the seminal *Only One Earth*, edited by Barbara Ward and René Dubos. *Only One Earth* outlined the current state of the planet and assessed the problems of high technology: the price of pollution; the use and abuse of the land; and the balance of resources. It examined the particular problems of the Third World and suggested global strategies for survival.

Welcomed by many ecologists and environmentalists as realistic and positive, *Only One Earth* was criticized by some as not going far enough, while others dismissed it as alarmist. The problem, of course, with any global strategies, is that they inevitably threaten various short-term national priorities and some politicians' vested interests. (The 'Global Summit' in Brazil in 1992 highlighted a similar problem.) However, the oil crisis of 1973 emphasized the relationship between natural resources, politics and social systems, and the sharp increase in petrol prices and fears of rationing provided the general public in the West with a foretaste of what they would experience if global oil supplies became severely depleted. Yet in spite of this sobering experience, the media and the public's interest in Green issues began to wane. The impetus for change was taken up by pressure groups and organizations such as Friends of the Earth, founded in the USA in 1969, while some governments – notably in Scandinavia, West Germany and the United States – pinned their colours to the mast of environmental accountability by legislating on, for example, lead-free petrol, recycling and 'acid rain'.

It is interesting to compare the responses of the public in the early 1970s and today to see whether Green issues will remain an important concern to manufacturers and designers. The main reason the public's interest lessened in the 1970s was, in my view, because the issues were predominantly on a macro-environmental level: the concerns of a book such as *Only One Earth* were, understandably and necessarily, global and seemed somewhat abstract and removed from most people's daily existence. Friends of the Earth, for example, came into being because its founder, David Brower, dismissed the policies of the then best-known environmental organization in the USA, the Sierra Club, as too inward-looking and parochial. Most people found it impossible to understand the interlocking complexity of causes and effects

The Body Shop, Refillable plastic standardized bottles
The standardized containers stand in opposition to the consumerist belief that the container and packaging should contribute to product identity and the unique selling proposition. The Body Shop containers are more akin to the Modernist belief in 'standardized, simple and impersonal' characteristics of design.

of the ecological system as a whole. There is a wealth of books and television programmes on macro-environmental issues – more so now than ever – but the key difference is that people are engaged on an individual level through *consuming*.

The emergence of the 'Green consumer'

In the late 1980s we witnessed the rapid growth of the 'Green consumer', who registers her or his ecological commitment through buying products which are supposed to be 'planet-friendly'. Green companies include the British-based Body Shop International and the Belgian-based Ecover. The Body Shop was started by Anita Roddick in 1976 and now has over 400 outlets in over 30 countries. Its products are presented as a model of Green conscience: all products are biodegradable and natural; animal testing is avoided; containers are basic and can be refilled; and packaging is minimal. Ecover offer household-cleaning agents – including washing powder, washing-up liquid, toilet cleaner and cream cleaner – that are free of petrol-based detergents, phosphates, optical and chlorine bleaches, synthetic perfumes and colourings, and enzymes. In their 48-page information handbook,

which details the company's objection to conventional cleaning chemicals, Ecover claim that their products are fully biodegradable – most within a maximum of three days, by which time 'all the active ingredients are broken down into natural harmless substances'. The company promises that, 'By using Ecover products you can contribute to a safer world.' Here is Green action at a micro-level that people can understand. Ecover, like other 'ecologically safe' ranges, has come out of the esoteric and forbidding enclave of the health store, and can be found in the supermarket alongside the (increasingly artificial colouring- and additive-free) baked beans.

Green consuming has certainly not occurred at the expense of global concerns. Friends of the Earth, for example, has grown from its humble American beginnings, and now has organizations around the world. It has launched truly global campaigns on whaling, acid rain, pesticides, tropical rainforests, marine pollution, and nuclear non-proliferation. Its membership increased nearly five-fold in the late 1980s. The environmental action group Greenpeace, which started in Canada in 1971, is similarly international and now has more than a million members in seventeen countries. No doubt the majority of both organizations' members are themselves 'Green consumers' and purchase the sort of items produced by Ecover; they may also purchase non-essential items such as tea, coffee, jewellery and clothes from 'Alternative Trading Organizations' such as Traidcraft, whose motto is 'trading for a fairer world', and who import products which are purchased at a fair price from Third World producers. The growth of such organizations demonstrates the increase in this form of Green consuming, initially amongst what has been rather dismissively referred to as the 'brown rice and sandals brigade'. It is predictable that people involved in macro-issues will follow through the logic of their actions to the micro-level of what they buy on a daily basis.

But now Green goods have come out of the closeted alternative trading store and into the spot-lit arena of the High Street emporium. While the route from an awareness of macro-issues to micro-consumption is relatively established, the significant change has been from micro-consumption to the possibility of macro-understanding. For example, the Body Shop invites organizations such as Greenpeace, Friends of the Earth and Shelter to campaign by making use of their shop-windows and counter-space; it also supports a range of projects designed to promote conservation and encourage youth employment. This campaigning rapidly went beyond the politically-aware and health-store shoppers to the – in marketing terms – mainstream consumer. Prompted by media interest, mainstream consumers may start by consciously selecting an ozone-friendly hairspray or furniture polish, but then progress to considering the ecological effects of their other purchases and their relationship to the social and political systems that

produce them. It would, however, be unrealistic to suppose that this happens in *many* cases: compared to the media outpourings which maintain the status quo, the opportunities to learn about the wider implications of consumerism are still relatively limited.

Far more common is what has been called the 'pale Green' consumer, who has some sympathies for particular Green issues, but who would not want to be thought of as a committed Green activist: such a person would probably even be suspicious of macro Green issues. This was certainly one of the findings in a report entitled *The Green Consumer?*, published in Britain in 1988. Its findings continue to be relevant. Although the report's authors looked at the implications of the 'Green consumer' for manufacturers, retailers, environmentalist groups and politicians, their motivation was to find out how manufacturers and retailers could ensure that they were able to identify and exploit opportunities rather than respond merely defensively to potential threats. As the sentiments and language indicate, the report was hardly the sort of publication that would emanate from the offices of the Friends of the Earth; it was as commercially orientated as one would expect from what was – at the time – a highly successful consumer-led marketing and design organization.

Of the 'Green consumer', the report concluded that if one meant a consumer whose every decision was dictated by an evaluation of the ecological consequences of her or his action, then the 'Green consumer' was as rare as an endangered species. However, if the term was expanded to include any consumer who might be influenced by ecological concerns as one of their purchasing factors, then the Green consumer is not only established, but on the increase. These 'pale Green' consumers, it was suggested, would be influenced by single-issue campaigns 'into making significant modifications to their behaviour' – a euphemism for parting with their money for a new or differently-marketed product or service.[5] Green issues are here to stay: carefully marketed and targeted environmentally-friendly products now have the potential to take 'a fast-track to widespread acceptance'.[6] However, the report also made it clear that:

> 'Green' is not yet an aspirational term – largely because of the rather alienating, fanatical, anti-progress image of the main environmentalist groups. Mainstream consumers wish to be able to make minor contributions to environmental protection, without making complete commitments – and they feel this goes against the 'all or nothing' approach of environmentalists.[7]

This is a fascinating quotation because it encapsulates the irony and the dilemma of the above model of the Green consumer. First, it posits the notion that Green might be just another 'lifestyle' term, no doubt with its role models and styling features, to which consumers might aspire. Second, the

perceived reluctance of consumers to make more than 'minor contributions' to environmental protection implies, probably very accurately, that the majority of people do not connect the micro with the macro: do not believe (or want to believe) that it is the social, economic and political system of consumerism as a whole that might need to be radically reformed if ecological balance and sustainability are to be achieved. If being termed Green signifies a commitment to macro environmental issues, the consumers studied in the report 'would be *embarrassed* to be identified as such' [my italics].[8]

The most pessimistic note in *The Green Consumer?* is struck when a comparison is made between Green issues and 'healthy eating' campaigns. Many people see Green concerns as an extension of the current health and fitness movement. However, as the report makes plain, healthy eating directly affects individuals 'personally', and is controlled by the individual. 'Green' concerns, however, are 'mainly communal and the action of individuals has to be reinforced by the action of others to make any major impact. Benefits of "Green" behaviour accrue to others, as well as to the individuals themselves.'[9] It is suggested that most mainstream consumers are unwilling to buy an ozone-friendly hairspray, for example, for ethical or public-spirited reasons. The research revealed that consumers expect either a financial incentive or a personal reward for their 'enlightened' choice. The authors acknowledged that there is widespread resentment towards the concept of paying more purely for ecological reasons and, if a financial advantage is not forthcoming, a personal reward in the form of kudos or status is sought. One can feel some empathy with those respondents in the report who expressed a feeling of helplessness against the powers of vested interests; and one can hope that those respondents who reject the ecological lobby as the 'doom and gloom' brigade will be open to reasoned argument; but one can only despair at both the shortsightedness of many of the under-30s respondents who 'have been caught up in today's trumpeted values of self-achievement and visible consumption and regard their own personal and career development to be of overwhelming importance',[10] and the selfish tendencies of those who would rather see an increase in pollution than feel that their neighbour has indirectly gained at their expense.

Taken in the context of our high-consumption, marketing-orientated, capitalist society, the 'Green consumer' is – almost invariably – first and foremost a consumer, and only nominally Green. This was highlighted in 1989 when the 'Green Shopping Day' in Britain, orientated to 'pale Green' consumers, was boycotted by 'deep Greens' and some Green campaigning organizations, who considered mounting their own 'No Shopping Day' as a protest against the main problem in our society: excessive consuming. The term the 'Green consumer', 'deep Greens' argued, validates consuming: a

better term would be the 'Green conserver'. 'Deep Greens' also raise
questions about the desirability of those companies which are supposedly
committed to Green values. Anita Roddick of The Body Shop may shun the
glossy campaigns and slick advertising of consumerism, proclaiming:

> I don't want the baggage that goes with advertising agencies. I don't want the
> advertising-speak. I don't want the seduction of words and images that fool you
> into believing in things that don't exist. And I'm never comfortable with
> advertising people.[11]

She may also espouse a commitment to ecological and social issues that is
undoubtedly genuine, but this commitment is possible only because of The
Body Shop's financial success. That success is something that Roddick is
equally concerned about: 'I passionately believe that we have developed
within our shops a unique, almost perfect formula for selling our products.'[12]
No doubt the company's contented shareholders are in complete agreement.

Green politics: shades and varieties

Some would argue that there is no contradiction in the term 'Green
capitalists'; no intrinsic contradiction between public good and private profit.
The Body Shop's head of Environmental Projects said on behalf of her
employer: 'Ultimately, we can't see any distinction between commercial
advantage and being a concerned business.'[13] However, pointing out that a
book that was published about The Body Shop is part of a 'Business Profile'
series that includes British Airways, John Button in *Green Pages* alerts his
readers to 'the possibility that The Body Shop might be the currently
acceptable face of an economic system that is ultimately unacceptable.'[14]

Reports and approaches which think only in terms of consumers explicitly
or implicitly condone a political and economic system that is, for the most
part, antithetical to truly Green values. A perspective on the Green
consumer can be gained from *Only One Earth*, a book which dates back to a
more idealistic era. It is significant that, throughout the book, the authors
employ the word 'citizens' rather than 'consumers'. The pro-consumerist
Right think increasingly in terms of 'consumers' rather than 'citizens': the
latter being a word they dislike (in spite of recent attempts in Britain to
appropriate it from the Left via the concept of 'Citizen's Charters') almost as
much as 'society'. For Green sympathizers, on the other hand, 'consumers'
are either a sub-group of 'citizens' or an occasional mode of citizenship. This
represents a fundamentally different political outlook on society.

The politics of Green design – there can be no singular politic – have to be
squarely faced. At one extreme there will be the puritanical 'flat earther'
opposed to virtually any consuming; and at the other the staunch capitalist

who believes that Green problems can be solved by market forces. The latter strategy has been adopted by those governments in the West who are employing a policy of either taxing 'dirty' products so that they will become uneconomical in the marketplace, or subsidizing 'friendly' products such as lead-free petrol so that they are more likely to be chosen by the consumer. Like *The Green Consumer?*, this approach presumes self-interest to be the key motivating factor. Another characteristic response of the political Right to Green issues is to see each issue as an individual and discrete problem which can be tackled and solved with a 'one off' solution. No convincing defence is mounted to the argument that a great many ecological problems are symptoms of the same cause, and that continually treating symptoms rather than the root cause solves nothing in the long term. But it is not just the Right who are guilty of this: a similar criticism can be levelled at the Left, at least in the former Communist countries, whose record on pollution was simply disasterous.

Indeed, Greens believe that viewing politics as a Left/Right continuum is outmoded and misleading, because Left and Right have much that is negative in common. This is a point made by Jonathon Porritt, previously director of Friends of the Earth and a leading spokesperson for the Green movement:

Both are dedicated to industrial growth, to the expansion of the means of production, to a materialist ethic as the best means of meeting people's needs, and to unimpeded technological development. Both rely on increasing centralization and large-scale bureaucratic control and co-ordination. From a viewpoint of narrow scientific rationalism, both insist that the planet is there to be conquered, that big is self-evidently beautiful, and that what cannot be measured is of no importance. Economics dominates; art, morals and social values are all relegated to a dependent status.[15]

Porritt concludes that the similarities between the two dominant ideologies are of greater significance than their differences. The fundamental ideologies are, Porritt continues, united in an all-embracing 'super-ideology' for which he employs the term 'industrialism'. Furthermore, in that it is conditioned to thrive on the 'ruthless exploitation of both people and planet', 'industrialism' is 'the greatest threat we face'.[16]

Seeing Green, from which the above quotations were taken, was published in 1984, and it is interesting to note how the political scene has changed since that time. Most main political parties now claim to be sympathetic to Green issues, but their 'Greenness' is subservient to their prevalent ideologies which, from a Green point of view, may be inconsistent, contradictory, or in fundamental conflict with their Green policies. Even if a 'Green ministry' or Green-tinged Department of the Environment were set up, these might

simply be tokenism or even a marginalization of Green issues – which directly affect the use and employment of *all* our resources. It can be argued, therefore, that Green policies must underpin *all* governmental legislation if the issues are to be taken seriously and meaningfully.

The traffic has, however, been two-way and Green parties, following electoral successes – most notably in Germany – have had to face up to political realities. This has led to much soul-searching and some destructive in-fighting, so that factions of Die Grünen, for example, quit the party organization while claiming that their colleagues were selling short their ideals in the pursuit of power. One of the areas of discord has been economic growth. For years Greens have argued for a policy of zero growth and the inevitable lowering of the material standard of living. With many voters flirting with voting Green, some Green parties are now arguing that some growth is possible so long as it is environmentally and socially sustainable, and not built upon the back of the Third World. It is obviously going to be supremely difficult to convince voters to vote for a party committed to decreasing their material standard of living, but this is a task which the Greens cannot duck.

The Green movement, like the Left, is a broad church. It is like the Left in so much as it is (more or less) united in its rejection of capitalism, but divided in its vision of the ideal political organization of society. Thus to talk about Green design as if it is some fixed set of principles or consistent methodology is misleading. Green design ultimately has to be defined in relation to the particular complexion of Green politics. For radical anarcho-Greens, Green design will be activist and participatory, with complete reuse and recycling replacing the use of any 'new' materials. Buddho-Greens see no need for any but the most basic objects, and preach a simple and meditative way of living without possessions. For these groups, consuming is itself a symptom of a decadent civilization. But, while our cultural and social habits of consuming still predominate, one of the key questions is bound to be, how do we consume more responsibly? In Porritt's words: 'The problem for the future is to ensure that the interests of the individual are more in line with those of society at large and with those of the planet.'[17]

Towards a greener design

The sorts of Green questions a designer or consumer will ask her- or himself will, as discussed above, vary depending on both the political viewpoint of the questioner, and the particular type of product or service under review. In their book *Taking Charge*, The Simple Living Collective of San Francisco propose four 'consumption criteria':[18]

1. Does what I own or buy promote activity, self-reliance and involvement, or does it induce passivity and dependence?
2. Are my consumption patterns basically satisfying, or do I buy much that serves no real need?
3. How tied is my present job and lifestyle to instalment payments, maintenance and repair costs, and the expectations of others?
4. Do I consider the impact of my consumption patterns on other people and on the Earth?

The rather 'Californian' nature of these questions, especially if considered at length, are more likely to provoke a life-crisis than produce a pragmatic decision in a High Street store on a Saturday morning. Whilst a life-crisis may indeed be the outcome of adopting a commitment to a Green way of living, it is also useful to consider questions slightly more focused on Green design.

A major step in this direction were the 'Ten questions for the Green Designer' listed in a booklet prepared for the Design Council by John Elkington Associates in 1986, and subsequently reprinted in Elkington's own *Green Pages: The Business of Saving the World*. These are:

1. Is there a risk of disastrous failure?
Elkington cites the social and environmental disasters at Bhopal in India where over 2,000 people were killed as a result of a chemical leak at the Union Carbide factory, and the Chernobyl nuclear disaster. Environmental impact assessments, risk assessments and rigorous safety standards all help in avoiding such failures.
2. Could the product be cleaner?
Catalytic converters and lead-free petrol for cars, and ozone-friendly aerosols are examples of how products can be made cleaner in their performance.
3. Is it energy-efficient?
It has been calculated by a government department that £7 billion is wasted every year in Britain because of inefficient energy usage. Bad insulation in houses, and the utilization of waste heat from industrial production methods, are both areas that could be greatly improved.
4. Could it be quieter?
Complaints to local authorities nearly quadrupled in Britain between the mid-1970s and mid-1980s and, according to Elkington, the problem is getting worse.
5. Should it be more intelligent?
As the cost of computing power decreases, more and more products – such as kitchen scales which switch themselves off after a short period of non-use, and jet engines which constantly check their fuel efficiency – can be designed with features which monitor and modify their own performance.

6. Is it over-designed?

The Green designer should constantly challenge the client's assumptions by asking whether the product needs to be so heavy, so strong or so powerful. The miniature glass bottles sold in aircraft are being replaced by some airlines with plastic ones. As plastic weighs five times less than glass, this will lead to a significant saving, calculated at many thousands of pounds, of the aircraft's fuel bill.

7. How long will it last?

Many products are badly-designed in that they break down before their materials decay. Thorn EMI's 2D light source, for example, is rated to last as much as five times longer than a 60w or 100w bulb, and can cut energy costs by up to 75 per cent.

8. What happens when its useful life ends?

Reuse or recycling should become a central component of a product's original design.

9. Could it find an environmental market?

Even some of the most dangerous materials can be transformed. Asbestos can be transformed into a totally non-toxic glass, creating not only a safe and useful product, but saving the alternative cost of bagging, transporting and tipping waste asbestos.

10. Will it appeal to the Green consumer?

Elkington argues that 'Good design helps communicate ideas and sell products . . . the emergence of the "Green Consumer" is simply a matter of time. Increasingly [some] companies . . . seek to ensure that their products are not only environmentally acceptable – but pick up sales because of it.'[19]

There is much to commend Elkington's list of questions, which encompass issues relating to the public good, and matters relevant to private enterprise. Such a combination mirrors John Elkington's own work, which combines research on behalf of, for example, the United Nations Development Programme, and the writing of publications such as *The Green Capitalists: Industry's Search for Environmental Excellence* (1986). That volume looks at the ways in which many of the world's major companies – among them ICI, Rolls Royce and Glaxo – are trying to improve their environmental records and images. Because, for many Greens, the label 'Green Capitalist' is a contradiction in terms, Elkington's books have been criticized, rigorous though their technical information may be, for what some see as their bias towards the consumerist system:

How much praise should ICI's environmental efforts receive while they continue to send to the Third World poisonous pesticides which are banned in Europe? How pleased can we be with Rolls Royce's efforts to produce a less polluting aero engine while they continue to sell most of their output to the military?[20]

Is Elkington committing the same sins as the political Right in viewing Green design as one-off solutions to particular symptoms, rather than acknowledging underlying causes? In not detecting the interconnectedness of the consumerist system? In supporting Green design because it has, at the bottom line, *commercial* appeal? Sara Parkin, a prominent British Green, complained that, 'Whatever Elkington's motives, he has not so much turned confrontation into cooperation by his "bridge-building" exercise as delivered the Green movement into the lap of the industrialist.'[21]

An even greater issue is raised by another of the companies which Elkington praises – The Body Shop. The issue is this: however Green their products are, do we really *need* them? Anita Roddick acknowledges that The Body Shop:

. . . is perceived to be within the cosmetics industry, whose major product is garbage – it's simply packaging, the biggest me-too industry there is. We, on the other hand, are an asexual, anarchic, fairly political company. We have environmental departments, community care departments . . . Anyway, the things we do *apart* from selling the product are more important to us . . .[22]

Without contradicting Roddick's assertions, the fact remains that The Body Shop *is* a part of the cosmetics industry. This alone condemns the concern in the eyes of many Greens as trivial, unnecessary and wasteful of human and material resources; it could also be said to be exploitative of people's psychological weaknesses and of their fear of not conforming to 'beautiful' stereotypes.

Green design, need, and consumerism

This leads directly to a question which Elkington ignores but which must underlie all others: 'Do I *need* this product or service?' Any discussion of Green design has to deal with the question of society's values, and Greens would persuasively argue that our values are too materialistic, too competitive and macho: a Greener society must be more non-materialistic, cooperative and 'female' (as opposed to 'feminine'). A survey of Australians who led lives of 'voluntary simplicity' concluded that we could still 'live comfortably on around one quarter of present per capita volume of commercial production'. (This would, however, mean that '75 per cent of firms would go bankrupt' – something which would be unacceptable within our present political and economic system.)[23] We cannot simply and unambiguously disentangle 'needs' and 'wants' in a society that is accustomed to abundance and sophistication. Is a quest for recognition, status, social position and self-esteem a transhistorical, universal human need, or a socially-constructed undesirable want exploited by greedy manufacturers

and unscrupulous advertisers? Or is it that the quest is transhistorical and universal, but that the materialistically-based solutions in our society are destructive to the well-being of ourselves and the planet?

The question about whether one needs the particular product or service is one that applies, of course, not only to Green issues but also to all the other issues discussed in this book, whether the 'socially useful' product debate, 'responsible' design, or 'labour-saving' gadgets for the kitchen. The Green ethos is one of simplicity in which 'less is more': the quality of life matters more than the material standard of living. Each British house contains an average of 23 electrical and four gas appliances; five battery driven items and 18 electric lights. Are all of these *needed*? Ninety-five per cent of consumers who buy multi-attachment vacuum cleaners, food processors and sewing machines never use all the special attachments. Some design pundits foresee a return to, for example, simple kitchen gadgets as both 'the ultimate expression of chic sophistication, and as the expression of anti-consumption feelings at the same time. Buying dozens of marginally useful, soon to be forgotten plastic electrical appliances may soon become a socially embarrassing thing to do among certain social strata.'[24]

However, the contemporary status quo is that we are encouraged to believe that you simply must have an onboard computer for your skis to tell you how fast and far you have travelled; a robot which silently glides into your dining-room 'to deliver hors d'œuvres to your surprised friends on his handy serving tray'; a 'golf ball with a chemically luminous stick which fits snugly into the ball and lights up for 4–8 hours'; or a 'soft, cuddly, fire-resistant acrylic fur electronic pet' which will respond to the clap of your hands and 'saves a fortune in vet's bills'. These, and many similar 'prestigious and desirable items' were included in a recent, widely-circulated catalogue which announces that, to earn a place in the catalogue:

. . . a product has to offer a positive benefit. Perhaps it's new, or not generally available in the shops. Perhaps it solves one of life's irritating problems or is a particularly ingenious gadget. Above all, we insist it must be the very best product of its type we can find anywhere – that's a promise.

Beguiling though some such products may be, Greens would argue that they represent unnecessary consumerism and a waste of human and material resources, as well as contributing to a materialistic and competitive ethic that increases personal anxiety and stress. Not surprisingly, one of the catalogue's most popular items was a 'stress card monitor' which reacts to changes in skin temperature 'to indicate whether you're relaxed, calm, tense or stressed. On the card's reverse are hints to help you relax'!

Increasing consumerism has led to an extraordinary proliferation of gadgets, the majority of which are more task-specific than those mentioned

above. At the extreme of this tendency, one mail-order catalogue proudly offers an 'egg wedger that cuts six perfect sections with one squeeze'; an 'efficient and time-saving egg topper' which severs the top of a boiled egg, 'lifting it off neatly leaving no shell chips'; a hand egg-piercer to pierce eggs before boiling; and, presumably as an attempt to diversify away from the egg-bound market, a nasal hair clipper, and set of pedicure pads which 'lift, separate and cushion the toes' enabling easy 'painting and polishing without fuss or mess'. These are items which will probably be used once or twice and then forgotten or thrown away. Such 'efficient and time-saving' gadgets rarely fulfil their promise and soon contribute to the debris of the consumerist society. As a general rule, the more task-specific an item, the more it will be useless for all other functions; we should be wary of consumer items that use up raw materials and human labour and then spend 99.9 per cent of their time idle.

New product types are, however, less common than modified, updated or redesigned products. Innovations occur less for scientific or technological reasons than for economic ones: it is to both the manufacturer's and retailer's commercial advantage for us to buy the new version. We might be persuaded to buy because of the promise of the new model's 'improvements', or smoother operation, or more sophisticated appearance. The language of progress is frequently invoked in the marketing of goods and services: the new model will be easier to use, or quicker, or have more features than its predecessor; we need to 'move with the times'. Technology makes the new model possible and so it is self-evident, according to the logic of consumerism, that we should want to possess it. Our life will be easier and we will be seen by others to be more sophisticated and 'up to date'. Whereas at one time we were happy with a humble toothbrush, we were then offered the 'technological and dental advance' of the electric toothbrush. This in its turn is being made redundant – at least for those who must have the latest thing – by an 'oral hygiene system' which incorporates a two-speed rechargeable toothbrush with up to 3,000 brushing strokes a minute, and a high-pressure water jet to force out trapped food particles and reduce plaque.

The first video-cassette players could usually only cope with recording one programme per setting. Now they can be set to record automatically a dozen selections over a period of weeks or months, and be set to 'long play' to give us more value for money. Remote controls were introduced to ease back-aching operation, and now bar codes are printed in television guides which reduce the fiddly and relatively complex operation of setting recording times to a simple, single action. Technology has demonstrably eased the complexity of operations that we have to perform – although some may regret the relative de-skilling of the viewer! But many Greens would query whether there is a need for a video player, not only because it is a item which uses up

human and material resources, but because it commits us more deeply to a consumerist culture in which we are essentially passive. Similarly, televisions are now accompanied by a remote control which means that the viewer does not have to stir from her or his armchair. 'Zapping' from one channel to another has become a popular and engaging pastime, perhaps diminishing our ability to concentrate in depth on a more demanding programme and increasing our desire for sensationalism.

Many consumer items do genuinely add to the quality of life. The video player, if used for 'time shifting' programmes, can liberate the viewer from having to watch an important programme at an inconvenient time. The word processor, as most writers enthusiastically endorse, has made the trouble-some and messy task of revising, editing or reordering text – previously with scissors and paste – as simple and uncomplicated as it can ever be. But the problem is that we can all be seduced by modifications that make a task slightly simpler and easier, but which thereby perpetuate the system of consumerism. There is no single or definite answer to the question 'Do I need this product or service?' because people – Greens included – have differing values, expectations and visions of material and non-material standards. It is, however, a question which needs to be continually asked.

Energy: consumption or conservation?

If the answer to the question 'Do I need this product?' is 'yes', then one of the first things to ascertain is whether the product is energy-efficient. Manufac-turers and retailers seldom supply this sort of information voluntarily or in a way which tells the whole truth, and one of the most significant pieces of governmental legislation would be internationally agreed measurements which would enable a consumer meaningfully to compare different manufacturers' products. It is certainly essential to know the information that magazines such as *Which?* or *Consumer Reports* provide: how the product performs in normal conditions; whether it is safe; and whether it is easy to use. The tests lead to a recommendation of 'the best buy' or 'good value for money' but these assessments seldom take into account the non-renewable resources a gadget uses in its manufacture; whether it uses recycled materials; how polluting it is; or how energy-efficient it is in its performance. At worst, consumer publications are too consumerist-orientated, and a change needs to occur so that uninformed consumerism gives way to aware conservation. The latter *is* happening in publications such as *The Green Consumer Guide* which supplies comparative tables for washing machines, dishwashers and refrigerators in terms of the electrical energy and quantity of water a washing machine uses on different wash programmes, or the average annual running costs of a refrigerator.

More refrigerators now conform to the 1987 Montreal Protocol and its successors, which proposed strict limits on the emission of substances harmful to the ozone layer. Alternatives to CFCs (chlorofluorocarbons) are now available, although in countries such as India, new thinking has yet to make an impact. Bosch has marketed a washing machine with an automatic detergent dosage mechanism which ensures greater economy; and Miele make a machine which breaks down the conventional main wash into mini-cycles, claiming to save on both energy and water. However, some manufacturers who claim their products are 'environmentally friendly' are guilty of misleading the public. While a refrigerator that uses fewer CFCs is obviously an improvement on one that uses more, the fact that CFCs are used at all is regrettable. In Germany a product can be given a 'Blue Angel' award if it makes modifications that are environmentally positive. Yet there is a significant difference in a relatively minor improvement, and a product which is fully 'friendly'. There is an urgent need for regularized information about such things as contents and energy consumption, and this standard and objective information will only be produced if there is central governmental legislation and a compulsory scheme. Until that happens, manufacturers, retailers and stores can and will mislead.

An appliance's energy consumption is often a complex matter. Energy-efficient lamps, for example, usually require much higher energy inputs during manufacture (and, furthermore, include plastics, tars and various potentially toxic elements). Ironically, low-efficiency tungsten lamps have a relatively low-energy production process and no toxic materials. One study analysed the energy that was used to manufacture recycled as opposed to non-recycled plastic carrier bags. The study revealed that virgin polythene needs three times as much energy and eight times as much water, and that the process generates more than double the amount of carbon dioxide, three times the sulphur dioxide, and double the volume of nitrous oxide.

Both manufacture and usage very obviously require energy, and so a balanced judgement on the merits of a product can only be made on the basis of a broad environmental audit, increasingly referred to as an LCA ('Life-Cycle Analysis'). This 'cradle-to-grave' approach analyses the manufacture and use of a particular product or product type, enabling both the manufacturer and the consumer to make an informed judgement about improvements to the item. An LCA of a washing machine, for example, would measure energy consumption, air pollution, water consumption, water pollution, and solid waste from conception to decomposition. A report commissioned by the Department of Trade and Industry as part of the United Kingdom's contribution to the development of European Community labelling criteria, revealed that by far the most significant environmental damage of a washing machine occurred not during its manufacture but

Dulas Engineering Ltd, Solar-powered portable lamp system
The lamp contains a powerful sealed lead-acid battery which is charged by placing the photovoltaic panel in sunlight during the day. A full charge will give three hours of 'free' and environmentally responsible lighting.

IN.form, Solosteam cooker
The Solosteam cooker addresses the need of the 26 per cent of the population who live alone – including 15 per cent of the population who are over 60 years of age – for a simple, healthy and energy-efficient way of preparing single meals. The three-tier system includes compartments for boiling, steaming and warming. The handle is designed for ease of use by people who may find ordinary pan handles difficult to grip.

during its working lifespan of, on average, eighteen years. And so, although improvements in manufacture could and should be made, the greatest improvement would come from improved operating energy efficiency, cutting water levels, and utilizing every gram of powder.

But even an LCA cannot give a complete and comprehensive picture because a product does not operate in isolation: it is invariably part of a

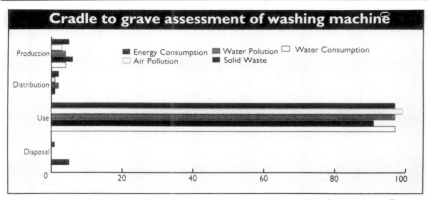

PA Consulting, Life-cycle analysis for a washing machine
The LCA for a washing machine reveals that improving energy efficiency, cutting water levels and utilizing every gram of powder are greater priorities for creating a Greener machine than making a machine's parts recyclable. This is not to suggest, however, that recyclability does not matter.

complex and interlocking system. For example, microwave ovens have been welcomed because they accelerate cooking times and so reduce the consumption of electricity. However, the increase of foods especially designed for microwaves has brought about an increase in the use of non-recyclable plastics, including containers which used to include CFCs in their manufacture. This highlights the need to view energy consumption (and efficiency) systematically, and also to acknowledge that a product's LCA needs to take into account its effects on other products, services or habits.

'What about the workers?'

The consumer product should not be considered in isolation from the means of its production, the materials from which it is produced, or from its eventual fate once it is discarded. We will presently be discussing processes of production in relation to materials but, before that, it is important to look at an issue that is usually overlooked in questions of Green design: processes of production and their relationship to the people directly involved at 'factory floor' level.

Two interconnected aspects of the processes of production need to be analysed: the social (the effect on the person's mental well-being) and the physical (the effect on her or his health). The most obvious example of a socially injurious process of production is the human conveyor belt: the type of work that demands mindless repetition with the minimum of satisfaction. When it was found that complex and skilled operations, broken down into simple, repetitive and frequently unskilled tasks performed by the same

individuals, resulted in a greater number of units being produced, social working conditions were transformed. 'Scientific management' was a concept and approach coined by Frederick Taylor – it was also known as 'Taylorism' (or 'Fordism' after Henry Ford) – at the turn of the century. It has developed through the years into the disciplines of 'operational research' or 'cost accounting'. The emphasis remains the same: the maximization of human and technical efficiency – usually involving incentives for piecework and unsociable hours to ensure that the factory's machinery is utilized without stoppage – at the cost to the worker of skill and satisfaction. Most industrially designed goods – from cars to video players – are manufactured in this way.

The monotony and operator boredom of line production can cause a loss of concentration which can easily lead to accidents. Official figures may seriously underestimate the maiming, general debilitation and occasional death which can result from both this and the pressure for faster and 'streamlined' production. What, to the majority of people, would be intolerable noise levels and poorly ventilated workspace environments are daily endured by a significant percentage of the workforce in the 'developed' world. Legislation on heating, lighting and ventilation is seldom more than minimal, and is often inadequately enforced by understaffed inspectorates. Working conditions in countries where labour is in cheap and in plentiful supply – including those in which some home computers and many other home electronics are manufactured – are even worse.

Marxists and social reformers have long argued that the 'anaesthetic' of the wage packet fails to compensate for the damage inflicted through dehumanized, fragmented and alienating work. Some companies – a celebrated example was Volvo – attempted to reduce the monotony by introducing a degree of versatility into the job: the worker is made responsible for several tasks, or tasks are swopped between workers every so often. So-called 'quality circles' are supposed to increase the quality of the product by enriching the worker's job, but most Greens dismiss this as superficially patching up a system that is fundamentally flawed. In the words of Sandy Irvine and Alec Ponton in *A Green Manifesto*, 'While it might be more fulfilling to be involved in the construction of a product from start to finish, real progress depends upon its social and environmental value.'[25]

Others posit that robots are the answer to mind-numbing, routine work, but the effects of increasing automation on unemployment are well-known. This leads some Greens to reject all but the most essential automated, mass-production processes because of their direct or indirect human cost, and to seek a return to an essentially craft-based means of production in which individual workers have greater participation and control. Other Greens prefer the idea of the 'two-tier economy' in which comprehensively

automated, state-of-the-art mass-production methods – so long as they are not detrimental to the environment – are used to produce society's commonplace daily items, alongside highly skilled and often labour-intensive craft or hand processes that are satisfying to the maker. Both groups claim as their mentor William Morris, whose opposition, a century ago, to alienating labour, and subsequent quest for the joy of labour, has long endeared him to generations of opponents to 'industrialism'.

Processes of production

The physical dangers of the processes of production were graphically brought to the world's attention at Bhopal. But such major disasters concerning noxious chemicals in distant lands ought not to obscure the dangers inherent in the production of items nearer home, whether coal or, until its fatal dangers were fully exposed, asbestos. Poisonous substances such as mercury and lead, and fumes from factories, have been part-and-parcel of industrial processes for a century or more. We have tended to assume that a substance or chemical is innocent until proven guilty, and so generations of workers or people living near industrial plants have suffered through long-term exposure to often small weekly dosages.

Batteries are an integral part of our convenience society, powering everything from calculators through to personal stereos and children's toys. They epitomize consumerist values. In the United Kingdom alone over 400 million batteries a year are produced, the vast majority of them non-renewable. But even worse than the sheer quantity of productions are their energy consumption, chemical composition and environmental effect. In terms of energy ratio, non-rechargeable batteries are highly inefficient, using 50 times more energy in their manufacture than they are able to give out in their working lives. Batteries are full of hazardous chemicals and, until recently, all household batteries contained mercury and/or cadmium, whilst car batteries are lead-acid types. These metals are all highly toxic, and the combined toxicity of the metals discarded from batteries into the environment every year exceeds that from radioactive waste. Ninety per cent of spent batteries end up in landfill sites, where they may cause water and land contamination. The incineration of batteries containing mercury is a serious air pollution problem, which the Danes, at least, have recognized by banning mercury-oxide batteries.

Once in the environment, metals from batteries do not biodegrade but enter the food chain: mercury poisoning can affect the central nervous system and can cause death; cadmium poisoning can cause organ damage and cancer; and lead poisoning can also affect the nervous system and cause organ damage. Even setting aside these heavy metals, batteries contain

caustic and corrosive chemicals. According to Richard North in *The Real Cost*:

The battery epitomises the chemical fall-out which is part and parcel of modern society, and whose impact we have been slow to assess. The effect of chemical pollution is the Cinderella of environmental concern. This is partly because toxic waste is such dangerous stuff, and so unattractive, that few people dare to investigate it; partly because it is so shrouded in commercial and state secrecy; and partly because its effects are so hard to quantify. Much of the evidence is circumstantial and anecdotal . . . Moreover, the worst fears of people living near dumps or downstream or downwind of plants do seem, rather often, to be justified.[26]

Legislation is making some improvements. Since 1989 EC regulations and Green awareness have forced manufacturers to eliminate or reduce mercury and cadmium from some of their batteries, and an EC directive now demands the labelling of a battery's heavy metal content, and the banning of alkaline batteries with a high mercury level. Nickel-cadmium (ni-cad) batteries are considerably more energy efficient because they can be recharged: one ni-cad battery can replace 250 alkalines, but they currently need to contain cadmium and so may be a pollution hazard if thrown away. Sweden and Switzerland already have recycling laws for ni-cad batteries, whilst voluntary schemes are underway in Germany, Austria and the Netherlands. Even though a battery charger is needed for rechargeable batteries, the savings on energy (and cost for the consumer) are considerable.

Much is made of the new, 'clean' technology associated with the microchip – technology that is, supposedly, making belching factory chimneys a Lowry-like vision of the past. Yet the 200-square kilometre Silicon Valley area south of San Francisco has severe pollution problems affecting its groundwater. Solvents, gases and acid used in etching and cleaning silicon chips have been seeping into the area's water sources. Seventy-five of the valley's ninety-eight storage sites have been found to have leaks, and there are local fears that birth defects have been caused as a result. Almost 1.5 per cent of electronics workers in the United States are said to suffer from industrially-related diseases, as against less than 0.5 per cent for the average of American workers. Acid burns, eye problems and skin irritations are ranked high amongst the electronics related problems. Headaches, dizziness, burning tongues, nausea and flu-like symptoms are also said to be common. Some workers have claimed that it was the electronics industry which caused their 'chemical sensation' (also known as 'environmental illness').

Materials and Green design

More work about the effects of processes of production – the human as well as environmental effects – needs to be carried out. Research into the characteristics and effects of materials is more advanced: what is now needed is for the research to be acted upon.

(i) Wood

The material that has attracted the most publicity is wood, due primarily to the alarming and seemingly unstoppable deforestation. In Africa, almost six million acres of tropical dry forest were destroyed each year in the 1980s; in Asia, more than four million acres of rainforest were destroyed annually in the same decade; in Central America in the last 30 years, almost two-thirds of rainforests have been destroyed to facilitate cattle ranching. Friends of the Earth claim that, every year, 200,000 square kilometres of tropical forests are cleared or seriously degraded. This works out at over a million acres every week, or 100 acres every minute. Rainforests are the main dispensary of raw materials for modern medicines (antibiotics, heart drugs, hormones, tranquillizers, ulcer treatments, anti-coagulants and many others); and a vital source of food (including rice, maize, peanuts, cocoa, oranges, bananas, tea and coffee) and jobs (industries reliant on fibres, latexes, oils, waxes, and the raw materials for plastics, soaps, gums, resins for paints and pharmaceuticals, dyes, lubricants and hydrocarbons). Their hot and humid climates are ideal for thousands of species of flowering plants, trees, birds, butterflies, mammals, reptiles and amphibians. Rainforests protect the soil, which is usually relatively infertile, and regulate the flow of water to farms, reservoirs and irrigation systems, rivers, lakes and streams. Without them, soil erosion and flooding rapidly increase. The earth loses its nutrients and food becomes harder to grow; dams, reservoirs and irrigation systems silt up; and droughts become more frequent.

Much attention has been focussed on the rainforests' role in regulating global weather patterns. As they are destroyed, rainfall cycles are disrupted and a warming of the Earth's atmosphere occurs – due to the build-up of carbon dioxide – that has become known as the 'greenhouse effect'. Nothing better demonstrates the interconnectedness of an ecosystem, and nothing better raises the need for responsible designing and consuming.

A simplistic solution would be to boycott timber from areas of deforestation, but this would only lead to deforestation in other parts of the world. A sudden shift of consumption from tropical hardwoods to temperate hardwoods, or from mahogany and parana pine to beech and oak, would merely shift the problem further along the line. Green design does not necessarily require the termination of the use of all tropical hardwoods, but it does

require a policy of *sustainability* – a key word in Green thinking. Timber is one of the planet's potentially renewable resources, both for energy and as material. Oil, coal, gas and most metals will eventually run out, but timber can be renewed: we simply have to plant at least as much as we cut down. The Green designer and consumer need to begin to think in terms of 'harvesting' rather than 'mining' timber – an approach akin to harvesting grain and fruit. Furthermore, the global ecology must be taken into account in trade: the old criteria based on supply and demand in a free-market economy with unrestricted trade are no longer adequate. Greens accept that the material standard of living to which we have become accustomed will have to be reduced – in effect we have been drawing heavily on our account while paying next to nothing in, and the time has come to begin to settle the balance.

One committed designer and maker, Chris Cox, believes that a combination of consumer- and designer/maker-pressure is the way forward:

The consumer on his/her own can do little, but thousands of consumers exercising choice have an awesome power. We in the trade have to begin to exercise that choice. If the choice isn't there yet, we have to demand it . . . We need to know under what circumstances our timber was produced in the same way we want to know its quality, colour and price . . . If there are enough customers out there who want to buy mahogany from a sustainable source, but don't want it otherwise, eventually this will filter back up through the industry to the people who *can* do something about it . . . It worked for people who wanted to know what the food they bought in packets consisted of.[27]

Cox went on to found AWARE – the Association of Woodusers Against Rainforest Exploitation – a trade association that is committed to using only sustainable tropical timbers. AWARE produces a directory of timbers with the full details (and supporting documentation) of the relevant planting schemes and supply figures. Friends of the Earth have also produced a guide for timber buyers entitled *The Good Wood Guide*. The guide clearly differentiates between timber grown in sustainably managed and non-sustainably managed plantations. It also lists alternative woods for specific interior uses, and retailers of 'acceptable' furniture.

An example of an enlightened distributor, which sells only sustainably-produced tropical timbers, is the Ecological Trading Company in Newcastle. These timbers come from an indian forestry co-operative in Peru where communities have donated parts of their forest lands to be managed sustainably by the co-operative. The Yanesha indians clear the forest in narrow strips of 20 metres wide by 500 metres long. They take out logs by bullock and cart, so minimizing the damage done by transport, and work on a 40-year cycle. As well as being run by local people, there are no middle traders and the timber is dispatched directly to its destination. While this

does not affect the price paid by the buyer, the indians themselves receive up to four times the amount that they obtained under the previous system. Another project has been established in Ecuador and further sources are being investigated in Nicaragua and Tanzania.

There is no reason why the consumption of over-used woods should not be reversed. The major determinant of consumption is taste: as the president of the Timber Trades Federation confessed, 'In many ways we are a fashion industry'. Regrettably, in the 1980s there was a fashion for light-coloured hardwoods in interior design, especially in the retail sector. This began to occur in the mid-1980s, and was in part a reaction to the chrome and leather look which designers and marketers thought dated and too 'hard' for the 'outdoor but sophisticated' look of the affluent late 1980s. Stores such as Next started the trend and were soon joined by a host of other retailers, as well as offices, restaurants, hotels and pubs. This resulted in a steady growth in imported hardwoods.

The use of such timbers may be put down to ignorance rather than indifference, but certainly underlines the need for designers and retailers to educate themselves about Green issues. In the Friends of the Earth's *Good Wood Guide* the list of architects who are positively Green is pathetically small. There are, unfortunately, few stores like The Body Shop which exclude all exploitative tropical rainforest products either in their products or interiors. Wood in interior design need not, of course, be banished but it must be specified with sustainability as the primary consideration. More than 60 per cent of the hardwoods used in our furniture come from the tropics, and only a tiny percentage of this is from sustainable sources. Peter Howard, of contractor Howard and Constable, has managed to convince some interior designers that they ought to use a sustainable alternative such as Burmese teak. He does not mince his words: 'In the short-term nature of modern retail design, the use of hardwoods is decadent.'[28] Designers or contractors with a Green conscience need to educate their clients; but it is to be hoped that public opinion will assert the greatest pressure on consumerist retailers – at point of sale.

(ii) Plastics

The one-off usage of wood in the high turnover arena of retail design is, as Peter Howard indicates, irresponsible. Other materials have greater re-cycling potential although, on the other hand, they are a greater problem than wood if they are *not* recycled or reused. In design, the material most associated with the second half of the twentieth century is plastic, a word which somewhat disguises the diversity of the thirty or so plastics in daily use. The manufacture of most plastics involves using that finite commodity oil in an energy-intensive process which is potentially polluting; the expanded

plastic containers for fast food are – as is now well-known – usually made with CFCs which contribute to the destruction of the ozone layer. There are two main categories of plastics: thermosetting and thermoplastics. Thermosetting plastics, including bakelite, polyester and polyurethane, are used for plugs, sockets, toys and consumer 'durables' such as radios. Thermoplastics are used for wrapping film and to make bottles and containers for drinks; they include polystyrene, PVC, perspex, nylon and teflon.

Only thermoplastics can be recycled by softening and remoulding. Yet, for the most part, this does not happen. Designers are centrally involved in this process because more than a third of plastics are in the form of packaging or convenience items that are used once and then discarded. Victor Papanek – whose work on responsible design will be discussed in the next chapter – cites a particularly sobering example of our recent use of plastics:

> . . . the largest quick-food restaurant chain proudly proclaiming on its sign '31 billion hamburgers sold so far' is also one of the worst chemical polluters in the world. Each hamburger, fish sandwich, egg burger or what-have-you comes in its own styrofoam sarcophagus, is further wrapped in plastic foil and accompanied by numerous condiments each in its own plastic foil pouch. The beverages also come in styrofoam cups with styrene lids and plastic cup straws: it has been estimated that 600 tons of non-destructible ecologically damaging petroleum-based wrappings constitute the non-edible garbage this firm purveys annually. All of these plastic wraps are carefully designed and manufactured . . . The consequences are disastrous.[29]

The percentage of soft drinks sold in plastic bottles had jumped from around eight per cent in 1980 to nearly 40 per cent by the end of the decade, adding to the 60 million tonnes of plastics made each year worldwide. Around two million tonnes of plastic are produced in Britain every year, and nearly half of this amount is thrown away. Over a third of the total plastics production is used for packaging. In the United States about three per cent of the country's oil and natural gas consumption is used up in making plastics and other synthetic materials, although greater efficiency has been achieved in recent years. The fossil energy required to produce different plastics varies considerably: from 215 kcal to produce a size 6 polystyrene tray, to 2,752 kcal to produce a quart-sized polypropylene bottle. Some Greens oppose the production of plastics because they consume significant quantities of finite fossil fuels. They may also oppose them because of the problem of disposing of most plastics. Plastics fill up 20 to 30 per cent of landfill sites because less than three per cent of post-consumer plastic waste is recycled. Most plastics do not biodegrade and will remain in the ground for centuries. An alternative to dumping plastic is burning it for fuel, but the danger of toxic emissions,

including CFCs when plastics are incinerated, is very real – although manageable.

On the other hand it might be argued that the permanency of plastics is a positive advantage. Thermosetting plastic or plastic-encased products, if they are designed carefully – not too brittle, so that they will not crack; rounded corners which will not be easily chipped; and reinforced where pressure is liable to be applied – should last for many years and thus become relatively more energy efficient. And, when they eventually are jettisoned, securely operated incinerators could convert them into an energy source without necessarily contributing to air pollution.

Biodegradability was, in the 1980s, seen as having great potential, but it is now widely accepted that this was a well-intentioned but unfortunate move in the wrong direction. Having initially welcomed them, environmentalists came to argue that many so-called biodegradable plastics only crumbled, leaving microscopic unbiodegradable plastic debris which could do damage to both land quality and animal life. The process of biodegradability also needs conditions (such as direct sunlight) which were seldom available, with the result that most biodegradable plastics contributed significantly to landfill sites. Greenpeace in the United States called biodegradability 'all hype and no substance', and quoted a Mobil spokesperson as saying, 'Degradability is just a marketing tool . . . It makes [consumers] feel good.' In the USA a boycott of all biodegradable plastics – because they were seen as an obstacle to reuse or recycling – was started in 1989.

There are two alternative ways of properly disposing of the (mostly thermoplastic) bottles and containers which we consume: reuse and recycling. With reuse, the permanency can again be turned to an advantage. A plastic egg carton can easily be reused many times without significant deterioration, and there is no reason why other containers – containers for washing-up liquid, hand cream, and motor oil for example – should not be taken back to stores to be refilled. As with all Green matters, if full economic accounting – which should include the costs related to disposal – is taken into account, the gap narrows. The main block on this course of action is consumers' habits, but the fact that Greens have quickly and willingly adapted to the new procedure, and that whole sections of society had to learn to act in this way during the Second World War when commodities and materials were scarce, shows that new cultural habits can be acquired – or re-acquired.

The type of plastic most suited to recycling is PET (polyethylene terephthalate), which is used in the manufacture of the large, clear plastic bottles with moulded bases that are favoured by the soft-drinks industry. Research into its recycling potential is currently underway, with the recycled material being used for a variety of unglamorous but useful functions such as filling for anoraks and sleeping bags.

IDEO Product Development, Energy-saving kettle
The kettle is produced from recycled plastic with insulating properties to retain the heat. It has two compartments: an upper water reservoir and a lower boiling chamber. A plunger dispenser regulates the amount of water let into the boiling chamber – which can be as little as a cup-full – and a built-in water filter reduces furring inside the kettle and extends its life.

There remain major problems in plastics recycling. Plastics cannot be efficiently recycled until they are separated into their different types, and this is asking a lot of consumers – although it does go on to an impressive extent in Germany and some other European countries. Unsorted plastics can, however, be reprocessed: a Dublin-based company creates board-like forms which can be used by local authorities as road signs and for agricultural purposes. The recycling potential could be realized if all plastics were coded by the manufacturers using a number or initial which the consumer could recognize and sort. It would, needless to say, be far simpler if containers could be made from the same plastic. PET could play this role, and PET collection schemes are underway, most notably in the Netherlands where PET bottle banks can be found in larger supermarkets. But even then, the cost of energy for transport and conversion, and the cost of ensuring rigorous standards of hygiene – manufacturers have to presume that bottles may have been used to store garden fertilizers – mean that, in the longer term, it may be better to move away from plastics for containers and back to glass and paper. Changes are now happening: the more 'Green consumer'-orientated supermarkets have returned to paper bags and cardboard egg boxes.

But the 'friendliness' of materials is seldom a simple matter. In November 1990, McDonald's announced that they were bowing to customer pressure and switching from plastics packaging to paper-based materials for their takeaway food-packs. Yet a recent study in the United States that compared paper-board and foam-based packaging concluded that foam-based containers required 30 per cent less energy to produce, and resulted in 46 per cent fewer atmospheric emissions and 42 per cent less water-borne waste. The public can hardly be expected to keep abreast of this complex technological research: the situation is bewildering enough for designers and companies. McDonald's were making decisions based on misinformed pressure, but a 'consumer-led' company is faced with the dilemma of either rejecting consumer demands on what it believes to be scientific grounds, or acceding to them in spite of the scientific evidence. The two approaches are typified by packaging expert Cathy Lauzon and former Michael Peters Brand New Development chair Dorothy MacKenzie. Lauzon warned designers to be 'careful not to bow to popular pressure without reviewing the proper research. It is wrong to use a material simply because of its *perceived* benefit.'[30] MacKenzie, however, welcomed the McDonald's decision: 'It shows that McDonald's is in tune with public concern over disposable packaging. You can have endless debates on what is safe, but the key thing is to show good intentions.'[31] Lauzon's and MacKenzie's statements highlight the potential conflict for designers between the profit motive and social/ ecological responsibility. MacKenzie's position also highlights how Green

design can be reduced to an aspect of marketing; it may become part of a consumer-relations exercise, and little more.

In some cases the move to plastics is undoubtedly advantageous. The design of Zanussi's Nexus washing machines, for example, launched in Britain in 1990, replaces much of the steel bodywork with a new plastics material that was developed by a company called Carboran; the machines are now more than 80 per cent recyclable. The new material permits operational components to clip on to the base assembly, saving a large number of ancillary fixing items. For servicing, or at the end of its primary life, the assembly can be stripped down and the copper, steel and Carboran separated for recycling. (Zanussi is also contemplating collecting the machines at the end of their life and undertaking responsibility for their recycling.) The Carboran itself can be melted down to form new pellets for second-generation machines. The use of plastic makes the machine considerably quieter which, allied to its energy and water efficiency and the consequent reduction in the quantity of the detergents used, make the Nexus attractive to consumers, whether or not they are Green.

(iii) Glass

Glass is a material that has enormous recycling and reuse potential, and it also highlights the anti-Green nature of marketing-led design. Every year over six billion glass bottles and jars are used in Britain, the equivalent of seven containers a week per household. The container industry accounts for 66 per cent of all glass used, but less than a third of the raw material comes from 'foreign cullet' – broken glass obtained as waste after it has been discarded by consumers. An additional 19 per cent is 'factory cullet' resulting from the manufacturing process. This means that a large proportion of glass is produced from raw materials. Recycling has two major attributes: every tonne of 'cullet' used saves 30 gallons of oil and replaces 1.2 tonnes of raw materials; and the quarrying of the main components of glass – sand, limestone and soda ash – has a significant environmental impact.

Bottle banks are familiar to most people. They were first introduced in 1977 by the Glass Manufacturers' Federation after Friends of the Earth campaigned against the decline in non-returnable bottles. The amount of recycling varies considerably in different countries, and reflects each government's varying commitments and priorities. In Holland, for example, there is one bottle bank for every 1,400 people, whereas in the United Kingdom there is one for every 17,000. About 62 per cent of all glass used in Holland is recycled; in Britain the figure is 13 per cent, and this dismal record is 'beaten' amongst other European Community members – where the average is 30.5 per cent – only by Ireland (with 8 per cent). Bottle banks have even been criticized by environmental groups because they encourage

**Zanussi Ltd, Nexus, 'Jetsystem RS'
washing machine**
Many of the functional components and
structural parts are moulded from Carboran,
an advanced polymer-based material which is
fully recyclable. The wash system saves on
electricity, detergent and water. Water
consumption, for example, is reduced because
the rinse sensor detects the amount of foaming
in the wash, and introduces exactly the amount
of water needed for rinsing.

the use of throw-away bottles; broken glass uses up more energy as it is
converted into new bottles, and far greater energy-saving would result from
the reuse of glass containers. However, in the absence of widespread re-use
schemes, bottlebanks are preferable to throwing the bottles in the dustbin.

The best form of reuse is for the container to be returned to the
distributor. The model for this transaction is the milk bottle, which has an

IDEO Product Development, Domestic bin-bank
Manufactured in recycled polypropylene, the domestic bin-bank has a four-position rotating carousel which separates glass, aluminium cans and other recyclable waste into compartments. Fitted under the worktop, and with a fold-away handle, the bin is removable to facilitate transport to a municipal recycling centre.

average lifespan of twenty-five return journeys. Because glass can withstand the high temperatures required for sterilization, the problem of adequate hygiene is overcome. In French supermarkets there is a successful return and refill system for many wine and beer bottles. A very few companies, such as The Body Shop, encourage consumers to bring in their 'empties' for refilling. In the past, Friends of the Earth has campaigned for legislation to make all bottles returnable; the organization also wanted bottles to be of a standard size and shape to help reuse. The campaign was not successful because it was opposed by manufacturers, retailers and, because of their role in the consumerist system, designers.

The particular shape of a product's container – in this case, its glass container – is perceived as a crucial part of its branding identity; it helps to create a 'value added' uniqueness that differentiates it from its competitors. The shape of a Coca Cola bottle, for example, is as much a part of the product's 'value' as the liquid it contains; it makes Coke instantly recognizable and, ultimately, helps to make it commercially successful. Thus, one of the designer's main tasks in our consumerist society is to create containers that communicate 'value added' qualities; that emphasize form over content. At the two extremes we have the ecologically friendly, standard and anonymous glass container in which the content is all-important; and, at the other, the irresponsible, superficial and unnecessary glass container which is at least as important as its content. The literal and symbolic weight accorded to the latter group clearly demonstrates where our society's priorities lie. The commercial growth of The Body Shop, with their refillable 'boring packaging like urine sample bottles' shows that anonymity need not mean economic failure.[32] The universal implementation of such packaging, however, would herald the realization that 90 per cent of new products have little or nothing to add to real choice and to the variety of life.

(iv) Metals

Two further materials – metals and paper – have little potential for reuse, but offer enormous scope for recycling. Sometimes the design of products made from these materials is intrinsically ecologically unsound. For example, tin-plated aerosol cans containing anything from hairsprays to dairy cream are non-recyclable; they cannot be punctured or burned because they may contain a nitrous oxide propellant that damages the ozone layer. The most environment-friendly alternative would be a (reusable) glass container with a mechanical pump which uses air pressure and needs no added propellant.

More often, however, the metal container could be recycled but is not; and here, both designers and consumers can assert a major influence. Eleven and a half thousand million cans are made each year of which 5,500 million are for drinks, 4,000 million for human and pet food, and 2,000 million for paint

and other goods. Only one in fifty of these cans is at present recycled. Aluminium, which accounts for about half the canned drinks, has the greatest financial value, fetching between £450 and £850 for a tonne of recovered cans, compared to about £30 a tonne for tin-plate cans. Although aluminium is energy-intensive to produce, consuming thirty-one barrels of oil (or energy equivalent) for each ton of aluminium made from the imported bauxite ore, it can be recycled again and again at an equivalent of two barrels of oil a ton. The different metals need to be sorted before any recycling can take place. Labelling would help and there are recovery centres which can select aluminium by making use of the fact that it is not magnetic. Britain lags far behind the 43 per cent of aluminium cans recycled in the Netherlands, the 53 per cent in the United States, and the 95 per cent in Sweden. Designers can investigate the possibility of recycled aluminium, and consumers can lobby for compulsory labelling and a sharp increase in aluminium collection points.

(v) Paper

Paper is the material which the public most readily recognizes as recyclable. The three kilogrammes of paper and cardboard we throw away every week – 30 per cent by weight, 50 per cent by volume of domestic waste – is the most obvious demonstration of waste and potential recycling. Every person in the United Kingdom uses up the equivalent of two trees per person a year, but less than 20 per cent of household newspapers and magazines are recovered. As the quantity of pages and newspaper supplements expands, greater numbers of trees are being felled, energy use and costs are increasing, and pollution is resulting from the wood-pulping process. It therefore makes sense to make the fullest use of waste paper. It can be used as animal bedding, fuel logs, spray mixture for house insulation, and as a fuel in the form of pellets; or it can be recycled as paper.

Recycled paper is defined as paper or board that is made from at least 85–90 per cent old paper fibre. The manufacture of recycled paper leads to energy savings because only half the amount of energy and water is used in comparison with making virgin paper. The de-inking of waste paper has caused pollution problems in the past, but new technological processes are lessening the environmental impact. Recycled paper need no longer be grey: it can now compete with the sharpest white. It should, however, be borne in mind that the bleaching of pulp to make white paper can produce highly toxic by-products such as dioxins. And anyway, as people become used to off-whites, pure white paper may cease to symbolize purity and hygiene, and signify conspicuous consumption and environmental irresponsibility!

High-grade paper is frequently used when a lower grade would be perfectly adequate. But recycled paper does not necessarily mean a lowering

of standards. Graphic designers have a particular influence and responsibility when it comes to paper. Many recycled papers are excellent for artistic use. Some designers believe that not only does the recycled product offer a superior aesthetic quality but, because there is no bleach in the paper, both paper and illustration age better. Information about recycled paper can be misleading, as the term 'recycled' can refer to offcuts as well as repulped paper; it can also be confusing because the environmental friendliness of different processes of paper production are far from clear cut. Once again it demonstrates that the Green designer needs to be an informed and critical designer, no longer able to hide behind lame excuses such as 'I only know about visual things'. The implementation of a regularized, centralized and consistent labelling system is essential.

Packaging consumerist dreams

As Alastair Hay and Geoff Wright remark in the Friends of the Earth report *Once is Not Enough*:

Toilet rolls and tissues are . . . short-life items where it is arguable whether high quality paper is required. Andrex, which, through its adverts, encourages us to buy reams of loo paper for the puppy to play with, uses 100 per cent wood pulp and no recycled paper. Kleenex tissues, too, are made from pure wood pulp. Advertising persuades us to buy these products, but if we stop for a moment and consider what we use toilet paper and tissues for, it becomes difficult to insist that these be made from pure, virgin wood.[33]

It is no longer possible to think of advertising, because it is entertaining, as 'a bit of harmless fun'. The actions of manufacturers, marketers, designers and advertisers are ideologically loaded – and overwhelmingly often that ideology runs counter to the interests of the environment and is, therefore, in the longer run also counter to human interests.

Should it be acceptable to dress up chocolates in individually wrapped metallic paper and a cup, set into two layers separated by a plastic tray, and contained within a thick, heavy plastic box, as does Ferrero Rocher? What sort of value does this add and what does it say about our wider values? Packaging is, none the less, only a symptom: it is consumerist values which are the cause and problem. Governmental legislation is crucial if permanent changes in consuming are going to take place. In 1988 the Danish government actually prohibited non-refillable containers for beer and soft drinks, and permitted their sale only in approved bottles on the grounds that non-returnable bottles were an unnecessary burden on the environment. In 1985 the European Community recognized that the right to free trade was not absolute but must be seen in the light of environmental protection. Non-returnable drinks bottles have been banned in places as far apart as Denmark

Gary Rowland Associates, Shoe-packaging for 'French Connection'
Designed using pulp board consisting largely of recycled fibres, the shoe box can be easily converted into a display unit for the merchandise.

and Barbados. In Germany, the country with the most enlightened and enforced laws on recycling, legislation decrees that manufacturers are responsible for collecting their own discarded packaging. The non-profit-making organization DSD (Duales System Deutschland) is responsible for collections, and makes use of a green spot on packaging which signifies that the pack can be collected for recycling. An extra rubbish bin has been supplied to every household for green spot items, and every householder is legally obliged to use it. Just under 100 companies (including Coca-Cola, Nestlé and Unilever) have agreed to accept back their waste and to pay their share of the costs of recycling.

The designer: responses and responsibilities

The designer has a key role to play in the Greening of design. S/he is in a special position between the producer and the consumer and can influence both parties. The designer can have a major influence over how things are made; the materials that are used; how they are constructed; how efficient they are to use; their ease of maintenance; and even their recycling/reuse potential.

Designers must not be just reactive, but proactive and environmentally committed. They must relinquish the attitude of 'I-was-only-obeying-orders', and assume greater responsibility for the 'cradle-to-grave' life-cycle of what they design. This is certainly the view of the plastics expert Sylvia Katz:

For too long designers seemed to have turned blind eyes to the after-effect of their creations. Design responsibility doesn't stop at the shop counter . . . Before any new packaging is designed it is vital that the two main issues – recycling techniques and second-use markets – are developed. I've never understood why most packaging, no matter how tastefully devised, produces such a quantity of paper, card, plastics and metal with no further purpose in the home. If the consumer can't think of a second use for it, then it is the designer's or manufacturer's responsibility to tell him. A challenge like this would help both our shrinking resources and educate the public.[34]

Adrian Judd of Friends of the Earth sees designers as having:

. . . an influential role to play in halting the slide towards disaster. Their aesthetic and construction skills in the packaging field can be combined with sound ecological sense to produce packaging that can and will sell products while causing the minimum of damage to our fragile earth.[35]

Too many designers, according to the creative director of a major international design group, are not thinking about Green issues in the first stages of a project – 'It is usually further down the line'.

In the defence of designers, those sympathetic to Green issues do have two major problems with which to contend. The first is the availability and reliability of information. With contradictory advice about, for example, the pros and cons of plastic over glass, or plastic over paper, the designer will often feel ill-equipped to make a definitive technological and environmental decision. Furthermore, the claims made by some manufacturers for their materials are unreliable and ambiguous. What the designer urgently needs is accessible, understandable and reliable information about materials, processes and their effects. The EDEN project (Environmental Design for Ecological Need) based at the Institute of Bioengineering at Brunel University, and the MILION project (named from an abbreviation of the Dutch for 'design for the environment'), part of Eindhoven's European Design Centre, are both attempts to provide, amongst other things, databases that will enable a designer to make an informed decision. Designers (and other interested parties) have also formed international networks such as CODE (Coalition on Design for the Environment), based in Boston, USA, and the Ecological Design Association, in order to exchange information and raise awareness.

The designer's other main problem is unsympathetic clients and manufacturers. The following comments by two British designers are typical: 'In terms of pack design, we are often given the container, and there's not a lot of opportunity to suggest anything else. It is frustrating when you'd like something to be packed in glass rather than plastic, but apart from a stand-up argument with the client, there's little you can do.' And, 'If the

Grammer AG, Natura chair
The Natura chair is said to be ninety per cent
recyclable. Screws and interlocking joints are
used instead of glue so that the chair can be
easily dismantled and the components re-used.

client is not motivated, then there is not much that can happen at the end of
the day. It is only when Government or EC legislation bites that clients will
do something.'[36] It seems that it is governmental legislation, allied to public
pressure, that will make the significant difference – as it has already in some
European countries and the United States.

When working in concert with a sympathetic manufacturer, the designer
can have a major impact. The German chair manufacturer Grammer has
launched a chair collection which claims to be 90 per cent recyclable: screws
and interlocking joints are used instead of glue so that the chairs can be
dismantled and the components reused. Herman Miller is buying back its
old chairs for recycling, and even BMW has announced that it is going to
start recycling its old cars – the ultimate 1980s designer status symbols – at a
factory in Germany. Whether this is a shrewd marketing ploy or a
manifestation of a significant change remains to be seen.

There is, undoubtedly, a growing body of ecologically aware and
technologically informed designers and groups who are beginning to assert
an influence on mainstream design thinking. One example is o2, an
international network of anti-consumerist designers in Denmark, France,
Italy, England and Austria who are committed to conservation and ecology.
Its founder, Niels Peter Flint, walked out of a well-paid job in the prestigious
studios of Ettore Sottsass in order to get o2 off the ground. Flint's action can
be seen as symbolizing a shift in fundamental values away from designing

'hundreds of fridges for Japanese teenagers or 2,000 separate pairs of doorhandles' to 'thinking about how to make things that cause as little pollution, as little consumption of energy, as possible. That means right from the production process through to its use – and then on to recycling.'[37] Flint rejects consumerist values: 'I was feeling more and more sick about doing crazy and bizarre things just to make profit. I wanted to find a new approach to design.'[38] One project, which Flint hopes will eventually be produced, is a range of kitchen products that use long-lasting recyclable plastics. Items such as cleaning brushes would have a long-life handle and shaft, but replaceable bristles in natural fibres. In collaboration with one of the major Danish electricity companies, 02 have developed an environmentally clean, doubly insulated electric pot which is highly energy efficient. Another project is a range of labels and packaging for a tropical rainforest product from Zambia. The group also hosts symposia and study days to help lobby more forcefully for Green design.

An influential international company which is showing signs of responding to the new thinking – at least in the design of its packaging – is Braun. Braun has always been perceived as a design-leader and its packaging has never been flamboyant or especially wasteful. Yet even Braun's cardboard packaging includes cellophane, which burns unpleasantly and prevents the cardboard from being recycled. A plastic coating, with properties similar to cellophane, is used on the boxes, while some of the inks contain toxic chemicals that emit poisonous fumes when burned. However, as soon as the company feels commercial damage would not result, Braun may start marketing its products in simple self-coloured paper packages that will be padded with recycled paper.

Hartmut Stroth, a member of Braun's design department with responsibility for packaging, has also conjectured about the implications of a Green approach to the company's products. Setting aside the issue of which products are actually needed rather than desired, Stroth admits that Braun and, of course, other companies, should consider non-polluting, biodegradable plastics which would decompose when their useful life was over. The consumer would have to accept a lesser degree of technical finish because such plastics would mould less well. At present, stabilizers have to be added to the plastics during production to ensure colour consistency; some of these, especially white and red, are cadmium-based and poisonous. Without such stabilizers, consumers would have to accept inconsistent colours; alternatively, a stable colour could be chosen, but this would have to be of a more natural hue. Braun's technologically crisp, 'Snow White's coffin' image would have been transformed.

Towards a Green aesthetic?

Does Green design presage, therefore, a new aesthetic? We have certainly witnessed a development away from the post-hippy, 'brown rice and sandals' aesthetic to a 'professional', mainstream and at times slick aesthetic in keeping with the expectations of the style-conscious and image-orientated consumer of the late 1980s. Organizations which, at one time, would have equated design with the unacceptable face of commercialism, now embrace design as part of their essential armoury in the battle for winning the hearts and minds of the public. The small-scale and amateur post-hippy aesthetic may have been appropriate to Green issues when they were confined to health shops and their leonine inhabitants, but today, just as political parties of the Left have had to come to terms with the Right's sophisticated marketing, so Green organizations realize they have to compete on equal visual terms with their consumerist competitors.

Historically, too, the Green consumer movement has entered a second stage of its development. The first stage was when a 'friendlier' version of an everyday product became available. As *Marketing* put it: 'Milking the first phase on Green, when "friendlier" products are favoured over their less friendly counterparts, has been relatively easy.'[39] The second stage began around the turn of the decade when the number of friendlier versions for a particular product – for example, washing detergent – became such that they either became the norm or, more commonly, had to compete between themselves. Leaves, flowers, birds and – although he must be turning in his grave at the bastardization of his art – Matisse-derived carefree figures floating, skipping or sauntering about the package were the graphic devices which signified 'caring Greenness' at this stage. However, research carried out by a major consultancy revealed that to the public these graphics were coming to signify 'poor performance', as the consumers' commitment to being more caring was tempered by the social guilt of producing clothes which (because of the absence of the normal bleaches) were less than sparkling white. And so the simple images of Greenness are having to be replaced by images of convincing efficiency in which the Green references become secondary. Increasingly, this is the case for a wide range of products: as Greenness becomes expected, overt references to Greenness disappear and Green graphics and packaging become more mainstream.

The homespun and folksy image of Green products is becoming less and less common. In the past Green products have, according to one designer, 'tried to look as if they have not been near a designer. They tried to be as utilitarian as possible.' Ecover's cleaning range has been redesigned in order to 'bring [it] into the Nineties . . . It is a new age for eco-products. They are no longer alternative products, they are mainstream.'[40] Ark products hardly

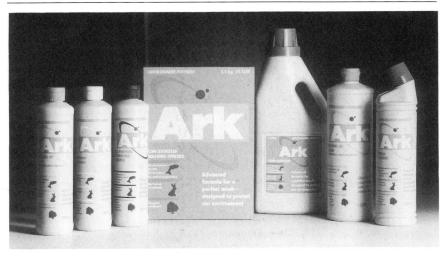

Ark Consumer Products Ltd
Ark products, with packaging designed by
David Davies Associates, promote a colourful
and dynamic image for their environmentally

friendly products, underlining the point that
the Green aesthetic need not be folksy or
homespun.

draw attention to their recycled card and biodestructible plastic containers,
opting instead for a dynamic, colourful, even 'fun' appearance. The Ark
packages were designed by David Davies Associates, the mainstream
consultancy which designed, amongst many other things, the Next interiors.
The initial idea was to go for an 'anti-packaging' black look, but Stuart
Baron, head of DDA's graphics, chose bright blue, red and yellow to avoid a
'homespun' image: 'We want to be aggressively competitive.'[41]

Perhaps the most significant example of a change from an amateur to a
'professional designer' image is provided by none other than Friends of the
Earth. From 1989 the group adopted a new corporate logo which sought to
'avoid any design cliché' and to communicate a more respectable, pro-
fessional, but also 'naturalistic' image – a photograph of the Earth taken from
the Moon. Graphic designer Simone Aylward of Gary Rowland Associates
explains that, 'It had to look quietly confident, but not too scary. Friends of
the Earth is renowned for its campaigning work, but some people still have
the wrong idea of it. I wanted to give a really professional impression.'[42] Even
more indicative of the change was the thinking behind the annual report for
1989, about which the designer (Paul Jenkins of Ranch Associates)
elucidates: 'We want it to look slick and corporate.'[43] Only a decade ago
'slick' and 'corporate' would have been two of the most damning words that
could have been used of an organization so far as any Green group was
concerned. When it comes to graphics and presentation, 'Green' and
'designer' are no longer mutually exclusive.

Is crop spraying changing the nature of what we eat?

CAMPAIGN FOR PESTICIDE-FREE FOOD

Friends of the Earth Ltd 377 City Road, London EC1V 1NA 01-837 0731

Gary Rowland Associates, Campaign advertisement for 'Friends of the Earth'
The campaign made use of simple yet telling images and copy that promoted thought rather than sloganizing.

Friends of the Earth

HELP
THE
EARTH
FIGHT
BACK

Gary Rowland Associates, Information leaflet for 'Friends of the Earth'
Gary Rowland Associates designed FoE's new corporate identity, which sought to 'avoid any design cliché' and to communicate a more professional yet caring image.

Green design has ceased to be the preserve of a particular type of person or segment of consumers, and now attracts marketing target groups that range from the predictably receptive 'reformers', to 'traditionalists' and even 'aspirers'. Consequently, the Green aesthetics used for products that are aimed at these different market segments reflect the established range of styles and aesthetics associated with each of these groups. There is now no single 'Green aesthetic', but a full stylistic diversity that extends from 'brown rice and sandals' to 'designer chic/slick'.

This stylistic diversity even, to an extent, reflects social pluralism. There is no reason why a more unified aesthetic, reflecting the earlier ethos of recycled paper, should return. If anything, diversity should increase as Green features become – one trusts – a normal part of every product. When it comes to packaging and product design, however, there are some important aspects to consider. Even when recycled materials are used in the packaging of Green products, the guiding principle must be 'less is more' – and this has aesthetic implications. Fewer materials (to make sorting for recycling easier), and less of each material, makes ecological sense, so Green packaging should avoid frills and fripperies. If a product does not actually *need* a package for protection, it ought not to have one. The package should be reused wherever possible.

As consumers, we are now used to stand-up flexible pouches that contain concentrated fabric softeners and liquid detergents – and to transferring the contents into the high-density polyethylene bottles which were previously used only once. The standardized and completely anonymous brick-shaped Tetra Pak is now being widely used; sales of the pack total nearly sixty billion a year worldwide. With the shape and dimensions of the Tetra Pak taken as given, the designer has to focus her or his attention on the graphics, not the package. The marketing-led approach which promotes wasteful and irresponsible packaging, and brand imagibility through the uniqueness of the container-shape, cannot be justified.

Readers with a knowledge of twentieth-century design history may be struck by the similarity between, on the one hand, the Green packaging and product aesthetics outlined in the above paragraph and, on the other, Modernist design of the 1920s and 1930s, as it was described in the first chapter. The call by Marcel Breuer, designer of the chrome and leather 'B33' chair beloved by generations of designers, for 'clear and logical forms, based on rational principles'; the argument for the clarity and beauty of primary forms by Walter Gropius, the founder of the Bauhaus; and the Bauhaus reaction to the 'wasteful frivolity' of Victorian design, all led to the quest for the creation of type-forms 'for all practical commodities of everyday use'. The logic of Modernist design, as one of its British proponents explained to a sceptical public, was 'standardization, simplicity

and impersonality': a minimalist aesthetic of 'less is more'.

Yet Modernist and Green design are essentially at odds. Modernist designers sought simple and standardized products not only because of the logic of mass-production processes, but also because of their belief that such forms in themselves signified reason over emotion, order over chaos, and even the triumph of man's will over nature. In their unambiguous commitment to industrialism, Modernists wanted their designs to express the machine age through a 'machine aesthetic' that was underpinned by an ideology of scientific rationalism. Green designers reject industrialism and the old, 'man'-centred scientific rationalism as a cause of the ecological imbalance that has resulted from an attitude of 'conquering' nature and exploiting resources. Not only do Greens replace 'man' by 'humans', but they seek to rebuild the whole idealist pyramid that presented *homo sapiens* as the apex of an increasingly progressive and cultivated civilization. *Homo sapiens* can no longer be set apart from nature, but must be seen as an integral part of an ecological system.

Modernists also subscribed to what can be described as 'aesthetico-moral' principles, including 'truth to materials' and 'integrity of surface'. Such principles were not justified simply by reference to rationalism and the values of classical aesthetics, but by the supposedly morally superior approach taken by the designer in not, for example, 'cheating' spectators into thinking that the materials that met their gaze were other than they seemed. A building which appeared to be in stone, but was really steel-frame with stone cladding, was beyond redemption in aesthetico-moral terms; so too was plastic which simulated wood; or veneers. Most Green designers would find this sort of guiding principle irrelevant in the post-Modernist, post-Pop age; design must be responsible but certainly need not be earnest. Plastics, for example, need no longer express their 'truth to material' and can again simulate other materials. Given the shortages of hardwoods, veneers are more and more likely to be used. According to the Timber Trades Federation of the United Kingdom, the use of veneers has been growing recently, facilitated by technological advances which have allowed the effective coupling of thin, decorative hardwood surfaces to modern timber compositions such as medium-density fibreboard. As well as being a better use of resources, the end product is also cheaper. Disguise and simulation, two of the most hated traits of the type of design despised by Modernists, look likely to become an acceptable part of several Green aesthetics.

Nevertheless, one strand of Green design is decidedly craft-orientated, and its proponents champion aesthetico-moral principles that derive from the design reformers of the nineteenth century: Pugin, Ruskin, Owen Jones and William Morris. The Victorian reformers clearly influenced the Modernists in terms of rationalist aesthetico-moral principles; what changed

fundamentally was the attitude to technology and the status of handwork *vis à vis* the machine. A continuous line of aesthetic thought can be traced from the Victorian reformers through designer-makers like Bernard Leech and Michael Cardew, to contemporary craftspersons such as John Makepeace. These modern designers uphold aesthetico-moral principles such as 'truth to materials', and try to bring out the unique quality of that material; they also subscribe to guiding principles such as Pugin's 'decorate construction but never construct decoration'. Aesthetico-moral Greens also identify strongly with Ruskin's and Morris's celebration of the 'joys of labour' – joys that are supposed to ensue from creating with one's own hands.

Ruskin believed that all art and design should be based on the study of nature which, for him, was nothing less than God's handiwork. Many Greens, whether or not they are religious, share a celebratory attitude to nature, and this often finds its way into design. The most obvious example – and it is certainly popular with the wider, even non-Green public – is the 'country cottage'-style kitchen. Indeed, the creators of advertising features and 'Ideal Home' exhibition mock-ups seem to think that a 'Green kitchen' is inevitably going to be traditional and 'cottagey' in style, resplendent with knotted and grained (sustainable) wooden surfaces and cupboards. There is no reason at all, as we have already discussed, why Greenness should be synonymous with a 'natural' appearance. During this early stage of environmental awareness, the concentration on a 'natural' Green aesthetic is understandable but, as Greenness infiltrates the majority of products, Green aesthetics will become as diverse as people's tastes. The types of Greens that identify with Ark's graphics, for example, are far more likely to choose (responsibly) synthetic materials and fashionable colour schemes.

However, while Green design can be virtually any colour you like, further research into the chemical properties of colour dyes and stabilizing agents may, as Braun's Hartmut Stroth suggests, lead to more muted, 'natural' colours instead of bright primaries. There is a clear parallel with health food, which has banished artificial colourings and become more self-coloured, or slightly enlivened by safe, non-artificial colouring agents. Stroth's comments about a reduction in technical perfection parallel the reduction in standards from the 'whiter-than-white' effect we have come to expect from conventional washing powders to the noticeably less-than-white we get from bleach-free, environmentally friendly ones. Perhaps these reductions in conventional expectations are a good thing if they both loosen the grip of 'scientific perfection' as the model to be striven for, and lessen the anxiety that individuals may feel when they fail to achieve the perfection depicted in advertisements.

Green design and consumerism

Ultimately, in Green design aesthetic questions must be guided by the far more crucial matter of the planet's resources and ecological well-being. These are matters that, whether we like it or not, affect all of us. Just as religion once provided what the critic Peter Fuller described as the 'shared symbolic order', so the genuine universality and 'globalism' of Green matters may provide us with the first shared symbolic order of the twentieth century. Green questions touch everyone, and inevitably exist in every facet of consuming and design. It is misleading to think about Green design as if it were a discrete category or mode of design. Just as questions of 'function' or 'style' are part of every design problem, so too should 'Green' factors be an integral – indeed central – part. It is also characteristic of Green matters that any particular aspect, however apparently inconsequential in itself, relates to a greater and interconnected whole. The micro is directly related to the macro, whether in terms of resources, pollution or human conditions. Green politics have shown us that design is not a simple matter of personal choice and preference, but a complex issue with interlocking human, social, political and environmental dimensions – dimensions which we will explore in greater depth in the next chapter when we examine the idea of responsible design and ethical consuming. Against this complexity, marketing-led design looks increasingly shallow and irresponsible.

Women's Environmental Network, 'Green kitchen'
The 'country cottage' style of kitchen is a popular interpretation of a Green kitchen, but there is no reason why Greenness should be based on the *appearance* of Nature.

3 Responsible Design and Ethical Consuming

If the post-'enterprise culture' era is supposed to be about 'integrity' and 'care', then it would seem that we are about to enter a period of responsible design and ethical consuming. But, if history is a reliable guide, socially useful production is always on its way but seldom arrives, thwarted by the values of consumerist society.

The spirit of '68

In the wake of the growing consumer awareness promoted by magazines such as *Which?* and *Consumer Reports*, and by lobbyists such as Ralph Nader, a significant amount of consumer legislation – such as the Molony report – was enacted in the 1960s. By the last years of that decade consumer awareness had given rise to what became known as, variously, the 'responsible' design movement or the 'socially useful product' debate. The period following the social and political disturbances of 1968 kindled a spirit of questioning and reappraisal that infected the design profession – or at least its more conscience-stricken fringe. In the leader column in *The Designer*, the journal of what was to become the Chartered Society of Designers (CSD), the editor worried: 'Do we [as designers] place too much importance upon our small refinements – the exact radius of a curve in the shank of a door handle, the precise weight of a printers' rule?' Designers needed to be more outward-looking and to ponder the relationship of design to society – its role and purpose. This was not idle navel contemplation or academic daydreaming because, 'What is at stake is nothing less than the quality of life itself – not in a century's time, but twenty, ten, two years' time. Now.'[1] It seems it has taken twenty years for such sentiments to come to maturity.

Designers were being implored to consider 'the wider issues at stake' but, with the wave of interest in 'the environment' – the stagnation of rivers, pollution of air, and the erosion of the countryside – any ethical concerns became channelled into whatever specific cause the more politically motivated radicals chose to champion, and this deflected debate from the real issues and the underlying causes of environmental problems. Symptoms, in other words, were being treated as causes. This position was most forcibly presented by the radical French Group at the 1970 International Design Conference, held annually in Aspen, Colorado. The Group lambasted

designers for their hollow concerns, and tried to expose the way that designers ignored the political nature and implications of design:

It is not true that society is ill, that nature is ill. The therapeutic mythology which tries to convince us that, if things are going wrong, it is due to microbes, to virus, or to some biological dysfunctions, this therapeutic mythology hides the political fact, the historical fact that it is a question of social structures and social contradictions, not a question of illness or deficient metabolism, which could easily be cured. . . Aspen is the Disneyland of environment and design . . . But the real problem is far beyond Aspen – it is the entire theory of design and environment itself, which constitutes a generalized Utopia, a Utopia produced by a capitalist system that assumes the appearance of a second *nature* in order to survive and perpetuate itself under the pretext of *nature*.[2]

Their conclusion, therefore, was that, 'Problems of design and environment only look like objective ones. In fact they are ideological problems.'[3] And it was nothing less than the ideology itself which needed to be fundamentally challenged and, in the view of the Group and its supporters, overthrown – hence their call for the abandonment of design for profit.

Radical design and designers

Others of an older generation had made much the same rallying call. Some were 'refound' as spiritual leaders and design gurus. Buckminster Fuller's reputation amongst the young, for example, had begun to rise from the mid-1960s, when those calling for a 'return-to-nature' in outbacks and deserts had discovered his geodesic domes. The domes could be constructed out of the recycled debris – metal sheeting from refrigerators and cars – of consumer society. When young designers turned to his ideas and (somewhat esoteric) writing, they found values with which they could identify. In 1961 Fuller had proposed to the International Union of Architects at the 5th World Congress in London:

. . . to officially initiate Phase I of Design Science Decade 1965–75 which will put world on notice that making world work is an invention initiative and not a political responsibility and is only solvable by a world design revolution which is the only revolution universally tolerable to diverse political interests of the world; and that the design revolution must be conducted by world-around students under university auspices and supported by professional degree accrediting boards and visiting committees of all the architectural, engineering and scientist professions and officially underwritten by their professional societies.[4]

Design, Fuller believed, could solve the world's problems if it dealt with the real issues and concerns, rather than the phoney desires dreamt up by capitalist manufacturers and their 'lackeys' . . . industrial designers. His

utopianism was based on an extreme rationalism and a total commitment to science and technology. He rejected all forms of broader political involvement because they got in the way of the utopian vision:

> It seems perfectly clear that when there is enough to go round man will not fight any more than he now fights for air. When man is successful in doing so much more with so much less that he can take care of everybody at a higher standard, then there will be no fundamental cause for war . . . Within 10 years it will be normal for man to be successful. Politics will become obsolete.[5]

Fuller offered a vision of compassionate, problem-solving, anti-consumerist design to those who dismissed or rejected politics as part of the problem rather than part of the solution. Decisions about design, Fuller and his followers thought, were too valuable an activity to be entrusted to self-seeking politicians.

In the late 1960s and early 1970s, Fuller's ideas were celebrated at conferences and events in both the United States and Europe. At these gatherings alternative shelters and sources of energy, including wind-powered equipment, were tried and tested; geodesic domes were erected; and temporary shelters made from cardboard were constructed for use in disaster areas. Books and manuals of a semi-underground nature followed. These gave information on do-it-yourself construction and easy-to-get parts. *The Whole Earth Catalog*, an imaginatively compiled directory of services and techniques, was periodically updated and widely available; the *Domebook One*, 'inspired by the work of Buckminster Fuller', gave a practical account of the construction of ten different domes.

The late-1960s ferment resulted in the development of several lines of thought in the 1970s. One of these was the alternative technology movement (which eventually became known as the appropriate technology movement), in which decentralized and ecologically sound energies and materials, and non-alienating social means of production, were developed. A second was a concern to design shelters for the Third World or the victims of earthquakes or other natural disasters. An example, designed in Germany for those made homeless by a Peruvian earthquake, was an igloo-sized balloon sprayed with polyurethane foam to form a temporary shelter. A third – and more extreme – development was the total rejection of architectural or design practice. This was the option chosen by radical designers who, in order to avoid compromise with the system they despised, gave design up completely in favour of direct-action politics. Anarcho-left direct political action, for example, was proposed by the ARSE group (Architectural Radicals, Students and Educators) in London who proclaimed, 'We shall build for society by building a new society first.'

Few of these developments answered the needs of radical designers who

were being educated in the mainstream system to design for mass pro-
duction, albeit the mass production of consumerist items. However, a
glimpse of how things might be – socially responsible mass-produced design
– had been offered by the WOBO (WOrld BOttle) project in the mid-1960s.
In 1960 Alfred Heineken of the Heineken Brewery had visited the island of
Curaçao in the Caribbean Sea. Dismayed by the condition of local housing,
which was constructed largely out of the debris of consumer society, and
appalled by the discarded junk and rubbish which included his own
company's bottles, Heineken conceived the idea that was to culminate three
years later in WOBO, the first mass-production container ever designed
from the outset for secondary use as a building component. Although every
returnable Dutch Heineken bottle made an average of 30 or more 'trips'
before being lost or destroyed, the lack of a collection and return facility on
the Caribbean island meant that each bottle was used only once before
becoming waste. Heineken intended to replace the standard 300 millilitre
export bottle with a redesign capable of being redeployed as a house brick
when empty. Given that Heineken's product was an established part of the
island's consumer culture, here was an idea for truly enlightened design; not
only would defaced beaches and clogged refuse systems be cleaned up, but
the bottle would be a cheap and, it was hoped, efficient source of housing in
an impoverished community.

The story of the WOBO project has been told elsewhere,[6] and its eventual
shelving highlights the conflict of value between social responsibility in
design, and the social irresponsibility of consumerism in which profit is the
over-arching concern. The prototype 'building brick' bottle redesign was
opposed by the marketers at Heineken because the long-necked Chianti-
style bottle, which had grooves in its side to receive the necks of other bottles,
was criticized as being too 'effeminate'. Because it did not look like a
standard beer bottle, and lacked the 'appropriate' connotations of mascu-
linity and ruggedness, the marketers felt that sales and profitability might
suffer. A second prototype, which sought to combine use-value with the
preferred image, was also abandoned.

The WOBO project had been an attempt – at least by Heineken himself –
to adapt consumerism so that it was no longer in conflict with social values.
Some dismissed his idea as superficial, because it still required the
substantial consumption of a non-essential item which used up both valuable
resources and the inhabitants' income. Economic power, critics argued,
remained in the capitalist economy. A more genuinely altruistic and
responsible approach would have been to pour money (rather than alcohol)
into the indigenous economy so that an industry could be built up which
could undertake a proper programme of housing construction. The essen-
tially political questions about ownership of resources, money and power are

The WOBO project
The illustration shows an early wooden model of the prototype WOBO bottle, revealing the vertical jointing system. The marketing department was unhappy with the bottle design, which they felt was 'effeminate' and, therefore, inappropriate for a beer bottle.

questions that inevitably provide the context for the contemporary debate about responsible design and socially useful products.

Victor Papanek and 'Design for the Real World'

The diverse and spasmodic attempts by groups and individuals to counter the social and ecological impact of consumerist design and its values at least demonstrated that, at around the turn of the decade, there was a spirit of dissatisfaction with the status quo in design. That spirit was given its most forceful and articulate voice with the publication of what has become a seminal text – Victor Papanek's *Design for the Real World*, published originally in Swedish in Sweden in 1970, and in English in 1971. Papanek's book quickly became the bible of the responsible design movement, and Papanek himself became an international leader to the dissatisfied or disaffected in design practices and education. The affection demonstrated by his followers was matched in intensity only by the dislike, and occasional hatred, expressed by those who supported or worked for the consumerist design industry. The issue of a completely revised edition of *Design for the Real World* in 1984 underlined the emergence of the most recent phase of the debate about consumerist values and design, as well as confirming the status of Papanek's key text.

Papanek was motivated to write *Design for the Real World* by the mismatch he felt existed between the power and influence of design, and the lack of moral responsibility felt by the design profession:

In an age of mass production when everything must be planned and designed, design has become the most powerful tool with which man shapes his tools and environments (and, by extension, society and himself). This demands high social and moral responsibility from the designer. It also demands greater understanding of the people by those who practise design and more insight into the design process by the public. Not a single volume on the responsibility of the designer, no book on design that considers the public in this way, has ever been published anywhere.[7]

There was no shortage of books about design, but 'when a sales-directed, profit-orientated, ecologically disengaged society practices design, [books about design] use beautiful photographs to illustrate the symptoms of our sickness, rather than listing the causes.'[8] A book which looked at design in its social context, and faced up to the moral issues, was urgently needed, 'so I decided to write the kind of book that I'd like to read.'[9] In the period between the publication of the first edition and that of the revised edition, we have witnessed the phenomenal growth of design, and a subsequent explosion of books about design. However, in the second edition, Papanek felt obliged to regret that 'none of the [recent] books addresses itself to the social and human dimensions of design.'[10]

Papanek's condemnation of consumerist design was tellingly summed up in his statement that, 'The action of the profession [of design] has been comparable to what would happen if all medical doctors were to forsake general practice and surgery and concentrate exclusively on dermatology, plastic surgery, and cosmetics.'[11] There was no justification for designing trivial and stylish consumer items for the affluent of the advantaged countries, when the majority of humankind was living below subsistence level. Papanek proposed what was, in effect, an agenda for design – a set of six design priorities.

The first was 'design for the Third World'. Papanek calculated that nearly three billion people were in need of some of the most basic tools and implements. Lighting, for example, was a scarce resource in many countries: 'there are more people without electric power today than the total population of earth before electricity was generally used.'[12] In spite of new materials, processes of manufacture, and techniques, no radically new and appropriate oil or paraffin lamps had been developed since Thomas Edison's day. There was also a need for an off-road vehicle which could cross some of the 84 per cent of the world's surface that is completely roadless terrain.

The second priority was the design of teaching and training devices for

retarded, handicapped or disabled people. Papanek argued that this area of design, which was often dismissed as 'design for minorities', constituted a larger area that was generally realized:

Cerebral palsy, poliomyelitis, myasthenia gravis, mongoloid cretinism, and many other crippling diseases and accidents affect one-tenth of the American public and their families (20 million people) and approximately 400 million people around the world. Yet the design of prosthetic devices, wheelchairs, and other invalid gear is by and large still on a Stone Age level.[13]

Products for disabled people often showed the harshness of the profit motive that underlay consumerism. Why else was it, Papanek asked, that one could buy a transistor radio for less than $10, while a simple hearing aid, using essentially the same components as the transistor radio, sold for between $300 and $1 100? The answer was, partly, scale of production: millions of the same radio might be manufactured and sold internationally, whereas a far smaller number of hearing aids might be manufactured and sold nationally. There were two possible remedies to this situation: first, the hearing aids could be produced with national rather than private resources, and made available very cheaply; or they could be manufactured internationally and their unit cost thus reduced. In both cases political and social issues about design – the ownership, control and allocation of resources in the public sector – would have to be faced.

'Design for medicine, surgery, dentistry, and hospital equipment' was Papanek's third priority for design. Instruments were either badly designed – 'most medical instruments, especially in neurosurgery, are unbelievably crude'[14] – or over-designed. In the latter case, a simpler and less sophisticated solution would not only be more adaptable and flexible, but would be cheaper to produce and maintain. Papanek stated that one of the main reasons for the spiralling costs of health care was the bad design of equipment. Marketing-led design values had even infected this kind of functional equipment: 'From time to time, illustrations of new biomedical equipment appear. Almost invariably these are "hi-style modern" cabinets, in nine delicious colours, surrounding the same old machine.'[15] While it is understandable that hospitals are trying to improve the appearance of their wards, and even some of the diagnostic and treatment equipment, to make them less clinical and so more psychologically comforting to patients, it is important to distinguish between psychological aspects of design – the carefully researched effects of colours and forms for example – and consumerist ones in which styles are chosen for their fashionableness or social associations.

With his fourth priority for design – 'design for experimental research' – Papanek continued his criticism of badly designed equipment: 'in thousands

of research laboratories, much of the equipment is antiquated, crude, jury-rigged, and high in cost.'[16] The politics of design also needed rethinking, because companies were guilty of overcharging governmental purchasing agencies. This was the case not only with major military hardware, but also with simple equipment such as an uncomplicated hexagon Allen wrench. Papenek reported that Senate hearings had established that overcharging sometimes amounted to price increases as large as 230,000 per cent, but accountability was hard to maintain. 'After enough Senate investigations, manufacturers might even decide to sell laboratory apparatus at an *honest* profit, instead of defrauding the public and research establishments alike'[17] – a case, surely, of the unacceptable face of the consumerist ethos of design for profit.

The design of survival systems for difficult environments such as polar icecaps, underwater, deserts, or space – 'systems design for sustaining human life under marginal conditions' – was the fifth priority for design. It was a priority made especially pressing because of the pollution caused by some of the existing systems.

The final priority – 'design for breakthrough concepts' – was a plea for radical design rethinking rather than the conservative approach of a continual refinement of existing products, or systems of 'additive' design in which more and more features or extra gadgets are added instead of re-analysing the basic problems. Automatic dishwashers, for example, waste millions of gallons of water a year; rather than merely marginally improving the consumption rate of dishwashers, 'the rethinking of "dishwashing" as a system might make it easier to clean dishes, as well as solving one of the basic survival problems: water conservation.'[18] The heating of rooms is another problem that Papanek believed needed rethinking, because many conventional systems are inefficient in energy and cost terms.

It was Papanek's opinion that the above are 'six possible directions in which the design profession can and must go if it is to do a worthwhile job. Few designers have realised the challenge so far or responded to it.'[19] A further category that might be added to those defined by Papanek is design for elderly people. The elderly as a category can itself be sub-divided into those who are in some way infirm through the normal processes of ageing; those with specific ageing disabilities such as arthritis; and those who are relatively fit and active. The sheer size and consuming power of the last of the sub-groups – the United States will have 21 million over-65s by 1995 and they are currently buying more than a third of all consumer products, drink more than a quarter of all the alcohol consumed, and spend more on their grandchildren than do their own children – ensures that elderly people, as a lifestyle taste group, will be catered for. But if one considers the first sub-group, those who are feeling the effects of the ageing process, one finds

Indes Design Consultants, Pillsafe
The Pillsafe is an electronically controlled
device for dispensing tablets, ensuring that
patients receive the right dosage at the right
time. The portable dispensing device connects
to a sophisticated base station which includes a
card reader and modem to allow programming
and the recording of prescriptions.

that few designers are addressing their needs. For example, the 60-year-old
eye needs three times as much light as a 20-year-old one, and its attendant
reduction of visual acuity and accommodation – the ability to see fine detail,
and to adapt from short to long focus and to changing light intensities –
throws up many implications for product ergonomics and graphic design.

Some would argue that, although design for the fit and young will often be
ergonomically unsatisfactory for elderly people – handles may be too styled
to grip easily, or typefaces too small to read – design with elderly people in
mind does not exclude young and middle-aged people from using the
products. But this argument for 'transgenerational' products or 'universal'
design (as it has been termed) is unlikely to convince manufacturers and
designers who operate in a consumerist system which equates so much
design with styling and product differentiation.

Papanek himself, as a practising designer and educator, outlined a number
of solutions for the challenges listed above in *Design for the Real World*. Some
had been taken only as far as the prototype stage; others had been fully
developed and produced. These included a range of designs, from muscle-

powered vehicles designed by Papanek and a student team in Sweden; through a one-station radio receiver for Third World countries, manufactured on a cottage-industry basis for nine cents; to a system for modular low energy usage electric rugs, based on the mechanics of the electric blanket and the principle that warm air rises.

Nor could Papanek be accused of unreasonably profiting from his design solutions. The system of patents and copyrights was, Papanek argued, detrimental to an enlightened role for design in society:

> If I design a toy that provides therapeutic exercise for handicapped children, then I think it is unjust to delay the release of the design by a year and a half, going through a patent application. I feel that ideas are plentiful and cheap, and it is wrong to make money from the needs of others.[20]

Papanek's approach was not to patent but, indeed, to publish widely and make available inexpensive detailed drawings for the construction of his designs.

Papanek and designers from the 'Real World'

Papanek has often been referred to dismissively as a 'do-gooder' designer and the champion of minorities. Papanek's indignant response is that, once the sum of people worldwide included in the six priority areas for design have been added together, 'we find that we have designed for the majority after all. It is only the industrial designer, style-happy in the eighties of this century, who, by concocting trivia for the marketplaces of a few abundant societies, really designs for the minority.'[21] This is a good point that exposes the insular and socialized view of consumerist designers who are conditioned to think of marketing-led design as the norm, and responsible design as something *other*. It is these sorts of prejudices and their political and social implications that confirm the necessity of texts about design which purposefully challenge conventional attitudes and values.

The most common criticism that has been levelled at Papanek since *Design for the Real World* was originally published – and it is a criticism that has also been aimed at the whole 'responsible design' movement – is his supposed naïvety about design in Western society. The design profession is understandably unsettled by Papanek's fundamental rejection of the way they earn their daily living, and their defensive reaction usually takes the form of a sneering accusation of naïvety in believing that society could be otherwise. Such a reaction, when challenged, usually takes recourse to prejudices about the changelessness of 'human nature' – a belief which is used, ultimately, to justify self-interest and greed. Were Papanek preaching that society could be changed tomorrow if designers acted differently, he *could* be accused of a

late-hippy mentality that mistakes good intentions for political and social reality, but he points out in the revised edition that:

. . . many professionals found it difficult to accept my proposal that design for areas previously neglected was *one more direction for design.* Instead they felt that I proposed *substituting* concern for the vast human needs in the world *for all commercial design, as now practised.* Nothing could be further from the truth: all I suggest is that we add some intelligently designed goods to a global marketplace now flooded with manufactured 'bads'.[22]

Indeed, Papanek suggests concrete ways in which designers who want to work responsibly can survive in a consumerist society. The best solution would be to work in one of Papanek's six priority areas, or to work for product evaluators or consumer groups and so forth. For those caught up working in a consumerist industry, Papanek suggests contributing one-tenth of their time or one-tenth of their income to socially responsible projects, while continuing with their jobs. This is an idea – especially the option of contributing time – that has increasingly appealed to younger designers, and organizations such as MediaNatura now act as clearing-houses for such projects.

The message of the book as a whole is that there are ways of accommodating 'responsible' work and earning a living as a consumerist designer, but that this is fraught with problems, compromises, inconsistencies and dangers. *Design for the Real World* is a very moral book in tone and expression and the author's fundamental tenet that 'it is wrong to make money from the needs of others' does underlie the text. This basic premise is liable to make the reader anxious, if not guilty, about the almost inevitable compromises between earning a living in consumerist society, and designing for Papanek's 'real' world.

The accusation of naïvety is inevitably levelled at any major criticism of the consumerist design system. But, while it would be naïve to think that the system could be easily changed to a more socially caring, just one, it would also be misguided to think that merely tampering with the current system can do little more than change some of the end-effects of a basically untenable, wasteful and exploitative system. A profound reconsideration of values and priorities *is* necessary, and so the protagonist of responsible design must always be vulnerable to such criticisms. What the protagonist must also do is suggest a staged way forward, otherwise s/he will be dismissed as merely utopian. In other words, both visions and strategies are important; one without the other leads either to daydreaming or to unclear half-measures.

It was probably the rather holier-than-thou moral tone of *Design for the Real World* that most offended many designers and readers. Coincidentally, it was this very tone which made Papenek a cult figure, elevating him to guru-

Design Report, *Greenpeace*

Design Logotype, *FFPS*

Design New Identity, *Plantlife*

Design Corporate Identity, *Imperial College*

Design New Identity, *EarthKind*

MediaNatura

MediaNatura acts as a creative broker between sympathetic individuals or groups in the creative professions and environmental clients. Media Natura contributes research, planning, project management and production skills to ensure that campaigns are as successful and creative as possible. Since 1988 it has completed more than 200 media projects.

like status amongst his followers. Such a status was not something he necessarily wished on himself. The tone also seems worse when, very occasionally, it is undermined by inconsistencies. We are told, in no uncertain terms, that 'the design of any product unrelated to its sociological, psychological, or ecological surroundings is no longer possible or acceptable',[23] and that all systems – private capitalist, state socialist, and mixed economies – 'built on the assumption that we must buy more, consume more, waste more, throw away more' are not acceptable or sustainable;[24] yet elsewhere we are told that 'it is only right and proper that "toys for adults" should be available to those willing to pay for them in an abundant society.'[25] After all, Papanek continues, designing responsibly is 'not an attempt to take all the fun out of life.'[26]

Papanek's inconsistencies aside, the question of 'fun' is not as trifling a matter as it may seem. Papanek seems to distinguish between *playfulness* in the design process (which he approves of as a catalyst for imaginative thinking), and *fun* or, at least, *unnecessity* as a characteristic of a product. Psychologists and anthropologists have long acknowledged the capacity for, and importance of, game-playing and fantasy in the human psyche and in societies – indeed art and decoration are deeply rooted in them. What might be described as Papanek's ultra-rationalism and seriousness about design has limitations if he does not realize the importance of fun and fantasy which, in our culture, are sometimes met in self-consciously designed consumerist items such as sleekly styled cars and radio-cassette players. These items cannot be justified in conventional rationalist terms, but they can provide an important emotional expression, as well as stimulating designers by increasing the vocabulary of forms and their relationships. It must be emphasized that this is not a justification for consumerism and marketing-led design *as a system*, but is by way of an attempt to tolerate certain products which we may not, ultimately, be able to justify in broader terms, but which are visually expressive, symbolically rich, or even just flamboyant. What matters is the balance of values for a society: too much 'fun' for its own sake leads to a complacent acceptance of consumerist values; a Papanekian rejection of fun (in spite of his lip service to it) reduces seriousness to earnestness, and risks the accusation of being 'holier-than-thou'. More importantly, earnestness can rapidly lead to second rate and unimaginative design solutions. Prose may be what we need to live by most of the time, but this fact alone makes poetry all the more significant and, indeed, necessary.

The above is, however, a relatively small point in relation to the substantive critique offered by *Design for the Real World*: the exposé of consumerism and its social irresponsibility, and the guilty role of designers. 'There are', Papanek wrote:

. . . professions more harmful than industrial design, but only a very few of them . . . Today, industrial design has put murder on a mass-production basis. By designing criminally unsafe automobiles that kill or maim nearly one million people around the world each year, by creating whole new species of permanent garbage to clutter up the landscape, and by choosing materials and processes that pollute the air we breathe, designers have become a dangerous breed.[27]

The design profession, not surprisingly, has reacted with a mixture of anger and disdain to Papanek's haranguing of their activities, and Papanek frequently complained that he had been blackballed by his professional society, who once threatened to boycott an exhibition of American industrial design at the Pompidou Centre in Paris if Papanek's work was included. One of the most disdainful put-downs has come from Stephen Bayley in the *Conran Directory of Design* (1985). Bayley dismissed Papanek as 'a cult figure while ecology was fashionable during the early seventies'.[28] The entry, of course, tells us much about its author and his commitment to consumerist design values.

The Lucas Plan and social responsibility

Whether positive or negative, responses to Papanek's book were frequently emotional in tone and this tended to polarize the debate about responsible design – a situation which has obtained until only very recently. One area in which Papanek's legacy has been especially keenly felt is in what has been termed the 'socially useful produce/production' debate, which appeared to reach its zenith in the mid-1980s, but is now beginning to find a new lease of life in the wake of the significant disarmament that has followed the end of the Cold War.

Taking their lead from Papanek's list of design priorities, proponents of socially useful design argue that we should set clear priorities for what we produce rather than either leaving decisions to market forces (and producing wasteful frivolities), or producing socially unnecessary, undesirable or harmful products. As Mike Cooley put it:

There is the appalling gap which now exists between that which technology could provide for society, and that which it actually does provide. We have a level of technological sophistication such that we can design and produce Concorde, yet in the same society we cannot provide enough simple heating systems to protect old age pensioners from hypothermia.[29]

Cooley had been prominent in the Lucas [Aerospace] Combine Shop Stewards' Committee in the mid-1970s which had been formed as a response to the British government's re-organization of the British aerospace industry. During 1975 and 1976 the Combine won international

acclaim for their alternative plan, which argued that more jobs could be saved and even created by Lucas moving into the production of new, socially useful products.

The Combine's definition of 'socially useful' emphasized that products must:

. . . be accessible and useful to everyone in the community and not confined to fulfilling the needs of the select few;
. . . take maximum advantage of the existing skills within a company and develop them to the advantage of the workforce and the community;
. . . be capable of being made and used in ways that do not impair the health and safety of the workforce or the community at large; and
. . . make minimum demands upon natural resources and improve the quality of the environment.[30]

These criteria were to be translated into products or systems which, for example, facilitated cheap transport, low-cost energy, or better technological support for the disabled. Crucial for the hoped-for success of the venture was the utilization of the expertise and technological know-how of the workforce.

It is significant that the Lucas plan was based on a premise that the workforce ought to be involved in the planning and decision-making process, because it reveals the assumption in the 'socially useful' design movement that it is not just a question of substituting one (desirable) product by another (undesirable one), but of substituting one form of organization of labour (based on a command relationship, 'a bad habit inherited from the army and the church' as one employee put it) by another (more participatory and democratic). This did not necessarily mean that the Combine wanted Lucas to be run as a workers' co-operative, but they did seek a principle of collective responsibility. To discuss just the end part of the process – products – would be considered, at best, incomplete and, at worst, misguided. The Lucas plan was essentially political because it questioned the ownership, production and distribution of power, resources and products and tried to claim the right for the workforce 'to work on products which actually help to solve human problems rather than create them'.[31]

The Lucas workers arrived at a 'shopping list' of possible products by both making an audit of their own skills and abilities, and discussing what they thought they would and should make. Between them they produced some 150 proposals for products that they could make as an alternative to the 'degradation of unemployment'. The planning was thorough and consisted of six documents, each of about 200 pages and containing technical details, engineering drawings, costings and supporting economic data, and labour and production implications. The range of products was Papanekian in its

responsibility. In the section dealing with alternative energy technologies, the plan advocated ideas for gaseous hydrogen fuel cells, heat pumps, solar-collecting units and small wind-electric machines which catered for the energy needs of communities rather than individual households. The plan included a stepping up of production of kidney dialysis machines and heart pacemakers to develop simple, portable life-support systems for the victims of coronary failure, and mechanical 'sight' mechanisms for the blind. The 'hobcart' was a simple, self-propelled vehicle for children with spina bifida. Several of the proposals were for intricate telechiric gear for use in the hazardous professions of deep-sea diving, oil rig maintenance, fire-fighting and mining. Related ideas included the collection of ocean bed mineral-bearing nodules, and submarine agriculture.

A transport section detailed a hybrid diesel-petrol power-pack which used a small internal combustion engine running at constant optimum revs to charge batteries (whenever the vehicle idled or decelerated) which were also used to provide motive power through an electric motor. Prototype tests claimed to show that the idea reduced fuel consumption by about 50 per cent and pollution by 80 per cent. Another proposal was for a road-rail vehicle that could be driven as an ordinary coach on the roads and transfer directly onto a rail network. Studies of this vehicle showed that, by using pneumatic tyres and a smaller, lighter frame than normal rolling stock, it could cope with sharper track curves and steeper gradients (up to one in six). These attributes would make it significantly simpler to lay track for the vehicle, because the massive earthworks necessary for conventional railway systems were not required. The Third World potential of many of these products was considerable.

All these products had to be not only environmentally sound and socially useful, but also non-alienating in their processes of manufacture – the plan's authors saw no point in perpetuating work conditions that were hazardous, polluting or mind-numbing.

When the plan was published in 1976 it was widely acclaimed, not only in Britain, but also in the United States and Europe – in particular in Germany, France and Sweden. Both the scale of the plan, and the type of industry from which it emerged, meant that it exerted a wide influence. While a workers' cooperative movement based on small groups of people – especially in service industries such as food production and wholesale supplies – was gathering momentum in the 1970s and 1980s, there were few opportunities for a large-scale operation to set an example in the way the Lucas Combine did. And the type of military-related hardware that Lucas produced served to underline the nature of the debate about *what* was being produced.

Socially useful product groups

In the former West Germany – no doubt because of the political awareness arising from being the buffer zone between West and East – the arms conversion movement has been at its most active. A number of Alternative Product Working Groups (Arbeitskeise Alternative Fertigung) were set up in several of the major military contractors, including Blohm & Voss, AEG, MBB, Krupp and MAK. Projects have ranged from an ambitious combined heat and power system to a more modest proposal for tyre-recycling equipment.

The American National Center for Appropriate Technology, based in Butte, Montana, has sought to develop and introduce small-scale, low-cost and self-help technologies appropriate to the needs and resources of low-income communities. Project ideas included a solar-powered wool scouring unit for a Navajo community; a water-pumping windmill; and a wood-fired bakery. In the 1980s several organizations facilitating socially responsible products were started in the United States and Europe. The following three British groups are typical – as are the problems that they share.

UDAP (the Unit for the Development of Alternative Products) is a joint venture between the Lucas Aerospace Combine Shop Steward Committee and the former Coventry Polytechnic. Its first aim was to 'help and encourage the exploration of socially useful projects for peaceful purposes, their technical and commercial evaluation, their design and development, possible modes of production and their contribution to society.' The consumerist criterion of profitability was rejected in favour of social usefulness, although the dissolution of County Councils and the resulting drastic reduction in funding has prompted a reorientation to products which have a more obvious market potential. One of the unit's major projects was the 'Bealift', an aid for bathing handicapped children, and this was manufactured by a co-operative which exports it to several European countries, as well as achieving substantial sales in the United Kingdom. Other projects have included a domestic ventilator to free people with respiratory problems from their ties to a hospital-based 'iron lung'; a portable lightweight unit to help people who have difficulty boarding a bus or coach; equipment for manufacturing fuel bricks from recycled paper for a community in Africa; and work on electric town vehicles.

Sheffield City Council and the former Sheffield Polytechnic jointly founded SCEPTRE (The Sheffield Centre for Product Development and Technological Resources), which is intended to develop new products 'particularly where the products will improve the quality of life by satisfying social needs'. The resource assisted the development of a shower tray for disabled users; a time-code lock; and a portable device for helping partially-

London Innovations Ltd, The 'Neater Eater'
The 'Neater Eater' is a device for helping people with intention tremor – a side effect of a number of disabling diseases and conditions – to feed themselves independently.

sighted people read faster. Longer-term funding is a constant problem for this type of organization, which sits uneasily in the enterprise culture of marketing-led design.

Like UDAP, the London Innovation Charitable Trust (LICT; now London Innovation Limited) are inspired by a belief that 'conventional market forces ignore a huge social market of unmet needs for products and services and that the public can and should contribute to the design and development of useful products to supply this social market.' LICT grew out of the London Innovation Network's Design Aid Service; this service was financially underwritten by a group of committed individuals before it became self-financing, again showing the precarious financial situation of, and the apparent lack of governmental support for, alternative product-design resources. The high cost of research and development means that many socially desirable products would never get beyond the drawing board if they were left to the profit-driven sector. LICT has set out its list of priorities in designing products. Top priority is given to products which assist the elderly, children and handicapped people; second, energy and resource-efficient products that promote conservation or improvement of the environment; third, products which reduce alienation by involving the intended user in the design process; and finally, products which retain or enhance skills in production, while taking advantage of modern materials and methods.

London Innovations Ltd, Cloudesley Chair
The chair is a flexible seating system catering for the majority of children with disabilities, especially those with limited muscle control. The illustrations show the test rig, and the product as manufactured.

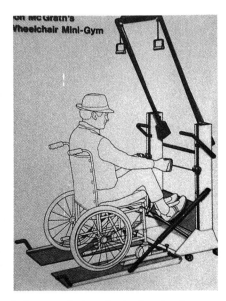

London Innovations Ltd, Wheelchair gym
The first illustration gives an indication of the rigorous ergonomic testing that is required before a product can be developed and produced.

One of LICT's major projects is the 'Neater Eater', a device for helping people with intention tremor – a side effect of a number of disabling diseases and conditions like MS and cerebral palsy – to feed themselves independently, making meal-times more convenient and less degrading. Another is the 'Cloudesley Chair', which is a flexible seating system that caters for the majority of children with disabilities, and especially those with limited muscle control. Other projects have developed a wheelchair gym, and a range of products for people with continence problems. The majority of projects for socially responsible products reach only the prototype stage, and they are seldom manufactured or produced in any useful quantity.

Roger Coleman, trustee to LICT, fully acknowledges the impact and influence of the Lucas Combine plan which, although over a decade and a half old, continues to inspire. It is certainly true that the influence of the Lucas plan is out of proportion to its actual achievement because, although the plan was heralded widely in the professional press at the time and was seen as a highly promising event for the future of British industrial production and labour relations, Lucas's management flatly rejected it in what became an acrimonious and recriminatory episode.[32] So, if it is just as simple to produce a tractor as a tank, and if you have won the moral high ground, why is 'socially useful' design such a small part of industrial production?

The marginalization of 'socially useful' design

The answer lies in the nature of consumerism and the system in which it operates most tellingly – capitalism. Although consumerism is upheld by the Right as the mechanism which gives power to the consumer – reference is frequently made to the consumer being 'king', and 'consumer sovereignty' – it is often the manufacturer or producer who has the real power because s/he has control of the resources. This was the case with Lucas Aerospace who, for whatever reasons, were not willing to commit resources to the Combine plan in spite of the identifiable consumer *need* for those products.

The historian of domestic technology, Ruth Schwartz Cowan, has researched the intricate and complex tale of 'how the refrigerator got its hum' – why the electric refrigerator with its humming compressor and built-in obsolescence was adopted by producers in preference to its gas counterpart with its silent and virtually maintenance-free absorption unit. The expected answer – that a unit with a limited lifespan will keep people consuming – is, surprisingly, not the complete answer. Profits, Cowan summarizes, are only partly compounded out of sales. Profits are also accrued from the amount of staff time which has to be spent on a product; whether it needs new marketing or whether existing arrangements are suitable; how easily manufacturing facilities can be converted; how reliably

an item can be mass-produced; and other considerations. General Electric (GE) became interested in refrigerators because it was experiencing financial difficulties after the First World War and needed to develop a new and different kind of product. The company opted for compression rather than absorption because, Cowan points out, it stood to make more profits from exploiting its own designs and its own expertise than someone else's.

Having entered the market with compression refrigerators, GE helped to improve that market, not just by its promotional efforts on its own behalf, but by the innovations that it could then sell to, or stimulate in, other manufacturers.

And having done all that, GE helped to sound the death knell for the absorption machinery, since only a remarkable technical staff and a remarkable marketing staff, combined with an even more remarkable fluidity of capital, could have successfully competed with the likes of General Electric, Westinghouse, General Motors, and Kelvinator.[33]

The machine that was 'best' from the point of view of the producer was not necessarily 'best' from the point of view of the consumer. What masquerades as 'consumer choice' is, therefore, more likely to be 'producer choice', especially for resource-intensive products. Cowan concludes that:

. . . the first question that gets asked about a new device is not Will it be good for the household – or even, Will householders buy it? but, rather, Can we manufacture it and sell it at a profit? Consumers do not get to choose among everything that they might like to have, but only among those things that manufacturers and financiers believe can be sold at a good profit. Profits are always the bottom line . . .[34]

This is a criticism also made by Papanek. 'Design', he asserts, 'must be independent of concern for the gross national product' if it is genuinely to serve, rather than exploit, society.[35]

Because of the prevailing system and ethos of consumerism, groups promoting 'socially useful' design exist only at the very margins of society. None is large enough in terms of resources to assert itself in a marketplace which favours vested interests and those who uphold the status quo of consumerist goods. Even if they are produced, socially useful goods may not succeed because sophisticated marketing, distribution and retail planning and resources may not be available or, indeed, be in keeping with the reformed ethos of design. Although an ardent supporter of 'socially useful' design, Phillip Cooke, a lecturer in Planning Theory and Urban Politics at UWIST in Cardiff, is sceptical about the movement's potential to change our society:

The lack of independent labour-generated investment capital means that socially useful production cannot make a substantial impact other than as rhetoric or very

small-scale experimentation. If the real function of the movement towards socially useful production is to offer limited hope that alternatives are possible, then that is an honourable purpose but we must be clear that movement beyond that position requires new institutions capable of generating large sums of investment capital.[36]

The need for a major change in financial institutions away from 'short-termism' – let alone a major change of priorities for companies away from the profit motive as the over-riding criterion of new product development – confirms that a profound shift towards 'socially useful' design – a shift, in classical Marxist terms, away from exchange-value to use-value – will only come about as the result of a corresponding and *prior* socio-political shift in society. There is a fundamental dilemma faced by politically-aware designers operating in a society whose values they oppose, and it is basically the same dilemma as the one faced by William Morris in the nineteenth century. Do you, as a designer, continue to 'minister to the swinish luxury of the rich' which, in twentieth-century international terms, may mean designing non-essential items for the 'haves' of the affluent nations, or do you put your energies into revolutionizing the institutions that uphold the 'rotten and corrupt' system? If design is a reflection of society's values, is continuing to be involved in design rather than being active in politics putting, in effect, the cart before the horse?

'Socially useful' design within the system

One honourable compromise for designers has been to work in the public sector, but this has become less effective as a strategy for two reasons: first, the public sector in most countries is decreasing as a result of 'privatization'; and, second, the remaining public sectors are having to adapt to 'enterprise culture' criteria in which use-value is superseded by exchange-value – goods and services produced by and in the public sector have, increasingly, to be financially viable. Units for socially useful products for disabled people, for example, usually only exist on a short-term basis, funded by a council with a social conscience, or by a voluntary organization relying on charity and goodwill. A volunteer in one such unit – by profession an engineering designer and lecturer – cheerfully explained that:

You just need a small room or shed near the hospital; volunteers are happy to use their phenomenal accumulation of skills; most institutions have leagues of friends who're happy to buy chairs and curtains but who, when asked, would buy machines and tools as well; most local firms would provide off-cuts of metal, wood, plastics and so on.

Is it really acceptable that, in an affluent society, we should so often rely on

volunteers, donations, and bits of scrap to produce aids for disabled people, and therapeutic toys?

Historically, the Left has used the public sector as a way of implementing policies, plans and values, including 'socially useful' design, especially in the health sector. Critics of this approach point, very convincingly, to the former Eastern bloc countries whose record on 'socially useful' design was completely overshadowed by bureaucracy and inefficiency; their system produced little more than shortages and technically obsolete and poorly designed products. The Left in the West is now moving away from this model because of its domineering centrism, which is unresponsive to changing needs and discourages participation and feedback, towards a redistribution of wealth and an increase of availability by *right*, which gives poorer individuals the choice that both a state socialist and a capitalist system deny. The danger of the new Left approach is that giving individuals more power in an otherwise substantially unreformed society merely compounds capitalist values – an approach which the Right found politically and electorally successful during the 1980s.

At a time of significant East/West disarmament – which ought to continue in the remaining years of this century – the socially useful product movement should be lobbying passionately for its worthy and sane cause. Without a reallocation of resources to manufactured products, unemployment will rise and the gap between rich and poor is bound to increase. The ethical argument for socially useful manufactured products ought also to win over more people in a period when the public is becoming more aware of the inter-connectedness of the world, its economy and ecology. However, the movement does run the risk of alienating the public if it demands an immediate and drastic reconstruction of society while using the outmoded language of class struggle. Take, for example, the following statement:

Through demanding the right to determine for ourselves what commodities we produce and the conditions and sets of relationships through which they are produced, we also implicitly demand a radical break in the way in which the present processes create us as workers and construct us as persons.[37]

The collective 'we' sits uneasily with the reality of a plural and multi-cultural society, especially when the 'we' refers to 'us as workers'. Such a simplistic and anachronistic view of society – the workers versus the oppressors – holds back the socially useful product movement by making it an all-or-nothing rejection of capitalism, rather than a synthesis of the best of both systems. A more positive tone is often achieved in Scandinavian social democratic countries, which combine capitalism and state provision to create an *ethos* in which social responsibility in design is taken very seriously.

For example, the Design Forum in Finland – roughly the equivalent to

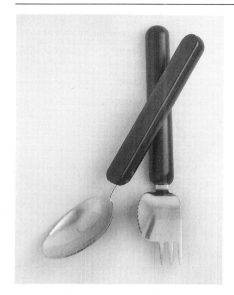

Ergonomi Design Gruppen, Combination cutlery
The EDG was founded in 1979 and works in many fields, from heavy industry to products for disabled people. This cutlery is designed for people with single-hand function.

Ergonomi Design Gruppen, Support cane
By increasing the load on arms and hands, conventional canes can cause pain in arthritis sufferers' wrists and shoulders. In response EDG developed an ergonomically determined handle which provides broader support than other canes.

Britain's Design Council – recently focused its attention on ecological issues (including energy-efficient housing), design for disabled people, industrial safety, and public sector design. Danish design has produced many commercially successful but socially useful products, including the Ballofix valve which enables an element in a plumbing, oil, air or gas system – such as a tap washer – to be quickly and simply isolated rather than having to close all or part of the system down. Lego, one of the most imaginative and flexible toys ever invented, was a characteristically Danish invention.

In Sweden, where design for handicapped people is, historically, a major concern, the Ergonomi Design Gruppen (EDG), a group with vast experience in designing for the working environment and users with special needs, have designed an 'eating and drinking programme' for RFSU Rehab (an organization which is now a private company, but was then a grant-aided foundation which advised on and supplied medical aids). The programme, which included combination cutlery for people with single-hand function, was sold commercially, but the cost was kept low by grants from insurance companies and public bodies. In fact, the programme needed to be funded, as no industrial producer could be found. EDG are also frequently commis-

sioned by state organizations such as The Institute for the Handicapped and the Work Environment Fund: the group suggests an area of research into the kind of products a particular disadvantaged user-group needs, and the Government draws up a contract which allows for investigation. Another commission for RFSU Rehab was a series of support canes for people with arthritis. In collaboration with a doctor, a physiotherapist and a number of patients the group analysed the limitations of conventional 'walking sticks' and canes. They found that, by increasing the load on the arms and hands, conventional canes cause pains in the user's wrists and shoulders because the cane's support surface against the palm of the hand is too small. EDG conceived of an entirely new cane in which the handle is ergonomically designed in relation to the irregular shape of the palm, thus providing broader support. The handle is attached to the cane by an articulated joint which can be set at the angle that most exactly suits the individual. The shaft of the cane is based at the rear of the handle so that it will not be in the way of the fingers.

Just how a society's ethos is formed – whether predominantly through education, the political system, social institutions, control of the media, or a self-perpetuating view of its own identity – is debatable. The way in which design operates within a different ethos in each society is neatly demonstrated in a short article by a leading British design pundit who was introducing an exhibition of Swedish design in the early 1980s. After a glib remark about Swedish design for disabled people being so lavish that it was almost a handicap not to be handicapped, he wrote that:

To British designers and design students, now – at last – applying themselves to the task of demonstrating the commercial significance of design to their current or prospective clients, the exhibition's emphasis on design for the disabled may appear a little old-fashioned, a throwback to the idealistic late 'sixties and early 'seventies. Not so. Swedish design, like Swedish engineering, is just as forward-looking as British.[38]

How reassuring to know that a concern with disabled design need not hold one back and make one appear dated in the style-conscious era of lifestyle products and marketing-led design values!

Third-world problems and priorities

There is an understandable tendency in the developed world to expect the Third World to avoid the former's mistakes in such matters as energy production and environmental pollution. Third World countries, on the other hand, resent both being told what is good for them, and having to pay (often quite literally) for the mistakes and high living of the West. The

production of CFCs in refrigerators is a case in point: if countries such as India are going to change to more environmentally friendly but more expensive substitutes, they have a right to expect the countries who have significantly contributed to the destruction of the ozone layer through their past sins to finance the change. Similarly, many in the West hope that the Third World will avoid the wasteful and socially divisive path of marketing-led design in favour of socially useful products. The logic ought to be in favour of responsible design: Third World countries – almost by definition – are characterized by scarcity rather than surplus and merely owning a product ought, therefore, to matter more to people than its particular make or styling. Yet few – if any – Third World countries are cocooned from Western values when it comes to design. The role of products in conferring status and power is daily transmitted on Western television programmes, especially soap operas, which are followed avidly in shanty towns from India to Brazil.

The tension in a Third World country between the basic needs of the vast majority of the population, and the consumerist desires of a relative few, is described by Ashoke Chatterjee of India's National Institute of Design:

Has the glossy image of studio design for sophisticated markets, so irresistible in the cross-currents of international exchange, overwhelmed the original challenge of design in India? Here, as in so many aspects of India's open and democratic life, the impact of the developed world is immediate. Rampant consumerism, and its design demands, reflects new policies towards a freer market within a nation still striving to meet the essential needs of millions. In this land of contrast and contradiction, which client will the designer choose?[39]

Chatterjee argues that the original motive for bringing design to India – 'to lift the quality of life for millions living at the margin of existence in villages and urban slums' – remains virtually untouched as designers are lured by the glamour and international prestige of designing seductive but socially questionable products.[40] The dilemma facing a designer in a country like India will often be as stark as the contrast between whether the designer should turn her or his attention to a new range of office equipment, or to the untapped resources of cane and bamboo in the remote north-east. The choice is not always straightforward, especially in an economy which is as concerned with space technology as it is with improving the ancient bullock cart.

Even if the dilemma of design in a Third World country is resolved in favour of socially responsible design, the designer has the difficult task of conceiving products and processes which are not only socially desirable but also culturally appropriate. For a product or process which does not grow out of the habits and customs of a country or region is unlikely to be successfully

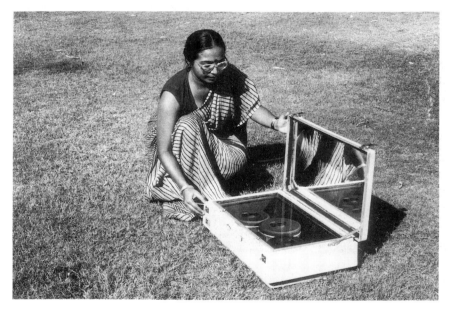

National Institute of Design, India, Gas stove

Designer: S. Balaram

The stove, specifically designed to suit the manufacturing capability of small units, offers improved thermal efficiency (from 58 to 70 per cent), and was designed with a top which collects spilt food and avoids the clogging of the gas nozzles. It has won awards and was selected by UNIDO as a 'know-how' resource for other Third World countries.

National Institute of Design, India, Solar cooker

Designer: S. K. Khanna and student team

This energy-efficient cooker was developed over a lengthy period to provide better heat retention, reduce weight, and improve portability. Although it is yet to achieve widespread public use, it demonstrates the Institute's commitment to responsible and Green design.

National Institute of Design, India, Cable drums

Designers: S. K. Khanna, Ravi Mokashi Punekar

Cable drums have invariably been made of wood and, because of their size and the distance over which they are transported, they have seldom been reused, resulting in a loss of thousands of tonnes of wood. The NID team created a solution that could be dismantled, reshipped to the producer, and reassembled for further use. The prototype was successfully tested, and the Indian Government recommended the design to other cable manufacturers to assist the national drive towards wood conservation.

National Institute of Design, India, Electronic voting machine

Designers: V. M. Parmar, J. A. Panchal

The aim was to design a voting machine which would speed up and protect election procedures amongst non-literate voters. The product was to be in two parts: a ballot unit to be operated by the voter, and a control unit through which the Presiding Officer could monitor voting operations. It was designed in aluminium or plastic to ensure ease of mass production and distribution. The unit is designed in modules to accommodate up to 16 candidates each, with the possibility of linking four units so as to provide for a total of 64 candidates in a single election procedure.

integrated into the society's culture. Products introduced to aid a group's economic development have sometimes failed completely because they did not take full enough account of the cultural factors of tradition and identity. To take a simple approach to design as a problem-solving activity is, in fact, a caricature. Design – whether concerned with socially responsible products or even consumerist luxuries – is a cultural activity in which meaning and identity relative to a group, society or country are essential considerations.

Technological processes of production, too, have to be 'appropriate' to the culture of a country or region. Much has been written about 'AT' (appropriate technology), and its relationship to responsible design in Third World countries cannot be neglected. Briefly, the main characteristics of appropriate technologies are that they are low in capital costs; use local materials whenever possible; create jobs, employ local skills and labour; are small enough in scale to be locally or regionally affordable; and can be understood, controlled and maintained by local groups wherever possible, without the need for a high level of Western-style education. Furthermore, they involve decentralized renewable energy sources such as wind power, solar energy, water power, or muscle power and are understandable to the people using them. They are unlikely to involve patents, royalties, consultancy fees or import duties, as these tend to maintain the reliance of developing countries on affluent countries. Finally – and this is facilitated by the 'people rather than technology' emphasis of AT – they need to be flexible so they can adapt to changing circumstances.[41] Much of the thinking behind the values of AT derives from another key book of the early 1970s: E. F. Schumacher's *Small is Beautiful*.

Cultural and technological considerations become especially crucial when a 'socially responsible' designer takes on work for a developing country. There is a grave danger that the designer sitting in her or his office in London, New York, Milan or wherever, will lack crucial knowledge about the culture of the Third World country. Even if the designer visits the country for a period, there is still a danger that s/he cannot become involved long enough or deeply enough to fully understand local customs and needs. Ideally, in Papanek's opinion, the designer should move to the country in order to:

. . . train designers to train designers. In other words he would become a 'seed project' helping to form a corps of able designers out of the indigenous population of the country. Thus within one generation at most, five years at least, he would be able to create a group of designers firmly committed to their own cultural heritage, their own life-style, and their own needs.[42]

Projects currently being undertaken at the Social Design Sector (SDS) in the Industrial Design Laboratory of the Federal University of Paraiba in

Brazil demonstrate the crucial mix of socially useful design, appropriate technology, and cultural suitability. The aim of the SDS is to design high-quality products that can be afforded by low-income groups: projects include pedal-powered washing equipment; a pedal-powered rice dehusker; school furniture and teaching materials for state schools; basic medical equipment for developing countries; and support for children with cerebral palsy. The person-powered washing machine, for example, which makes use of a simple reinforced concrete frame and readily available bicycle saddles and pedals, is designed to reduce drastically the physically demanding work of the poorly paid washer-women – who often suffer from skin diseases (due to handling soaps and detergents), back disorders, and muscular and circulatory problems. The seated, cycling motion not only reduces the problems that can result from up to twelve hours of standing and bending, but also greatly improves the blood circulation and thus lessens the risk of vein diseases. At the time of writing it was hoped that institutions responsible for public washing facilities in some of the major cities in Brazil would introduce the machine reasonably quickly. The medium-term aim is to provide a simple electric motor which would, needless to say, transform the women's working conditions radically.

The fact that a pedal-powered washing machine can still constitute an 'advance', and the prospect that in the *future* washing machines with electric motors may be available to washer-women, shows the incalculable gulf that exists between the affluent, industrialized countries and the Third World. The type, indeed the very provision, of design shows just how much design is integrally related to a society's economic, social and cultural fabric. The inclusion at this point of my thesis of the Brazilian washing machine is not intended to sound a puritanical note, but it should serve to underline the predominantly consumerist role of design in our own society: how our own design frequently panders to the socially constructed and implicitly con-doned desire for status and self-seeking gratification. To greater or lesser extent, design will always be related to prestige: whether your washing machine is electric or pedal-driven is no doubt a matter of prestige to Brazilian washer-women, just as the make, features, sophistication and styling are in consumerist society. But at the very least we should make sure we understand the 'rules of the game'; that is, we must understand how design is being *used* in the society in which we live.

Ethical investing

In Europe and the United States the arrival of the 'ethical' consumer and investor reveals the growing concern with political aspects of production, manufacture and design. The 'ethical consumer' is one who, in the 1970s

and 1980s, was likely to have boycotted South African food produce, and perhaps the stores that sold South African produce, and even companies and organizations such as banks which invested in South Africa. In the 1990s, companies that invest in countries with questionable regimes, or which have factories or manufacturing plants in Third World countries, but which exploit the labour force through unfair wages or poor safety conditions, or which cause an unacceptable level of environmental damage, are increasingly facing well-organized boycotts by ethically inclined consumers.

'Ethical investment' can be traced directly back to the late 1960s and the founding of the American Council on Economic Priorities – a body which grew out of the American public's resentment against companies that were supporting or involved in the Vietnam war. But it was in the late 1980s that 'ethical investment' and 'ethical consuming' both gathered considerable momentum. 'Ethical investment' has been dismissed by its critics as 'the acceptable face of an unacceptable system' for its attempt to combine social responsibility with a high level of personal profit. In its portfolio, for example, one of the main 'ethical investment' trusts in the United Kingdom offered potential investors the 'opportunity to invest without compromising your principles' as 'Profits don't have to be made at the expense of society.' It declares that its aim is:

... to invest, as far as practicable, in companies whose products or services make
a positive and healthy contribution to society. For example, we seek out
companies with healthy track records in labour relations, pollution control and
environmental protection. At the same time, we make every effort to avoid
investing in the tobacco industry, in alcohol, and in countries with dictatorships or
oppressive regimes such as South Africa or Chile. We do not invest in companies
involved in the arms trade, gambling or exploitation of animals.

The belief that responsibility and profit are not only *not* mutually exclusive, but are positively linked, is advanced via the dubious premise that 'concerned companies are usually operated by diligent, concerned managements, and this shows up in their financial performance'. The dilemma – for both companies and investors – occurs when ethical factors are likely to compromise a high financial return. Furthermore, ethical investment is seldom likely to benefit Third World countries, where profitability is a dim and distant hope. However, if the *Financial Times* is to be believed, 'the days when portfolio decisions could be made in a complete moral and social vacuum are numbered.'[43] At the very least, the phenomenon of ethical investment is symptomatic of the rejection of the naked consumerism of enterprise culture, in favour of a supposedly more caring and compassionate society.

Companies and organizations whose commitment to the Third World is perhaps more wholehearted distinguish between 'ethical' and 'social'

investment. In their share prospectus, the British company Traidcraft, a trading company committed to fairer dealing with the Third World, define an 'ethical' investment as:

> . . . seeking the *maximum financial return* to the investor consistent with the investor's own principles and not just the minimum standard provided by law. A 'social' investment by contrast considers the *combined return*, not only to the investor, but to the users of the funds, whose benefit the investor may wish to promote for a variety of reasons, while preserving the amount invested itself.[44]

Unusually – if not uniquely – on a share prospectus, Traidcraft starts by warning possible investors that 'this offer of shares should not be regarded as an investment for personal gain or profit': they will be 'investing in an enterprise seeking to set justice in trade above commercial advantage . . .'[45]

Traidcraft buys products from the Third World which are environmentally sound, and which are manufactured without harmful effect to the maker, to sell in Britain. Fair prices are paid and the local industry and economy are strengthened wherever possible. The aims of redistributing wealth in favour of the poor, and treating Third World suppliers as partners rather than as a group to be exploited, form the basis of the company's philosophy. In terms of *consuming*, Traidcraft 'encourage responsible shopping, by giving consumers the information they need and the opportunity to buy products, not just because they are useful, attractively designed and give good value for money, but because of the benefit they bring to the people who produce them.'[46] Traidcraft's product range includes handicrafts, jewellery, clothing and accessories, teas, coffees and foodstuffs, and the fact that the majority of its trading takes place in the Christmas period underlines the non-essential character of most of their products. The kind of Third World enterprises that Traidcraft is able to support are, by their very nature, small-scale, low technology, 'cottage' industries which are unlikely to produce the sort of socially responsible goods (in a Papanekian sense) that can be exported to developed countries. So, although the ethical consumer can buy some everyday items such as tea, coffee and recycled paper from Traidcraft, s/he cannot rely upon this type of company for larger and more technological products – such as cassette players and washing machines – that we consider normal in our society.

Ethical consuming

For some time now, various 'Green' guides have offered consumers advice on the healthiness of foodstuffs, and environmental implications of detergents and hardware such as refrigerators, and the sustainability of materials used in certain wood products. More recently, consumer guides have

appeared which are the 'ethical' equivalent, or alternative to, the mainstream consumer association magazines such as *Which?* The mainstream magazines are criticized for concentrating only on the functional efficiency of the product, without having regard to the environmental, social and political conditions in which it is produced. For the ethical consumer the functional efficiency of a product is far from the most important criterion. In the British magazine *The Ethical Consumer*, a bi-monthly magazine which commenced publication in 1989 and is run by a not-for-profit cooperative, brand names are discussed in relation to the companies that produce them. The tabulated analysis is based on a number of issues which include whether the company has any involvement in South Africa; whether the company operates in a country with an oppressive regime; the company's labour relations; wages and conditions of the workforce; the company's environmental responsibility; its involvement, directly or indirectly, in nuclear power or the infringement of land rights; its role in armaments or animal testing; and whether it has been involved in irresponsible marketing that may cause ill health.

The editors of *The Ethical Consumer* and kindred publications, such as *New Consumer*, argue that the world can become a better place through changes in consuming. Ethical consuming, the editors of *New Consumer* believe, can make 'corporate behaviour shift towards creating a more sustainable future. More sustainable in economic and social terms as well as environmentally.'[47] If profits are the prime motivation behind capitalist enterprises, then by not buying a company's goods and so helping to harm profitability, consumers can make a company change its products, and perhaps even its policies, towards political, social and environmental issues. In a sense, this is an updating of the call to 'Workers of the world unite' to 'Consumers of the world unite' – to which might be added 'You have nothing to lose but your chain-stores.' Solidarity and an organized consumer-force can, in other words, bring manufacturers to heel.

And lest one assumes that ethical consuming is practised by only a very small minority, market research reports on British shoppers' ethical stances reveal that nearly 50 per cent of those questioned were operating some kind of boycott or another. For most, environmental issues (over 60 per cent) – primarily the depletion of the ozone layer – animal testing abuses (over 50 per cent), and unacceptable governments in the product's country of origin were the prime reasons for boycotts, but some consumers were still avoiding products from Japan and Germany because of the parts that those nations played in the Second World War.

A prerequisite of action is information, and magazines such as *The Ethical Consumer* provide the basic facts on which consumers can decide whether or not to purchase from a particular company. For even greater detail, *New Consumer* published *Changing Corporate Values* in 1990, a 'guide to social and

CAMPAIGN

AGAINST
NESTLÉ

Stop bottle baby deaths

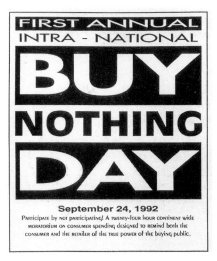

FIRST ANNUAL
INTRA - NATIONAL
BUY
NOTHING
DAY

September 24, 1992

Participate by not participating! A twenty-four hour continent wide
moratorium on consumer spending designed to remind both the
consumer and the retailer of the true power of the buying public.

Baby Milk Action, Campaign Against Nestlé

Baby Milk Action is a non-profit organization which campaigns to 'protect mothers and babies from the commercial promotion of bottle feeding in all countries, and to protect a woman's right to an informed choice'. The Campaign Against Nestlé, co-ordinated by Baby Milk Action in the UK, focuses on a boycott of Nestlé's highest-profile and biggest-selling brand, Nescafé.

Ted Dave, 'Buy Nothing Day', 24 September 1992

'Buy Nothing Day' does not compromise with consumerism; it opposes it. The idea of Vancouver artist Ted Dave, the day is supposed to provide a forum for North Americans who 'feel dissatisfied with the pandering attitude taken by the advertising industry towards the public'. He calls the holiday a 'gesture of protest for those of us who feel as if our lives and dreams have been marketed back to us'.

environmental policy and practice in Britain's top companies'. It included 128 companies, from eleven countries, who handle 40 per cent of our everyday spending. These companies have a worldwide turnover of £1,000 billion. Two thousand branded products, from soap and bread to compact discs and cars, come under scrutiny in the massive, 650-page volume. Few consumers will be willing or able to pay the £48 for the volume, but pocket-size guides akin to *The Green Consumer* have followed.[48]

Some companies fare well in 'ethical' reports; others fare so badly so consistently that consumer boycotts arise. For example, in the United States a successful consumer boycott of Campbells soups in the early 1980s persuaded the company to take greater responsibility for the dreadful working conditions of migrant workers on its subcontractors' farms. Coca Cola was the target of sustained boycotts in 1980 and 1984 when evidence suggested that attempts to unionize its Guatemalan bottling plant were being

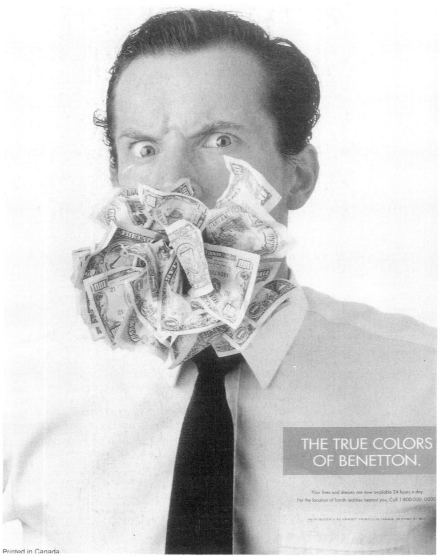

Printed in Canada

**The Media Foundation, 'The True Colors
of Benetton', 1992**
The Media Foundation proclaim that a
'movement is underway in North America – a
fundamental rethinking of our media culture.
It is a battle to regain our mental
environments, to wrest the control of the
airwaves from the $130 billion-a-year-
advertising industry and to create a society that
is media literate and truly free.' The
Foundation publishes sophisticated parodies of
major campaigns to undermine the companies,
'messages in their own terms'.

THE ANTI CONSUMERISM CAMPAIGN.

INGREDIENTS:

.rtch, emulsifier, E421, E362, su
ıore sugar, glucose concentrate, poı,
unsaturated fat, riboflavin, E121, stabi-
liser, E221, E666, flavour enhancer

PRODUCE

OF MANY

COUNTRIES

666349 826661

*Many of which are
starving.*

Anti-Consumerism Campaign
Although sharing similar aims and values to the Media Foundation, the British Anti-Consumerism Campaign fights consumerist values with guerrilla-like tactics, producing photocopied sheets, adding stickers to products, and defacing posters and advertisements.

met with intimidation and even killings. The most 'global' boycott has been of Nestlé for its supposedly irresponsible marketing of infant-food formula in the Third World. *The Ethical Consumer* devotes the back page of every issue to 'Boycott News', which provides updates on boycotts around the world.

The boycott of companies, rather than individual products, is a key difference between 'ethical' and 'Green' consuming. Campaigns against ozone-harmful aerosols, or products using tropical hardwoods or non-recyclable materials, can be very effective in changing the design or constituent parts of a particular product, but they might not affect a company's other products. The obvious shortcoming with reviewing products rather than companies is that some environment-friendly products may be produced by companies with a less than environment-friendly corporate record. The Green consumer approach does not always consider a broad enough range of concerns. A company might be using environmentally harmful materials and processes of production for other products it manufactures; it may be exploiting its workforce; or it may be investing its profits in armaments or undemocratic regimes. The editors of *The Ethical Consumer* convincingly argue that:

> Individuals can only begin to control events around them when they know who is doing what, when and why. The existence of brand names and brand images which conceal the real producer cannot be assisting this type of knowledge. Green consumerism, by failing to lift the veil of brand-name products, maintains a degree of ignorance among consumers. Combating this ignorance may be crucial to the evolution of real consumer power.[49]

This is a valid criticism. However, the editors acknowledge that 'the simplicity of green consumerism's brand-name approach may have contributed significantly to its mass appeal'; it can, therefore, be seen as an important phase in the development of the public's awareness that consuming is political.

Green supermarket guides and magazines like *The Ethical Consumer* threaten to turn what used to be a relatively simple sequence of purchases into a complex series of ethical discriminations and angst-ridden transactions – all of which require a dossier of factual information and an up-to-date knowledge of world events, political struggles, social injustices and environmental effects. But, at the very least, 'ethical consuming' helps to make people realize that consuming is a political act – it may even be the nearest most people come to feeling they are active participants in the political process. This is a point made by the editors of *The Ethical Consumer*:

> One of the most attractive features of an 'electorate' of politically informed consumers is that it devolves decision-making power to individuals. It has all the

usual flaws of a democratic structure – such as poor provision for minority interests. However, unlike general elections, where individuals are asked to express their opinions once every five years, radical consumers have the opportunity to vote five times a day.[50]

Ethical consuming may be the most promising manifestation of participatory democracy in recent years, but it may also be, as the editors of *The Ethical Consumer* admit, a reaction to the failure of Western politics, because 'consumer boycotts or radical consumer action tend to appear when normal political processes seem to be failing.'[51] For the most part, however, the activists realize that ethical consuming needs to be in addition to, rather than a substitute for, the conventional political processes.

Ethical consuming can, none the less, be seen as unmistakably political. At the time of the Gulf War, the editorial of *The Ethical Consumer* was much expanded to discuss the direct relevance of consumers' choices to the War. The anti-War, pro-sanctions lobby included ethical consumers who argued the 'enormous potential of using the [international] marketplace as a force for change'.[52] Here, it was felt, was the chance for a consumer boycott – international sanctions – on a scale which could alter world history. In retrospect, this was over-optimistic, but it provided a focus of attention that enabled the ethical consuming organizations to clarify their political position. The editors of *The Ethical Consumer* concluded that 'Ethical consumerism is essentially a pacifist philosophy. It argues that the marketplace is a vast untapped resource that people can use to express their ethical and political beliefs in a *non-violent* manner.'[53] Furthermore, companies which invested in unstable regimes such as Iraq would be boycotted. The editors also argued that the war capacity of the allies might also be the subject of attack from ethical consumers. Companies which produced armaments – such as General Electric – would have their non-military products boycotted.

Consuming or, rather, *not* consuming a particular product is actually a more ambiguous statement than not voting for a political party: as a consumer, your reason for not purchasing a particular product may be either because the product is not to your taste or liking, or because, even though you like the product, you disapprove of the company on some ethical ground. If the company is going to change its ethics rather than its products, it needs a clear signal about the reasons for the non-purchase, and this demands an active, letter-writing, even banner-waving brand of consuming. One ethical consumer suggests the following standard letter which could be sent, with relevant clauses ticked or crossed-out, to the manager of the store:

This is to let you know that while shopping at your store this week, I made a conscious decision not to buy:

1 ...

2 ...

3 .. because

– it may endanger my health
– it causes damage to the environment during its manufacture, use or disposal
– it causes unnecessary waste because of over-packaging
– it uses materials derived from threatened species or environments
– it involves cruelty to animals
– it adversely affects others who are struggling for justice
– I support the international boycott against its manufacturers.

I have nothing against your establishment, which I will probably continue to patronize, but I do this in the hope that you will convey my sentiments to the supplier of the item(s) in question. I believe that small actions such as the one I have taken and the one I invite you to take, do help in the long run to make the world a better place for all.[54]

The design profession and social responsibility

Design ought to be one of the professions at the forefront of 'making the world a better place for all'. Designers claim a status as 'professionals' but, unlike doctors whose ethical code is unambiguous and outward looking, designers often opt for commercial rewards, and the kind of celebrity stardom in their 'professional' press that makes them considerably closer to entertainers and salesmen than doctors or teachers. In Britain, the Society of Industrial Artists and Designers changed its name in 1987 to The Chartered Society of Designers 'to reflect', as a press release claims, 'its enhanced status and more positive and modern identity'. It further claims that the society 'is primarily concerned with promoting standards of competence, professional conduct and integrity within the design profession; [and] the establishment of the profession's interests in government and on official bodies.'[55] And yet the Society's official Code of Professional Conduct is extremely brief – and partial – in its general clause dealing with the designer's professional responsibilities. 'Designers', it specifies, 'work primarily for the benefit of their clients or their employers. Like everyone engaged in professional activities, designers have responsibilities not only to their clients or employers but also to their fellow practitioners and to society at large.'[56] The Code goes on to detail, in ten clauses – exactly half the clauses of the complete code – the designer's 'primary' responsibility, leaving the reader in no doubt that the terms 'client' and 'employer' are here synonymous. The term 'client', in other words, does not refer to the user, recipient or purchaser of the product or service, but to the designer's

employer. The final five clauses – the remaining four not referred to here are merely introductory – deal with 'the designer's responsibility to his [sic] fellow practitioners' in terms of fair play, plagiarism, and critical opinions. Apart from the seemingly tacked-on reference to 'society at large' in the general clause about the designer's responsibilities, no mention is made about professional ethics and wider responsibilities.

One commentator regards any desire that designers might have to be thought of as members of a profession as being detrimental to their personal interests because 'they probably won't achieve it without saddling themselves with some of the restrictions that bind other such professionals.' Designers who work for the private sector:

... stand to gain greater financial rewards than almost all doctors, for example, *because* they are operating within a world where profit is the prime motive and a highly flexible, if strictly legal, set of unwritten rules are based primarily on encouraging the creation of wealth. Designers' codes of conduct paradoxically attempt to justify the endowment of professional status while trying not to restrict business opportunities.

An equivalent Hippocratic Oath for designers would be incompatible with the business activities that the practice of design now inevitably involves . . .[57]

The American equivalent of the CSD's code of conduct, published by the Industrial Designers Society of America (IDSA), includes a series of clauses of ethical practice. The first of the nine deals with the designer's responsibility to the public, stating that 'we will participate only in projects we judge to be ethically sound'. IDSA has also set up an 'Ethics Advisory Council' to deal with wider issues about the responsibilities of the designer. The ICOGRADA/ICSID/IFI (International Council of Graphic Design Association/International Council of Societies of Industrial Design/International Federation of Interior Architects and Interior Designers) Code of Professional Conduct also places the designer's 'responsibilities to the community' before her/his responsibility to the client.

Many designers in Britain feel no need for a professional code. Indeed, most designers apparently feel that there is no need for a professional society, because most are not members. Following the design boom of the 1980s, governmental deregulation and the growth of enterprise culture, it is probably the case that the majority of designers think of designing as a business rather than a profession. This is not necessarily to be regretted if it makes society clearer about what it can expect of designers. But now that more and more designers are coming to realize that the values of marketing-led design are detrimental to the health of contemporary and future society, it is crucial that those with a fully professional outlook face up to the issue of ethics and the designer's role in society. Otherwise – to twist one of its most common definitions – design will remain a problem-creating activity.

4 Feminist Perspectives

Critiques of patriarchy

As contemporary feminism began to gather momentum following the radical political and social questioning of the late 1960s, it seemed inevitable that consumerist design would be confronted head-on in feminist critiques. For, if design was an expression of society, and society was patriarchal, design would reflect male domination.[1] Following on from the more general critiques published in the late 1960s and early 1970s – such as Kate Millett's *Sexual Politics* (1969), Eva Figes' *Patriarchal Attitudes* (1970), and Germaine Greer's *The Female Eunuch* (1970) – which concentrated on society's social and political construction of femininity, a strand of feminist criticism focussed on the contexts and ideologies in which consumerist design operated. The use of gender stereotyping in advertising – as discussed, for example, in Judith Williamson's *Decoding Advertisements* (1978) – was relatively easy prey because it was so blatant; a more complex subject was the various forms of 'women's work' in the home. Books such as Ann Oakley's *Housewife* (1974), and Ellen Malos's book of extracts dealing with *The Politics of Housework* (1980) exposed the underlying patriarchal assumptions about housework and the role of women.

Two keyworks of this strand of feminism in the early 1980s – one American, one British – were Ruth Schwartz Cowan's *More Work for Mother: The Ironies of Household Technology from the Open Hearth to the Microwave* (1983) and Caroline Davidson's *A Woman's Work is Never Done: A History of Housework in the British Isles 1650–1950* (1982). Both brought into focus the relationship between housework and the development of domestic technological items such as washing machines, irons and microwaves. Also from the United States was Dolores Hayden's *The Grand Domestic Revolution: A History of Feminist Designs for American Houses, Neighbourhoods and Cities* (1981), while in Britain, Leonore Davidoff and Catherine Hall's essay on 'The Architecture of Public and Private Life' (1982) informed the feminist debate. Marion Roberts's *Living in a Man-Made World* (1991) has added a highly valuable British perspective to this earlier work.

Paralleling these studies, feminist design histories attempted to redress some of the bias that had resulted from a patriarchal view of history. One of

the first books, Isabelle Anscombe's *A Woman's Touch: Women in Design from 1860 to the Present Day* (1984) was critically berated by most feminist design historians because it failed to question the underlying male values and assumptions about design practice and history. A similar reception greeted Liz McQuiston's *Women in Design – A Contemporary View* (1988), which merely profiled a number of female designers without questioning the foundation of femaleness in relation to design and the design profession. The various conferences and discussion groups on the theme of women in design gave rise to the more recent *A View from the Interior: Feminism, Women and Design* (1989), edited by Judy Attfield and Pat Kirkham, which presents a series of essays that map out the issues that are pertinent to feminist design and history.

The 1980s also saw the development of specialist feminist architecture and design groups. The Feminist Design Collective, started in London in 1978, was formed with the aim of understanding and developing a feminist approach to architecture through discussion and practice. The group transmogrified into the Matrix collective in 1980, continuing the aim of providing advice, information and designs for, among others, women's community groups. Their *Making Space: Women and the Man-Made Environment* was published in 1984. Matrix were able to offer free advice while they were funded by the Greater London Council, whose Women's Committee also addressed a range of issues directly that affected women in the built environment. The Women's Design Service (WDS), an information and resource centre on women and the built environment, publishes a magazine, *WEB*, subtitled 'Women and the Built Environment', which deals with such issues as housing, leisure, children's play spaces and crèche facilities. The Women's Environmental Network (WEN) is a pressure and campaign group that was formed in 1988 'to give ordinary women clear information about the environmental problems that affect them specifically – like consumer goods, pregnancy and radiation, things you eat and buy every day, the transport system and development plans.'

In spite of the enormous importance of feminist critiques of design, and in spite of the wealth of books on various aspects of feminism in the last decade, depressingly little has been published specifically about feminist design. Some major contributions to an understanding of feminism and design, including Phil Goodall's 'Design and Gender' essay (1983), have been tucked away in relatively esoteric, small-circulation journals such as *Block*. *Feminist Arts News* (*FAN*) devoted an issue to design in 1985 but, again, its circulation is small. One could argue that this relative paucity of material is healthy, in that feminism should not be packaged into discrete areas of activity such as 'design': to attempt to do so is to fall into the male academic practice of separation through specialization. Because the major feminist

issues are all-embracing and holistic, design should not be discussed in isolation.

The counter-argument is more convincing: design should be directly discussed because, according to the editors of *FAN*'s issue on design:

> . . . design is so pervasive in our lives. We sit on it, live in it, eat off it, work with it, read it, see through it, wear it. As a branch of professional expertise design works on environments, objects and images. It's also an everyday activity that most of us engage in. Design has an economic role and social effects. Since the processes that lead to the formation of commodities are crucial to material culture, design as a terrain needs to be understood. Particularly by women, as we live in a material world largely not of our making (though with consent) and our role is predominantly to respond or consume rather than one of initiation and production.[2]

Furthermore, design tells us about the society in which we live. It should be studied, in the words of the design historian Cheryl Buckley, because it 'is a process of representation. It represents political, economic, and cultural power and values . . . Designs, as cultural products, have meanings encoded within them which are decoded by producers, advertisers and consumers according to their own cultural codes.'[3] Nor, in Buckley's view, is it the case that work on feminism and design is not being undertaken, it's just that it 'rarely seems to get published'.[4]

Books about design, as any cursory visit to a bookshop will reveal, almost invariably deal with 'star' designers (usually male), historical design movements (which show a male bias in their conventional, patriarchal approach), or professional, male-determined organizations and activities. This is even true of fashion design, which is traditionally associated with women and which is certainly more actively practised by women designers than industrial product design. Until the publication of feminist books on fashion, such as Elizabeth Wilson's *Adorned in Dreams: Fashion and Modernity* (1985), fashion books upheld and promoted *feminity* (with its connotations of decorativeness and triviality), as opposed to *femaleness*, as the essence of female clothing.

Buckley's advice to design historians is equally valid to those writing about contemporary design: 'one of the main issues for historians to tackle . . . is patriarchy and its value systems.'[5] This includes the terms and processes by which inferior status is assigned to certain design activities. The ideological nature and implications of terms such as 'feminine', 'delicate' and 'decorative' within the context of women's design need to be understood and challenged. Second, it is crucial that design historians recognize the patriarchal bias of the sexual division of labour which attributes to women certain design skills on the basis of biology. Third, in Buckley's words, design historians must acknowledge that women and their designs fulfil a 'critical structuring role in design history in that they provide the negative to

the male positive – they occupy the space left by men'. And finally, historians should take note of the value system which gives privilege to exchange-value over use-value, because at a very simple level, as Elizabeth Bird has pointed out, 'the objects women produce have been consumed by being used, rather than preserved as a store of exchange-value. Pots get broken and textiles wear out.'[6] If we examine consumerist design from a feminist perspective, then both inadequacies in its functional performance, and certain implicit values and meanings, become ever more apparent.

Gender stereotyping

The two major feminist criticisms of marketing-led design are that it stereotypes women in a sexist way, and that it disregards women as end-users. The two criticisms are interrelated because both result from a patriarchal society, in which women are granted an inferior status to men.

Gender stereotyping, as mentioned above, has always been most readily observable in advertising. Women are usually depicted as mothers, cleaners, cooks or beautiful appendages; that is, in a serving and/or servile role. They represent the general carer or dutiful servant who maintains order so that others (men and children) can get on with their lives; the provider of sustenance and primary needs; or the sex object who underlines a man's status, power or attractiveness. Women in advertising act as if the latest washing powder, floor cleaner or deodorant is the ultimate answer to their existential problems on Planet Earth. They provide *meaning* for a product both in terms of its supposed necessity and its apparent level of success: 'advertising creates both an ideal use for a product and an ideal user.'[7] And if the ecstasy does not derive directly from a product, it is implicitly suggested by means of a woman's sexual attractiveness and availability, that it will be unleashed by the man who buys the new car or aftershave. A product's meaning is determined by its social, cultural and political context. Advertisers are well aware of this: advertising is an attempt to create or enhance meaning via association or evocation. It is a way of making the product more desirable because of its 'added value'.

It has always been a limiting view to think of design as a straightforward problem-solving activity. Products are not – and, in consumerist society, certainly not – bought just to fulfil primary functions or use-value. They are also bought to confirm status, confer prestige and, in a general sense, to satisfy longing (if only temporarily). It might be argued that many products – such as washing powder – are not intrinsically stereotyped. This is true but, in a consumerist society, it is not possible neatly to separate out a product's function from its image, or its use-value from its exchange-value. Unless you have somehow contrived to cocoon yourself from the media and advertising,

when you buy a product you are consuming a total mix of the product and its meaning. And it is the advertisers' and marketers' hope that – as in the case of a lifestyle product like Coca Cola – *they* have fixed the meaning so that it will have the maximum effect in the marketplace. This may all, of course, be obvious to the reader, but it is necessary to make the point that the meaning of a product cannot be derived solely from an analysis of its particular form and decoration. Most contemporary cultural critics would deny that we can enter an art gallery – let alone the marketplace – with a disinterested aesthetic faculty attuned to abstract form, as Formalist critics might have supposed. We take to an analysis of any consumerist product external societal and cultural factors that shape our perception and understanding.

Washing powder may not be intrinsically stereotyped – even its packaging and graphics may be gender-free – but many products wear their stereotyping as blazenly as a sloganized T-shirt. Any shop or catalogue with a range of product lines will almost certainly offer 'feminine' versions of a product. Mugs with delicate and detailed pictures of flowers or sentimentalized cuddly animals, and casserole dishes and saucepans with romantic images of nature in contrived patterns or vistas, are all aimed at the conventional 'feminine' woman. Products associated with cooking or the kitchen – the 'woman's realm' – are often treated in this unsubtle way. The situation is more complex when it comes to technological products. If the product is located in the kitchen, such as a toaster, it is likely to receive the same 'feminine' graphic treatment, especially as kitchen accessories are increasingly graphically co-ordinated.

[Personal technological products utilize form and colour to denote femininity or 'difference'. The woman's electric or battery-operated shaver, for example, is a relatively recent product development compared to its male counterpart. Male shavers are almost invariably 'masculine': matt black and/or silver, sometimes with red-line highlighting like a sports car; monolithic and chunky; and sometimes with a 'rugged' texture, supposedly to improve handling. Apart from the different location and different coarseness of body hair, shaving is essentially a common activity and the electric shaver could be a unisex product – the extra power that the male shaver needs for facial hair would not damage female skin, and the ergonomic differences of design resulting from body location are minor (some female shavers are ergonomically identical to male shavers). Yet most female shavers are clearly gendered through colour (white for purity or hygiene; or colour for fashionability) and form (less monolithic, more curved, and more 'elegant'). So whereas male electric or battery shavers signify technology and powerfulness (and so masculinity), female shavers connote hygiene, prettiness and fashionability (and thus femininity). The norm is, needless to say, the male shaver: the female shaver, in departing from the

norm, reinforces women as 'different'. Beyond mere product design and styling, the whole question of female shavers raises the feminist issue of depilation. Women are indoctrinated to remove visible body hair because of its direct confirmation of body processes, and because the smooth- and silky-skinned female body, associated with the pre-independent female child, constitutes the 'feminine' ideal. This time-consuming and, for many feminists, pointless and reactionary activity adds to the burden of women's labours. Manufacturers would argue that they were only responding to consumers' demands, but this misses the point that these 'demands' are socially constructed and developed. The rise of the female shaver, a marketing and economic triumph, demonstrates the anti-feminist tendencies of consumerist design: upholding gender stereotyping and maintaining social pressures.

The comments about the design and styling of the female shaver show that to stereotype femininity as simply images of flowers and furry animals is inadequate. Marketing theory – as we saw in the first chapter – now recognizes socio-psychological categories of consumers rather than categories based on type of work and income. 'Mainstreamers' may read romantic novels, show considerable loyalty to 'big name' brands, companies and retailers, and be attracted to conforming and confirming imagery such as flowers. Other groups have other tastes which are equally 'feminine'. 'Aspirers', for example, will seek the fashionable and socially prestigious and so may, in the case of shavers, purchase a Braun-like design of pure form and simplicity which is less overtly feminine, but ultimately still strongly gendered. 'Reformers' constitute the group most likely to reject marketing-led design and its stereotyping, but 'reformers' are still consumers and, like 'Green consumers', seldom reject consumerism as a system.

Gender stereotyping in clothing is the most fully researched and well-documented area of feminist critiques of design. Clothing is probably the most visible means of giving form to gender construction and femininity. Feminine clothes are 'pretty', 'delicate', 'decorative' or 'sexy'; they are designed for the satisfaction of the (male) viewer rather than the comfort of the (female) wearer. Laura Ashley clothing, for example, has endorsed femininity, albeit a slightly shifting vision of femininity, throughout the 1980s, from images of rural simplicity, through the 'romance [and] understated femininity' of patterns with 'the most delicate mix of lace and flowers', to 'Edwardian-inspired' formal ball-gowns which are 'well-mannered, elegant, sensual and flattering . . . happy at the smartest cocktail party, the finest restaurant, or the most intimate dinner for two.'

Clothing does not only signify femininity visually, but also helps to determine it physically: many clothes are designed not only to look feminine, but also to consolidate feminine body-movement and language. Elaborate

garments may restrict movement or bring about discomfort or exposure if a woman moves in anything but a careful or demure way. Shoes are often neither ergonomic nor comfortable and subvert natural balance. They are also often flimsy and would fall apart easily if used for much more than standing in. Generally, feminine fashions constrict and inhibit movement while male fashions facilitate movement and activity. The feminine woman poses silently and statically; the masculine man is boisterously active. And fashionableness usually means a series of absurd manifestations of femininity. Some feminist writers argue that to reject fashion in favour of purely sensible and functional clothing (even if the functions – which implies particular activities and roles – are determined by women rather than men) is a puritanical denial of a creative expression. The fact that men have become less ashamed of admitting their participation in fashion and, more importantly, the rise of 'female' fashions which do not conform to feminine models – such as comfortable but inelegant shoes, and clothes which do not restrict or impede – show that femaleness is not necessarily incompatible with fashion.

Predictably enough, gender stereotyping percolates down to children's clothing; indeed, it is in this arena that it is most marked, in spite of the fact that children's bodies are less differentiated than adults. One interesting recent example is from one of the slightly more enlightened firms associated with 'aspirers'. The front of their catalogue illustrates the post-macho 'new man' caringly and lovingly protecting his baby. While the cover image may have broken with the stereotypes associated with children's clothing cata- logues, the inside pages showed that the change was little more than cosmetic. Images of girls in decorative or over-elaborate costumes, passive and coy, contrasted with boys in workaday clothes or activity outfits running, jumping or role playing at explorers or – in one case – mechanics, complete with smeared axle grease on their foreheads!

Toys are a crude and blunt microcosm of the adult world and its stereotypes. Girls' toys frequently promote patience (embroidery kits), grooming expertise ('My Little Pony') and care (nurses' outfits); they can be played with quietly and with little physical movement. Boys' toys are based on war and action; they encourage physical activity and noise. The activities related to boys' toys suggest a spreading area of space, while girls' toys are contained within an enclosing space: 'Action Man' (and his contemporary derivatives) take off in helicopters and space ships; 'Barbie' (and her friends) keep their spotless home in order awaiting the return of Ken. Her extended space is nothing more than the glittering ball, either at Ken's side or as a venue for meeting the Ken of her dreams.

Companies producing stereotyping marketing-led design would no doubt argue that they are providing what the public demands; this demand provides the meaning and validation of consumer- and marketing-led design. This

argued that the profitability of many such
.e so. If the public demanded non-stereotyp-
..nies would happily provide it. But, because of its
..ety is hardly likely to demand it, and so marketing-led
,or role in upholding the socially and culturally reactionary

Women as users

The second feminist criticism of marketing-led design is that many products are badly designed in relation to women as users. In some cases products are so badly designed that they cause long-term injuries. Nurses, the feminist architect and designer Rosy Martin points out, 'suffer from back injuries – it is the major reason for leaving the profession – yet where is the work on efficient patient-lifting machines?'[8] In a paper written for a conference on the 'Organisation and Control of the Labour Process', Margaret Bruce rightly complains that:

. . . irons are uncomfortable and heavy to use for sustained periods of time, tools for putting up shelves and mending cars are often heavy and are designed with the 'macho' man in mind, foodmixers are clumsy, awkward to clean and clutter up work-tops, and fridge door and seals perish long before the useful life of the appliance has ended.[9]

The reason is, as Bruce goes on to demonstrate, that the vast majority of products are designed either *by* men (producers) *for* women (consumers), or by men for men. When consistent and regular, the effect on women can be as damaging psychologically as physically: 'Women may be put off using power tools, such as drills, because they are heavy, unwieldy', writes Goodall:

[we] tend to assume that if we can't use them properly it is our fault, rather than a design feature that does not accommodate to our physical needs . . . Far from being designed in the light of scientific investigation into differentiated use, much familiar machinery originated in an industrial context or by rule of thumb, based on masculine experience. All too often men are content to let us go on thinking it is our incompetence rather than divulging their knowledge of tools in use which makes their capacities visible.[10]

This kind of experience confirms the negative attitude to machinery, equipment and technology that many women form during childhood and school, and which is reinforced by advertising and design in consumerist, patriarchal society. Cynthia Cockburn, in an essay about technological processes and productive machinery, questions whether the bias of male designers is conscious or 'planned':

This need not be conspiracy, it is merely the out
power. It is a complex point. Women vary in bodi.
vary in orientation, some having learned more cor
than others. Many processes could be carried or
smaller or less muscular operators or reorganis
of the 'average' woman.[11]

Cockburn's general point about machine
directly applied to Bruce's complaint at
be insensitive designers for women as u.
ing the physical characteristics of wome
women feel as 'at home' with advanced tech
majority will have developed less confidenc
processes.

The result of this, according to Cockburi
muscle, capability, tools and machinery by m ..ce of
women's subordination, indeed it is part of the _, wnich females are
constituted as women.'[12] It is not insignificant that it is almost always the
male who controls the remote control unit of a television (power through
technology); and who learns how to programme a video recorder (control
through technology). Male familiarity with technology partly acounts for the
relative expertise of men with videos, but the fact that women can master – it
is interesting to note how ludicrous the word *mistress* sounds in this context –
a sewing machine (which men usually find unfathomable) shows that
machine expertise is not absolute but gendered (sewing machine = 'fiddly'
= female/'women's work'). Furthermore, in the case of the video recorder,
the male is likely to have had time to learn the operations while the female
was busy with cooking, washing up, or getting the children ready for bed.
The example of the video also raises a related design and women issue: with
the advent of videos, entertainment and leisure has shifted to the home, so
further 'imprisoning' many women.

Women as providers

A product's implications and meaning cannot, therefore, be isolated from its
social context. In no area of design is this more apparent than in the design of
'labour-saving' equipment. It is now a well-rehearsed argument that, since
the advent of equipment and products marketed as cutting down the
housewife's workload, the number of hours worked by most housewives on
household and family chores has not only not decreased, but has actually
risen.[13] This is not surprising in relation to the inter-war period, when the
'servantless home' was becoming the norm in comfortable middle-class
circles, but it is a less predictable phenomenon for the post-war, consumerist

period when the catch-phrase 'labour-saving' was employed with almost monotonous regularity in the marketing of household equipment. In fact, the housewife's workload climbed from 70 hours a week in 1950 to 77 hours twenty years later.[14] Ann Oakley in her research concludes that 'the amount of time housework takes shows no tendency to decrease with the increasing availability of domestic appliances, or with the expansion of women's opportunities outside the home.'[15] Nor is there any evidence to suggest that this trend has reversed in the last twenty years.

The increase is partly related to expectations: the *qualitative* demands of 'women's work' have increased. Cowan describes the change from housework as a chore to:

> . . . something quite different – an emotional 'trip'. Laundering was not just laundering, but an expression of love; the housewife who truly loved her family would protect them from the embarrassment of tattletale grey. Feeding the family was not just feeding the family, but a way to express the housewife's artistic inclinations and a way to encourage feelings of family loyalty and affection. Diapering the baby was not just diapering, but a time to build the baby's sense of security and love for the mother. Cleaning the bathroom sink was not just cleaning, but an exercise of protective maternal instincts, providing a way for the housewife to keep her family safe from disease.[16]

Housework acquired psycho-social meaning for the housewife through consumerist marketing and advertising.

In particular, expectations about meals changed in keeping with social mobility and consumerist values. Holidays abroad became more common from the 1960s; different types of restaurants based on national cuisine or specialist diets – for example, vegetarian – expanded the palette; and magazines and colour supplements bombarded their readers with mouth-watering but time-consuming suggestions to break away from the monotony of 'meat-and-two-veg'. Not only did a new vocabulary and grammar of cooking have to be learned, but a new range of equipment was necessary to grind, shred, liquidize and pulverize. A mixer became an 'essential' kitchen machine because it carried out difficult functions speedily, but it also brought with it fiddly and difficult cleaning needs. Goodall makes a telling point: 'The use of mixers to provide omelettes for 200 saves time, and effort. With the same operation for a family of four a proportionally large time is spent preparing the machine for use.'[17]

The microwave cooker is another product which can actually increase workload, although it is supposed to increase convenience and lessen time. Instead of the family sitting down to eat the same food together at one time, the microwave is sold as providing 'flexibility', which means, in effect, that different members of the family can eat different meals at different times. If labour is spread across the family, the housewife's workload will be

decreased, but if she is expected to take control of all the meals, then her time is eaten into. The advantage and flexibility of the microwave is gained by the consumers (the family) at the expense of the producer's (the housewife's) time. Feminist critiques of labour-saving devices seldom suggest a wholesale ransacking of the kitchen. For Judy Attfield, 'It is one thing to discuss how masculine technology which produced household appliances has not really liberated women from the home, but quite another to throw away our automatic washing machine.'[18] Technology has clearly brought benefits to the quality of life, but it is certainly not neutral in its effects and implications, especially when it comes to gender roles in a consumerist, patriarchal society.

Style and gender

The two major feminist criticisms of consumerist design – that it stereotypes and that it is badly designed for women as users – frequently overlap. The visual appearance of many consumerist items, especially the technological items, compounds gender difference and discourages or alienates potential or actual female users by making the devices look more difficult to use than they actually are. A colleague puts it this way:

> Many products I find alien and therefore inaccessible because of the way they *look*. Cars, stereo- and video-equipment is designed for male customers: shiny, black, hard-edged, machine-like, technological. Women do use machines but they have a less-aggressive look, e.g. vacuum-cleaners, cookers, sewing machines, and some unisex typewriters. Machines used by men are considered 'technology'; whereas women's machines are not.[19]

There is, however, a danger that while men's consumerist technology appears mysterious and technologically advanced, women's consumerist technology could merely be packaged in some other, equally formulated way. Sometimes the ergonomic appearance of men's design indicates that this design is being designed ergonomically; whereas consumerist design for women looks less ergonomic because it is more 'feminine', and is poorly made. My colleague again:

> Men's tools – such as DIY – are taken seriously and designed sturdily; women's tools are not. Vacuum cleaners, brooms and dustpans are plasticy, flimsy and brightly-coloured with 'taste' in mind in spite of the fact that women use these tools much more frequently than, say, a man might use a power drill or hedge-trimmer. These items are not made to the same standard.

The last few years have witnessed a partial reaction against overtly macho styling, and even ergonomic appearances, in favour of what has variously been called 'sensorial'[20] or 'soft',[21] in which sensual qualities have been given greater import. But the arrival of what might be considered a more

l. hnology has to be treated with caution. Martin claims
th.

This 'hard' forms and manifestations of technology, the
hard-· ards a consideration of the sensual, comfort response,
subjec ·d since it implies a greater understanding of people's
psychoi eds. On the other hand, it also highlights the
marketing or sucn ~~~~~·l pleasures as commodities and this addition of a
'feminine' ingredient to product design is most certainly *not feminist*.[22]

'Soft' styling, in other words, may be just another superficial consumerist
aesthetic which ignores all the basic feminist issues – it may be no more than
femininity for designer-consumers. 'Soft' styling may indeed utilize an
approach to ergonomics that is more inclusive and which deals with
psychological and psycho-social factors. However, the commodification of
perceived needs or desire, which Martin refers to and which lies at the heart
of marketing-led design, may remain unquestioned and unchallenged.

An interesting example of function, form and gender is illustrated by
Bruce. She examines a range of prototype irons that were created by male
and female industrial design students in response to an identical brief,
arguing that the 'female student's prototype has taken into account the fiddly
bits – ironing sleeves, gathers, tucks – so that the rounded top reaches the
places other irons can't.'[23] She concludes that the 'male designer was much
more concerned with "style", the female with "user need", namely, the
problem of ironing sleeves and making a compact iron'.[24] Whether this
particular distinction would be upheld by further analysis is less important
than the general point that Bruce is making: the different approaches of the
students arise out of their respective 'successful' induction into gendered
roles in a patriarchal society.

Designing with 'tacit knowledge'

What usually happens, because of the paucity of female industrial designers,
is that women's 'tacit knowlege' is not drawn upon. Design methodologists
acknowledge that 'tacit knowledge' is an essential component of the skills
and qualitative decision-making processes of designers. It is the difference
between 'knowing what' and 'knowing how': the former refers to the
explicitly stated rules of doing something; the latter is the implicitly and
internalized knowledge of doing something. 'Tacit knowledge' is knowledge
'we know but cannot tell'; it is intrinsically non-verbal, is derived from
experience, and often makes the difference between doing something in a
satisfactory manner, and doing it well. Anyone can learn what to do by
following the rules or instructions for an activity such as cooking or playing

tennis, but it is only once you have internalized the rules ar
for the activity, based on experience and the need for j
tuning', that you are likely to do it well. Of course, the crit
success in an activity may vary. This is indeed what hap|
designers applaud other male designers and award prizes
ally breathtaking, but often functionally mind-numbing, oɔ,ᴄ ᴜᴄ. ᴀ11
iron, to return to a previous example, may be aesthetically pleasing and visually
sophisticated by the standards of a classical aesthetic, but it may still be poor at
coping with the 'fiddly' bits of a sleeve. Men's 'tacit knowledge' may be at its
best when dealing with the visual discriminations and niceties of abstract form,
whereas women's 'tacit knowledge', because of their socialization and
experience, may relate more to an object's use and/or 'meaning'. Of course,
this is not to say that a female designer can never be as inspired as a male
designer in the realm of abstract form: individuals often confound their
socialization, or may occasionally even manage to avoid it entirely. At the other
extreme, women may be socialized into a male preserve, and thus become
'honorary' members, and play by male rules. This, in effect, is the option open
to female industrial designers.

Designing in a man's world

Industrial design is a man's world – literally. Only about two per cent of
British industrial design graduates are women. Women tend to enter the
traditionally female/feminine realm of fashion and textiles and, to a lesser
extent, graphics and illustration (where there is a balance of genders). Male
students heavily outweigh female students in interiors, furniture and ceramic
courses. The percentage gets worse when one looks at the design industry, in
which less than one per cent of industrial designers are women. The Design
Innovation Group's work between 1982 and 1984 on British manufacturing
companies employing from twenty-five to two thousand people showed that
in a typical sector (office furniture), 72 per cent of firms employed in-house
industrial designers, but only one company employed a woman in this
capacity. International comparison found that a similar situation obtained in
European companies, although 20 per cent of the industrial designers
employed by Japanese companies were female. Of the forty-three inter-
national female designers in McQuiston's book, *Women in Design*, only a
handful identified themselves as industrial designers, and none mentioned
or revealed feminist or female concerns in her statement or the designs
depicted in the book. (To back up the Design Innovation Group's findings,
virtually half the selected designers worked in graphics or animation.
Fashion design, where some of the most feminist designers might have been
located, was not even included in the book.)

The quantitative situation of women in industrial design may improve in the later 1990s as the competition for jobs slackens, due to demographic changes, and women have more opportunity to resume careers in their middle years. Schools and colleges may also change the way that they approach or market design to make it less technical and masculine. However, there is still little prospect of equal numbers, and females are likely to remain a definite minority, as will female tutors. The unwritten rules of the game are likely to remain masculine and so, as Bruce and Jenny Lewis lament:

Women working in such male-dominated environments cannot relax and 'be one of the boys', are not privy to the private conversations and networks of the men and so do not have the same support channels as their male colleagues and so on. This is by no means a trivial point, as it determines who gets on and who does not in career terms.[25]

In the Design Innovation Group survey previously cited, industrialists unambiguously voiced their perception of industrial design as being 'a job for the lads': 'Consistently, product design was described as "technical", "dirty" and "industrial" with the implication that this profession is not suitable for women. The work requires the ability to liaise with production engineers "who would not take orders from or listen to a woman".'[26] Patriarchal attitudes will inevitably change more slowly than material conditions.

The last quotation begins to give some indication of the qualitative situations of women working in industrial design. The professional and organizational structure of marketing-led industrial design consultancies is especially male-dominated, making great use of male networks and male bonding which heighten women's disadvantages. Hours are long and unpredictable and a young aspiring designer has to demonstrate total commitment and boundless energy to meet client and project requirements. A female designer trying to manage both a career and a family in such circumstances will be enormously disadvantaged; as career breaks are unheard of, women tend to find themselves trapped at lower levels of the profession.

The culture of design

But it is the professional ethos of marketing-led industrial design which is so profoundly anti-feminist. 'The culture', write Bruce and Lewis, 'is entrepreneurial – everyone competing individualistically for more money and more recognition, in terms of write-ups and rewards.'[27] Many young designers in the consultancies reflect the naked egotism and brazen ambition of enterprise culture. Feminists reject the value system that underlies this attitude.

Bruce claims that because women are 'invisible' in the industrial design profession, and their 'tacit knowledge' not drawn upon, 'designs and markets which meet women's needs and concerns are underdeveloped.'[28] Would more women in design mean the growth of feminist design? Or are feminist and marketing-led design incompatible? Can consumerist design serve feminism and provide the goods and services that women believe would create an egalitarian and caring society? The fundamental conflict of values was highlighted in a 'face to face' conversation, transcripted in *Creative Review*, between Rodney Fitch, then managing director of what was once Britain's biggest design consultancy, and Jos Boys, a member of the Matrix group. The conversation focussed on the mid-1980s retail design boom, and whom it benefited. Boys identified the fundamental issue as:

. . . the relationship between people and the places they use and live in . . . A lot of the environment is treated just on the level of appearances. Design becomes a series of events you pass through once. The city becomes a chaotic place, full of random, uncontrollable events, which can either excite you or alienate you depending on your resources. Whether or not you have a car or money affects your relationship with the environment.[29]

Boys's starting point is people, who may or may not desire to consume. Fitch's response, which is a claim that the retail environment responds to 'customer needs, and the intelligibility of the design environment',[30] presumes as its starting point the customer or consumer. The difference is significant and resurfaces at other times in the conversation. When Boys complains that his account of design turns 'everyone into consumers', Fitch retorts:

The problem with turning people into consumers is only a problem if you believe people shouldn't have things. I think people should have better things, lots of things, the more the better. The moment you think they shouldn't then you have a very superior view of what's good for people.[31]

Fitch's simple consumerist populism is premised on the financially autonomous consumer and disregards any questions about the public realm, and goods or services that cannot be consumed by materialistic individuals. In the act of consuming, according to Fitch, people 'are expressing their preferences by claiming their individuality' (although one wonders whether his nouns were not meant in the reverse order).[32] In the consumerist value system, a definition of 'good design' is straightforward: 'Whether environments or products, something that is well-designed not only looks good and works well but also sells. If it doesn't sell, it isn't good design.'[33] In a way that is typical of marketing-led designers, Fitch returns always to the *sine qua non* of consumerism: making money.

The reply from Boys, as one might expect, was to question the very basis of

Fitch's value system: 'But I don't think designers should always take the priorities of the market as the norm. Some things are obvious to everyone *except* designers. Take lighting in relation to women and safety.'[34] Boys could not be accused of naïve anti-consumerism, and acknowledged during the conversation that people would always have to go shopping, but 'people could be provided with other things in shops besides the opportunity to consume – such as nappy-changing facilities. There's a conflict between social needs in shops and the need to make the space pay.'[35] In the end, Boys continued, consumerism always prioritizes profit maximization over social needs or even convenience:

> Take department stores. In a male-dominated world, the men's department is on the ground-floor because men have the spending power and will only want to slip quickly in and out of a store. Mother with baby in a buggy will probably have to drag herself up several flights of stairs to find what she wants or go to the toy department.[36]

This was not a criticism Fitch had any sympathy with, and in his final statement he asserted that 'we should disabuse the view that the female consumer is oppressed, downtrodden, powerless, never listened to.' His next remark was perhaps truer than he realized: 'I don't know what world you live in but it's not the world I live in.'[37] The world of a (then) highly successful male entrepreneur is indeed very different from that of a feminist who often works with unwaged single-parent women on council housing estates!

Design for children

However, one must never underestimate the ability of consumerism (and, in a more general sense, capitalism) to adapt in order to respond to a changing situation. Sometimes there are products which women are happy to make use of which can be incorporated into the consumerist system. Women's needs and market forces can, so long as the woman is able to afford the products, operate for mutual benefit. In the last decade, such has increasingly been the case with a lot of the design associated with babies. First, it has to be acknowledged that to presume that designs for baby facilities fall within the woman's realm is itself stereotyping. Such designs ought to be unisex, and there is some indication that this is beginning to occur. If they are unisex, it is crucial that ergonomic considerations are based on the female user as much as the male. An 'average' woman must be able to manipulate the product without undue difficulty.

 Some of the more recent 'buggy' pushchairs, for example, are now designed for one-hand assembly so that a mother trying to look after her child with one hand will also be able to assemble the pushchair from its

collapsed position. Buggies provide an interesting illustration of the need for women's 'tacit knowledge'. In the past, design awards have been given (usually by men) for buggies in fashionable colours and 'go-faster' graphics which *looked* good (to men, because they reminded them of car styling) rather than because they were functionally superior. At one design ceremony that I attended, an award-winning buggy was scathingly criticized by a mother in the audience who claimed with considerable authority that it was extremely difficult to assemble and could trap fingers, that it overbalanced easily, that it had no shopping bag or parcel facility, and that it was not equipped with an easily attachable rain-hood. It transpired that the buggy was designed by a man who had no direct, everyday experience of using such a vehicle. And it is probably significant that it was male designers who orientated the seat so that it pointed forward, thus denying the child any contact with the parent, as well as facing the child toward the road with all its fumes, noise and dangers. Recent designs, making far greater use of women's 'tacit knowledge' have provided buggies and pushchairs with reversible swivel-seat units, integral shopping trays or bags, and adjustable handle heights. Improvements have been made in the lightness/strength ratio, which is of especial relevance to women. The problem of adequate, but easy-to-assemble and convenient to store, rain protection remains a problem.

'Tacit knowledge' is also being used to consider the pushchair in relation to its various ancillary functions. Buggies and pushchairs now have seats which can be removed to make way for a carry-cot. The carry-cot itself is adjustable and can fold away flat. Designs are even being considered for a pushchair seat which can be attached quickly but securely to a car seat. Needless to say, none of the designs mentioned above is cheap, for they retail at around £100. Consumerist design solutions always presuppose a financially viable consumer! Other recent consumerist products have made life easier for women as mothers. A device that plugs into a car lighter-socket to warm a baby's feeding bottle, and bowls and beakers with click-on plastic lids so that food and drink are portable, are useful products which make life less of a struggle.

Pro-consumerist writers argue that market forces are the best mechanism for giving the public what it wants, because they create the financial power to develop desired products. An example of socially useful product development for parents is an improved feeding bottle that is manufactured by Avent. It makes use of Silopren, a rubbery material with advantages of softness, durability, a lack of rubbery smell and taste, stability, and an ability to withstand hot and cold sterilization methods. The teat has a built-in skirt which clamps against the bottle when it is inverted, preventing leaks. When the baby sucks, negative pressure causes a valve to open and air is allowed in through tiny holes behind the skirt. Like a nipple, but unlike conventional

teats, the Avent teat has several tiny holes, pierced by laser. The teat is fitted to a short, broad, wide-necked polycarbonate bottle. This shape of bottle makes mixing the infant feed easier than is the case with the more common tall and thin bottle, which has a neck-opening the size of a large coin. Avent have also manufactured a breast pump which can be used to express breast milk using only one hand. Both of these products required the kind of painstaking and costly research and development (R&D) which only highly profitable and consumerist-orientated companies are able to afford.

Product development and innovation usually require a considerable R&D budget, and a frequent criticism of state-controlled industries was that in this area, particularly, inertia and poor standards predominated. The performance of manufacturing industries in what was the Eastern bloc countries was generally held up as evidence of this criticism. However, the counter argument is that the number of genuinely improved product developments, such as the infant-feeding equipment described above, constitute a very small proportion of consumerist products, the majority of which are unnecessary and wasteful of resources. There is no inherent reason why some form of non-consumerist structure could not produce socially useful products. The problem is ultimately a political one about the ownership of resources; determining social priorities; and the social ethos of the society.

For example, feminists might argue that the prohibitive price of improved products such as buggy-pushchairs could be circumvented if, say, maternity units at hospitals operated a loan system of equipment in the same way as some social service departments loan wheelchairs. Considering the relatively short period of time a buggy is needed, this would make economic sense to many parents at a time when expenditure increases for essential items like children's clothing. That this does not happen is due to a range of factors: economic (too little funding in the public sector); political (prioritizing private affluence for certain sectors of the population); social (people are encouraged to aspire to ownership); and commercial (consumerist companies would argue that this sort of scheme would undermine their profitability, and thus retard R&D).

Alternative criteria

When women design products, they are sometimes radically different from the existing norm. Research undertaken on women's criteria for car design revealed an emphasis on function, ergonomics and safety, which was at odds with the seductively advertised status symbols that massage the male ego.[38] Women claimed that they wanted functional, durable, environmentally friendly, low-speed cars which were easy to clean and maintain, even to the extent of having engine parts labelled to help do-it-yourself repair and

maintenance. Seat heights would be adjustable and seat belts would be padded. Many of the health and safety features recommended by women – including rear seat-belts, childproof locks and lead-free petrol – have become more common as manufacturers try to gain a competitive edge by responding to the market. However, a ramp to lift or wheel a buggy or trolley directly into the car without any lifting; privacy for breastfeeding; and built-in entertainment for children do not seem to form part of the manufacturers' planning. Even more unlikely to be fulfilled is the call for a public car transport system, combining high-technology computers and low-energy, and renewable and non-polluting fuels, in which individual needs for convenience are met by numerous 'podlike' vehicles located in community spaces such as housing estates and health centres.[39]

The criteria underlying the community-linked transport system tie in closely with Boys's contention that the relationship between people and the places that they use is the fundamental issue for women in design. Such an approach takes the emphasis away from products and objects, and points it towards relationships and meanings. Other feminists have also attacked the consumerist ambition of identifying, encouraging or creating a desire, and then producing a product to fulfil it. Phil Goodall and Erica Matlow argue that:

Well-intentioned feminists may still use unexamined assumptions about women's desire and about the nature of design and such a strategy serves to render femininity and female desire into commodity forms and further open-up womanhood to the market – not liberate them.[40]

They resolutely oppose the idea that design should be intrinsically, or even normally, concerned with producing '*things*, rather than social and economic relations or ideas, desires, pleasures, miseries'.[41] Martin is in complete agreement: 'Feminist design must ask the question of women: Is a product needed at all? Would a service, or a reorganisation of existing social or physical management be better than a product?'[42] This explains why so much feminist design thinking has been given over to considering socio-spatial issues rather than designs for products or commodities.

Socio-spatial perspectives

An example of a socio-spatial design in relation to retail is the provision of crèches and supervised play areas in shopping centres and some of the more progressive department stores such as Ikea. Crèche provision is of particular significance to women because research on shopping patterns undertaken by the Greater London Council's Women's Committee conclusively estab-lished that it is – as one could easily predict – women who bear the main

burden of daily and weekly shopping for households. Ten per cent of women are accompanied on their shopping trips by young children, and as a result 'these expeditions are frequently slowed down or curtailed'.[43] Some shops are now beginning to provide facilities, but other stores see social provision as hostile to profit. When questioned about their lack of special provision for children and their parents, Marks and Spencer surprisingly replied: 'the provision of a breastfeeding/changing area is not necessarily in all our customers' interests. By introducing this facility we would considerably reduce our selling space.'[44] Most women would unreservedly welcome childcare facilities which benefit both the parent or carer and the child,[45] but there remains a suspicion by feminists that the mother is being relieved of her offspring in order to make her a less harassed, more relaxed and therefore a 'better' (more receptive, more co-operative) consumer.

On the other hand, crèche provision means that isolated parents have the opportunity to make contact with other parents, and single parents and childminders can have a break and receive support. Analysis of one inner-city crèche revealed the important role that crèches can play in helping parents and children from minority groups to integrate into local communities. In a society in which the public realm is threatened by privatized and profit-maximizing consumerist culture, a crèche in a shopping centre can help to provide a space for social intercourse – especially amongst women. Sue Cavanagh compares new shopping centres with:

Older town centres [which] offer communities amenities such as clinics, dentists, libraries, etc, which do not only focus on consuming. They also offer more opportunities for informal social meetings and are usually more accessible by public transport or on foot from residential districts than the new shopping developments which tend to favour the more affluent car-owning shoppers.[46]

Out-of-town shopping complexes further disadvantage low-income women, the majority of whom are working-class and/or black, because these women lack private transport. The report published by the Women's Design Service details sixteen categories of design guidelines for crèche design, ranging from space and signposting to floor-surfaces and play equipment. However, the design guidelines cannot be divorced from the broader social and economic issues that relate to gender roles and expectations, financial provision and sources of funding, and the priorities determined by consumerist criteria (including the siting of shopping facilities). It cannot be over-emphasized that designers who deal only with 'solutions' to the perceived needs identified by consumerism, without questioning the social and gender implications of their work, may well produce attractive and appealing 'toys for the boys' which ignore, disregard, manipulate or stereotype women. Nothing can better illustrate a legitimate and urgent 'women's issue' in design.

That crèche provision is necessarily described as a 'women's issue' also illustrates our social and cultural attitude to childcare. As Cavanagh comments: 'We look forward to a time when men are equally involved in domestic and caring tasks and see the provision of good public facilities for children and their carers as an important step towards making childcare more socially visible and valued.'[47] Motorway services and some of the more progressive stores sometimes now offer a 'childcare room', whereas previously they may have signposted a 'mothers' room'. Some women may, however, regret the loss that a 'mothers' room' provides for privacy, or even just conversation with other women. Women, obviously, vary in their demands and values: ultimately one can no more talk about a singular and unified 'women's design' than one can talk of a 'men's design' – a point acknowledged by feminist writers.[48]

Design in relation to housing and housing estates is a further example of socio-spatial design that is of crucial concern to women. Goodall takes some satisfaction that women:

> . . . may have been active in tenants' campaigns, damp campaigns, in reclaiming public space for women's use from sexual harrassment and violence. [But women] . . . have been less active in demanding of planning authorities physical and spatial conditions that would make it possible to break down divisions by gender in personal and public life. Housing types are predicated on a limited number of household forms, the family, single persons, the elderly for example and do not readily allow for larger looser groupings. In their spatial capacity and form, as well as in their relation to workplaces, homes make a reorganisation of paid work and personal life practically impossible.[49]

Historians including Hayden, Roberts, and Davidoff and Hall have demonstrated the integral relationship between gender politics and the material form of domestic environment in both the United States and Europe. Houses have been increasingly designed around the model of the nuclear family, with a father who goes out to work, and a mother that stays at home, even though, nowadays, fewer than half of children come from such homes. Matrix refer to the 'privatization of family life' in which each household becomes more separate from the next; this may conform to the ideal of the 'home as castle', but it also isolates women from one another.[50] Communal wash-facilities or play-areas, ideas in good currency in some 1920s and 1930s public-housing design, for example, are less and less common today. Layout has, feminists would argue, reflected male priorities, with most ground-floor space being given over to entertainment and status, while the work areas for cooking and laundering have been tucked away into ever-smaller kitchens that are designed for one person – with the result that labour is less likely to be shared. Kitchens are usually placed at the rear of the house, where an interesting view is less likely – some houses of the 1950s

placed kitchens at the front of the house so that they overlooked the street and the children's communal play areas, and thus acted to reduce the woman's sense of isolation.

Matrix complain that modern society 'pays lip service to the importance of mothering but does not cherish its mothers'.[51] The presence of a baby or young child reveals how many houses are ill-conceived for children. One mother describes the type of problem caused by an unsuitable spatial organization and layout:

Our hall is particularly narrow, so I knew a normal pram was out of the question and I bought one of those pram-buggies . . . When I wanted to go out I would have to 1) take the bouncing chair down to the hall, 2) come upstairs . . . and dress Kim in his outdoor clothes and take him down and strap him in the chair, 3) go upstairs and dismantle the pram and take the buggy wheels down to the hall, 4) go upstairs and carry the carrycot and blankets down to the hall (very difficult to manoeuvre this quite heavy object down the narrow stairs), 5) take the buggy wheels down the steep front steps to the pavement and set them up, 6) take the carrycot down to the pavement and fix it to the wheels, shouting through the open front door to Kim so he didn't feel abandoned, 7) rush in and get Kim . . . and carry him down the front steps and put him in the pram and *at last* set out on our expedition.[52]

This is not to suggest that all houses should be built to a standard pattern based around children, but it would surely make sense if considerably more were. A front door which has a ramp rather than two or three steep steps (or perhaps a combination), and a large, warm hall where a pram and, later, a tricycle can be kept, would be major design innovations. Again, perhaps, the lack of the 'tacit knowledge' of women in the design process – the number of practising women architects is shamefully low – is a cause of the problem.

The design of spaces on estates and in town and cities has also received considerable attention from women. The inconsiderate design of walls, garages and other structures can create unlit corners where intruders may hide. Lighting in and around buildings, particularly near doorways, car parks and alleyways, can make an environment potentially threatening and dangerous for a woman. Underpasses are a haven for muggers. The way spaces interconnect by means of stairs can disregard the needs of a mother with a pram, or disabled users. There are many such examples of poor design which need never have occurred, or which could be rectified by redesign.

Symptoms or causes?

However, feminists are sometimes suspicious of the 'design fix' approach. One of the recommendations in the WDS's report on 'Women's Safety on

Housing Estates' expressed significant reservations about the role of design in solving the sorts of problems discussed in the report:

Solutions that are based solely on design changes are often inadequate and a waste of money. Design guidelines can sometimes trivialise the problem by appearing to reduce safety issues to a matter of appropriate design.[53]

In other words, an emphasis on treating the symptoms of a problem glosses over what may be its social and cultural causes. By presuming the change has to be with the effect rather than the cause, the design 'solution' can be seen to be accepting the status quo. Harrassment and threatening behaviour by men might be reduced by redesigning the environment and so limiting the opportunities for when it can happen, but the best solution would be a change in men's behaviour. Women rightly object when they are the ones who have to modify their activities and lifestyles ('don't go out alone at night'; 'don't hitch a ride') because of men's behaviour. What is often presented as a design problem is really a social and cultural issue.

If the discussion is contained within the conventional design discourse it will miss the point. 'Women', writes Martin:

. . . need to gain knowledge of the means to effect the decisions that control their material and social environment. Then designers would be better able to serve them, rather than perpetuating the power imbalances. This requires a political change . . . Design in its broadest sense is power, control and defining new possibilities to aim for. So, as women, we need to criticise design from a position of knowledge, as users and as practitioners and to initiate new possibilities ourselves.[54]

One of the main problems, as Martin acknowledges, is that product designers:

. . . have the problem of the means of (mass) production; there are not (m)any feminist manufacturers to work with. There are a few women's Co-ops, however, and if the ideas of . . . technology networks can be developed, there is a possibility for feminist industrial design practice to exist. It is also possible to construct the design brief and the design activity in a feminist way, and then try to convince manufacturers of the economic sense of producing an object thus researched.[55]

It would seem that, for the foreseeable future, feminist designers and critics will be able to effect but small changes on marketing-led design; manufacturers will, by and large, continue to respond to short-term, patriarchally determined demands in which perceived needs are quickly commodified. And some of those changes will occur only because they are in the manufacturer's financial interests. Any broader changes in design will only result from positive changes in the culture and politics of society.

Consumerist design trades deeply and – in its terms – successfully on gender stereotypes for constructing the meaning of and context for a product, and it will remain fundamentally conservative. The issue of consumerist design and feminism again goes to show that the terms 'market' and 'society' are far from synonymous.

5 The Way Forward?

The introduction to *Design For Society* stated that the *mood* was right for a reassessment of the role and status of design in society. The previous chapters have, I hope, demonstrated that the *time* is now right for such a reassessment. Historically, we have reached a juncture at which there are momentous political changes in the Eastern European countries; where social and economic inequalities between the industrialized countries and the Third World are increasingly exposed as unjust and destabilizing; and where ecological damage is making us aware of the futility of thinking always of myopic 'national interests'. We are forced to acknowledge that, in the words of Kenneth Adams, Comino Fellow of the Royal Society of Arts, 'market economies would appear to have within them the seeds of their own destruction'. Writing about the need fundamentally to change attitudes in consumerist societies, Adams states the unavoidable conclusion that the 'planet cannot sustain the continuous economic growth required to fuel a worldwide market economy, especially when linked with a rapidly expanding world population'.[1]

Design directly expresses the cultural, social, political and economic complexion of a society, and it thus provides a snapshot of that society's condition. In so doing it reveals a great deal about a society's priorities and values. Design matters: it is too important just to celebrate, collect or historicize. The world situation demands that we develop a greater awareness of design's explicit and implicit values and their implications, and exercise a greater control of design in our societies. This is the project towards which this book has attempted to contribute. If any reader thinks it is an *anti*-design book, he or she has not – I would venture to suggest – questioned his or her assumptions about design and society. It *is* against a certain type of design which, for the reasons examined in the previous chapters, is often environmentally or socially damaging. It is *pro*-design because to be anything else naïvely denies the power of design in people's lives, and also its overwhelmingly positive potential to effect change.

We have seen that the value system of marketing-led design grows out of the circumstances of an advanced consumerist society and can be traced directly back to its American progenitor in the inter-war years; this underlines the fact that design cannot be meaningfully considered outside its social, economic and political context. The current condition is often

referred to as 'postmodern', but that word is so widely and loosely used as to hinder thinking rather than clarify it. It may be more helpful to adopt the second part of the title of an influential essay by Fredric Jameson, the American cultural historian, entitled 'Postmodernism, or The Cultural Logic of Late Capitalism'. 'Late Capitalism', as Jameson points out, does not imply capitalism's terminal stage, but a mature stage with which the present book's analysis of the development of consumerist society and consumer-led design accords. He argues that:

> . . . aesthetic production today has become integrated into commodity production generally: the frantic economic urgency of producing fresh waves of ever more novel-seeming goods (from clothing to airplanes), at ever greater rates of turnover, now assigns an increasingly essential structural function and position to aesthetic innovation and experimentation.[2]

This is a situation which we can recognize, in sharp definition, in marketing-led design, with its aestheticization of design and the increasingly rapid product innovation. What Colin Campbell describes as the condition of 'longing' is a virtually inevitable effect of the adoption of aestheticization and innovation.

If we are to distance ourselves from our condition in order to understand society's values, we need critically to examine the relationship between design and society. We have to remind ourselves that a cultural condition is not *natural*, but socially, politically and economically constructed. In the words of Campbell, there is a tendency to take some form of behaviour or set of values – marketing-led design, for example – for granted:

> . . . and to assume that, even though it might not be morally desirable, it is at least a perfectly 'normal' or 'rational' mode of acting. It takes only a little reflection to realise, however, that such a view is neither supported by psychology nor anthropology, but is merely the product of a deep-seated ethnocentricity.[3]

Campbell is perhaps cavalier to use the word 'merely' in relation to 'deep-seated ethnocentricity'. When something is so deep-seated, change has to occur at an equally deep-seated level, otherwise it is fleeting and structurally impermanent. As the editorial in the first issue of *The Ethical Consumer* warned: 'Changing the way individuals perceive the shiny goods on supermarket shelves is primarily a cultural change.'[4] Consuming and design are symptoms of cultural habits and expressions of cultural values and, as such, are resistant to change.

For change in design to take place we must start by analysing and examining the values and role of design in relation to society. At one level we need to assess a societal value such as 'progressivism', which gives an apparent legitimacy not only to the constant and rapid innovation of marketing-led design, but to the technological determinism prevalent in

society and, indeed, in capitalism itself. At a more concrete level we need to study the role of the designer who, in consumerist society, may well be said to have become 'the capitalist's lackey'.[5]

The debate about whether design is a profession or a business highlights the issue of the designer's responsibility to society. One 'unreconstructed' designer probably speaks for many of his profession/industry when he asks:

> Does 'society as a whole' really expect anything from designers as a profession? Do they even know who we are, or give a damn anyway? Wouldn't 'society' prefer to see our industry as an integral part of a healthy economy, striving to create opportunity and employment, rather than an elitist profession which . . . must surely go the way of the dinosaur?[6]

This limited and exclusive view can be contrasted with another designer's heartfelt comment:

> If industrial design is to set itself up as a profession, it must work out whether or not it is a *servant* of industry and whether or not it is a profession which faces up to moral issues . . . What is important, however, is that the designer should never become the tool of the marketing profession – a clown, prostitute or stylist.[7]

It might be argued that including clowns and prostitutes alongside stylists is unfair to clowns and prostitutes – who surely play a useful role in society as therapists of one sort or another – but the rhetorical point, that design based on the values of styling is as healthy as a society based on clowning and prostitution, is striking.

We have seen in the previous chapters that some reassessments of aspects of design have occurred, but they have been piecemeal; there is an urgent need to see the reassessments in the broader context of society and societies. Western society is undergoing profound social changes as it shifts from being an industrial to being a post-industrial society, or from a Modernist to Post-Modernist society, with all that this means in terms of such things as the changing role of leisure in relation to work. An emphasis on the quality of life is, for the prosperous inhabitants of the West, replacing an emphasis on quantity. This not only applies to personal ownership in a time of relative abundance but, for example, to technological matters, where the obsession with making a machine which is faster or bigger is being questioned by those who believe that the machine should be more socially and environmentally useful and responsible. This sort of questioning dates from the late 1960s and it is firmly rooted in historical circumstances – as we have seen in the previous chapters.

'Quality of life' is not, of course, synonymous with 'standard of living', and it is the confusion of these as criteria that dogs so much contemporary political and social debate. The shift might be about a transition from quantity to quality, but we are still employing criteria that are attached to the

old condition. For example, in the 1980s there was much talk about the quality of life, but the concept of 'quality' was frequently selfishly defined. In the 1990s words like 'integrity' and 'honesty' may be worth little more than the adverts in which they are so often contained, but they are at least symptoms of a concern to redress the balance of society in favour of more public values.

These values imply a commitment not only to the currently fashionable designer-notions of 'integrity' and 'honesty', but also to societal notions of 'equality' and 'justice' – terms which seemed archaic in the 1980s but which are now returning to political agendas. The balance between private affluence and social responsibility does seem to be beginning to shift more towards the latter. That this is a general and widespread shift seems to be confirmed by a recent annual survey carried out by the International Research Institute on Social Change in twelve European countries, North America, Brazil, Argentina and Japan. The survey showed that:

> . . . there is a strong majority even among the very rich prepared to pay more in tax to alleviate poverty. Greater equality is not just an objective for socialists. It is an objective for many people across the political spectrum. It is based on the trend towards social empathy.[8]

One writer has cast the shift in terms of a replacement of the *entrepreneur* by the *entredonneur*: 'The classic, mythical entrepreneur is a kind of lone hero unfettered by the constraints of the specialist professions. The true entrepreneur – fixer, trouble shooter and exploiter – should give way to the more socially responsible entredonneur: the giver, not the taker.'[9]

Design For Society reflects the current debate about the quality of life. Inevitably, when one is addressing such an issue, one is engaging in a debate about values, and it is not only healthy but crucial that values are discussed explicitly rather than implicitly. This has not happened nearly enough in the design profession or design press. Values must be translated into standards and criteria, and inevitably lead back to the fundamental question 'What is good design?'

To most people involved with design, the 'What is good design?' question is either irrelevant or historically loaded. Those who find it irrelevant would also find it meaningless, because the answer they give is self-evident: 'good design is that which is commercially successful'. This is no more – and no less – than a restating of the American industrial design definition of 'good design' as 'good business'. It recalls Lippincott's claim that 'no product, however well its aesthetic functions are fulfilled, may be termed a good example of industrial design unless it meets the acid test of high sales through public acceptance. Good industrial design means mass acceptance.' His assertion that, 'There is only one reason for hiring an industrial designer, and

that is to increase the sales of a product', was echoed by Henry Dreyfuss, who categorically stated that 'industrial designers are employed primarily for one simple reason: to increase the profits of the client company.'

Few contemporary designers would be prepared to admit to the public that they agree with these sentiments, although presumably they mouth them privately to their clients. These sentiments have, however, been publicly stated in the political arena. In the mid-1980s the Conservative government looked towards design as a key weapon in the economic strategy for a more prosperous Britain. Under the banner of a campaign entitled 'Design for Profit', the government, through the Department of Trade and Industry and the Design Council, published a 'Profit by Design' brochure which highlighted the profit motive: 'To put it simply, the design process is a planning exercise to maximise sales and profits.' By 1987 the Government's 'minister for design', John Butcher, was defining 'good design' as the 'planning process for products or services that fully satisfy the aspirations of the customer'.[10] But, as we saw in the first chapter, the aspirations of the customer/consumer have to be manipulated: 'It is no good producing something that responds to what the customer thinks he wants now – you have to aim for what he will discover he wants in the future.'[11] Design, Butcher continued, should serve the 'national interest', which he defined as 'the creation of wealth'.[12] The minister praised the approach to design of several successful companies: 'Here is design at work. Improving competitiveness. Winning markets. Increasing profitability . . . That's what design is about.'[13] The competitive, 'enterprise culture' ethos of design was summed up in his comment about the role of design in society: 'Stripped down to its basics, it's about the survival of the fittest.'[14] The 'law of the jungle' mentality is here applied to national prowess: successful design is a way of giving 'the international competition a sound drubbing'.[15]

There are also those who regard the question 'What is good design?' as too historically loaded. This results from the use of the term 'good design' in the late 1940s and 1950s to represent a restricted view of design that was essentially related to professional middle-class taste. In Britain, the motives of the 'good design' movement grew out of the sense of egalitarianism (albeit one in which experts knew best) and altruism (rather than the profit motive) that was part of the vision of the new democratic Britain – a vision that had dominated the propaganda of the latter part of the Second World War. In this vision, manufacturers' profits resulted – so it was hoped – from meeting the real needs of the public through 'good design', not from creating and satisfying unnecessary materialist desires.

A definition of 'good design' was attempted by the director of the Design Council, Gordon Russell, in the very first issue of *Design*, the Council's own monthly magazine, which commenced publication in 1949. Russell rhetor-

ically asked what it is that the consumer demands (which really meant what s/he *should* demand) of a product: 'He demands something which is well made of good and suitable materials, which does its job efficiently and gives him pleasure, at a price he can afford to pay. So the first design question is "Does it work?"' Russell continued that, 'Good design always takes into account the technique of production, the material to be used and the purpose for which the object is wanted.'[16] This was a definition which married functionalism (e.g. 'form follows function'; 'fitness to purpose'), and the aesthetico-moral principles (e.g. 'truth to materials'; 'integrity of surface') that had been derived from Owen Jones and other design 'reformers' of the mid-nineteenth century. Standards were presumed to be objective and transcendent, so that a definitive judgement about a product could be made so long as one knew the task for which it was designed – its 'primary' function – and recognized the manifestations of the supposedly timeless aesthetico-moral principles. During this period the emphasis in the definition of 'good design' was thus largely on the product, rather than on the consumer or manufacturer (e.g. the social role of products; market segmentation; ease of manufacture; profit motive).

This is not to imply that the commercial role of design was ignored – from the very first issue of *Design*, Council spokespersons acknowledged the economic importance of design – but this was never to be at the expense of standards of 'good design'. In fact, if ever it came down to a situation of one or the other – of 'good design' *or* commercial success – the Council's sympathies were with the former. Michael Farr, editor of *Design* from 1952 to the end of the decade, analysed the aims of the profession in 1955 in *Design in British Industry*. Addressing the motto (which was even used by the Council) that 'good design is good business', Farr retorted that 'I am convinced that it is scarcely a half-truth and never susceptible to generalization. The great mistake that propaganda can make is to lure manufacturers and retailers into improvements of design by promising them an increase in sales.'[17] It was more honest, he remarked, to admit that 'successive improvements in design *can* maintain sales at their normal level. And that, I suggest, is the balance between private business and social duty that every manufacturer and retailer should strive to attain.'[18] Lest anyone was unclear about the true purpose of design, Farr proclaimed that the question of design was essentially 'a social question, it is an integral part of *the* social question of our time. To fight against the shoddy design of those goods by which most of our fellow men are surrounded becomes a duty.'[19]

But a suspicion grew that the quest for 'good design' was little more than an attempt to promote an exclusive notion of 'good taste'. Certainly the products selected for the Design Council as exemplifying 'good design' changed very little between the opening of the Design Centre in 1956 and

the mid-1960s. They were characterized by bareness, simplicity, squareness or roundness, solidity, and seriousness. If there was any decoration it would be discrete. Materials would usually be traditional, and workmanship and techniques 'honest'. Scandinavian design epitomized 'good design' in the 1950s and early 1960s, both in its appearance and its social associations.

The Council justified the fact that the designs looked alike by maintaining that they all illustrated the proper and correct principles of designing, but the introduction of product testing by bodies such as the Consumers' Association, reported in magazines such as *Which?*, gave considerable weight to the accusation that the functional look often disguised functional inefficiency: form did not follow function, but was instead used to imply it. Although they asserted that 'form follows function', Modernists were guilty of reversing the slogan and naïvely assuming that mechanical efficiency was a corollary of certain proportions. And if naïvety did not underlie the assumption, a belief in the unquestioned authority of a certain kind of taste did. Ultimately, principles were being used to justify taste.

The architectural historian and design writer Reyner Banham, in a scathing article about the way that 'good design' and 'good taste' were being treated as if synonymous by the Design Council, anticipated and answered the Council's objection that 'quality-testing is not the Council's business, and that it was formed to raise the level of public taste. But tasteful rubbish is still rubbish.'[20] Some time later the American sociologist Herbert Gans exposed the relationship of 'good design' and a particular taste culture, firmly placing it in 'progressive upper-middle' class culture. Such products were consumed by a group which saw itself as 'forward-looking, enlightened and enlightening, contemporary and reformist, out to vanquish the obsolescent, the unnecessarily complicated, and the dishonest.'[21]

For some, the phrase 'good design' retains its connotations of taste even today. For others, the old-fashioned notion of 'good design' is socially and politically unacceptable because it presumes a universal and timeless standard which, by definition, relegates all that does not conform to it as inferior. This 'high culture' definition, closely related to Modernism, was undermined by the social (and taste) upheavals of 1960s consumerism and youth culture. Bodies such as the Design Council had been caught hopelessly wrong-footed by the explosion of Pop in the 1960s and were in danger of appearing anachronistic and out of touch. Council chairman Paul Reilly perspicaciously concluded that 'good design' had to be defined in largely social, and not aesthetic, terms:

We are shifting perhaps from attachment to permanent, universal values to acceptance that a design may be valid at a given time for a given purpose to a given group of people in a given set of circumstances, but that outside these limits

it may not be valid at all . . . All that this means is that a product must be good of its kind for the set of circumstances for which it has been designed.[22]

The implication for design of the social changes that had occurred in Britain was that a hierarchical single design structure, based on universal and changeless values, had been replaced by values that were relative to time, place, group and circumstance. An important point to note is that Reilly was not claiming that the question of standards had declined into total relativism, but that standards were contingent upon what I have elsewhere termed a 'plurality of hierarchies'.[23] Reilly's ideas opened up the possibility of giving design theory a sound social, pluralistic and democratic footing.

Andy Warhol once remarked that Pop Art was about liking things. Unfortunately, Warhol's 'theory' of Pop has been influential, whereas Reilly's theory of design has not. Warhol, to recall another of his aphorisms, became famous for considerably longer than the fifteen minutes he forecast as every individual's expectation in the mass-media age, whereas Reilly, however unfortunately, has been famous for a considerably shorter period. We have rapidly slid into judgemental relativism, so that subjective 'liking' has replaced any more coherent and rigorous position about criteria and standards. The question of 'good design' has not been asked: partly because no definition – however inclusive and plural – existed; and partly because such questions seemed unfashionable, and too firmly associated with moral seriousness and killjoy aesthetics. This lack of criticality in the last quarter-century has left a vacuum which, given the consumerist nature of society and the power of marketing-led design, has been filled by the descendants of Lippincott and Dreyfuss. One of the major problems with their definition is that 'good design' (that is, commercially successful design) may also be *bad design* in terms of functional and technical performance – the sort of criteria employed by *Which?*

Yet the social and environmental issues relating to design that have been examined in this book make even Reilly's definition of good design inadequate. Defining good design is certainly not straightforward, because the definition must be inclusive and plural: we can no longer tolerate the exclusiveness of Modernist absolutism, nor do we have what the late Peter Fuller used to describe as a 'shared symbolic order', as was once provided by religion. Good design must combine a maximizing of the functional and technical performance of the product with a use of materials and methods of production that takes into account their environmental effects (the sort of criteria upheld by Greens); and it may even incorporate the sort of criteria applied by ethical consumers (the company's labour relations and financial investments), 'responsible' designers and consumers (whether the product is socially desirable), and feminists (whether it reinforces gender stereotyping).

An example of one product – not in itself an unusual or extreme example – will highlight the lack of criticality in contemporary thinking about design, criteria, standards and values. The Ross RE5050 radio received much design-media coverage and acclaim. But of the half dozen articles about the radio in the design press, not one addressed any aspect of the performance of the radio over and above the design feature of the concealed controls. Yet *Which?* – as we have already seen – found the radio deficient in aspects of its performance. I am not suggesting that each writer should have submitted the product to laboratory testing, but that critical comments based on the individual writer's (supposedly) informed opinion could have been included. None addressed even the *styling* of the radio in terms of a critical semiotic analysis. None looked at the implications of it being designed in Britain but manufactured by Third World labour. It was more important to the writers that 'nothing detracts from the pleasing, uncluttered shape' and that the radio was available in 'fashionable grey, black, red or white'. These last comments appeared in *Design Selection*, a short-lived magazine published by the Design Council and purporting to feature 'the best of British design'. In other words, the design press took the values of marketing-led design as *given* and merely 'hyped' the radio in much the same way as a company press release.

Of the issues surrounding this type of product, the design press said nothing, yet these issues are both relevant and worthy of discussion. Consequently, designers – like consumers – are usually ignorant of the many ethical issues that surround the products they design. The design of radios and radio-cassette players, for example, almost invariably involves making use of a cheap, passive and, many would argue, exploited workforce in Hong Kong, Singapore, South Korea or Taiwan. Until 1987 – there has been an improvement since – manufacturers in the last two countries paid only 14 per cent of the wages paid in Japan. But as wages rise, production moves to a cheaper country: currently Thailand, Malaysia, Indonesia and the Philippines are the most 'favoured'. Workers frequently suffer from eye complaints ranging from near-sightedness, as a result of doing close assembly work of small components, to conjunctivitis. Continual headaches may also result from staring into a microscope for eight hours a day. Further health and safety risks arise from the use of toxic metals, chemicals and gases in the production of components such as gallium arsenide semiconductors. The industry is also the principal user of CFC–113, a solvent it uses to de-flux printed circuit boards after soldering and for other cleaning applications. CFC–113 is one of the five most harmful CFCs in terms of ozone depletion and global warming, and there are readily available and relatively harmless substitutes. Some manufacturers, including Hitachi and Matsushita, have promised to phase it out. The benefit will not only be to the environment, but

also to the workforce, to whom short-term, acute exposure of CFC–113 can cause giddiness, nausea and unconsciousness, whilst chronic exposure may lead to organ damage and cancer.

The manufacture of radios and radio-cassettes is so bad that, according to *The Ethical Consumer*, 'it is impossible for consumers to avoid buying [one] that has not been associated with poor workers' rights at some stage of its production.'[24] When the magazine came to assessing the ethical performance of the major manufacturing companies, such household brand-names as Aiwa, Akai, Ferguson, Grundig, Philips, Pye, Sharp, Sony, Telefunken and Toshiba were cited as belonging to companies which are significantly involved in armaments, while Sharp, Toshiba, Mitsubishi and Akai are part of companies which are claimed to be guilty of widespread deforestation. The cynic might presume that all big companies are as bad as one another and so there is no point in consuming ethically, but the fact that, even in the ethically blemished area of radio and radio-cassette manufacture, companies the size of Sanyo, Samsung and Ssangyong are given a reasonably clean bill of health demonstrates that positive ethical consuming is possible.

Readers may argue that articles on design would become unreadable if such worthy and conscience-pricking detail drowned out the excitement of new styling features and fashionable colour schemes. I would agree to the extent that I am not proposing an 'either/or' situation, but one in which one type of discourse lies alongside the other. Like an increasing number of consumers in the late twentieth century, I want to have both types of information. What I am objecting to is that at the moment we have only one type of design discourse to the exclusion of all others. The reason this matters is that it renders society less informed, less open, and less democratic. To recount Richard Hamilton's enduring words of over thirty years ago: 'An ideal culture, in my terms, is one in which awareness of its condition is universal.'[25] In a genuinely democratic society *values* are explicitly and openly debated and justified.

This is, undoubtedly, a political point and emphasizes the integral relationship between a society's politics and its design. William Morris was one of the first to realize that design reflects political power and control and that a proper reform of design would grow out of a reform of politics. However, the relationship between the two is usually glossed over in current debates and is almost always ignored by designers. To state this does not make *Design For Society* a doctrinaire Left-Wing diatribe, upholding old-fashioned Left-Wing authoritarian views in which everything is centrally planned and tightly controlled. Nor does it make it a simplistically anti-consumerist book. It now seems inconceivable that the Left in Britain – or other mainstream parties of the Left in Europe – will again make the sort of anti-affluence, anti-consumerist, anti-American statements that it made in

the 1950s. The Left in Europe has, broadly speaking, moved nearer the position occupied by the Democrats in the United States; that is, it has accepted the market economy but seeks to regulate and control its more unacceptable manifestations. Accepting that social attitudes have fundamentally changed, the Left has acknowledged that private affluence is the aspiration of the vast majority of the population.

Design For Society does not deny the economic importance of design, but neither does it posit 'the economic' as the *raison d'être* of design. The Right's emphasis on design's economic role cannot be upheld if the questions of long-term environmental and social effect are taken into account along with the short-term financial gain. No economic system which has its own in-built self-destruct mechanism can seriously be defended for very long. Rather than replacing any social or political rationale, the economic argument – when followed through with full accounting – actually forces one to acknowledge the interconnectedness and inter-relationship between the economic, political, ecological, social and cultural spheres.

Politically, our society must seek a better balance between the private and the public, and so avoid what has frequently degenerated into – to use a well-worn phrase – private affluence and public squalor. This requires greater and more effective checks and balances rather than an immediate and wholesale rejection of every part of the system. We supposedly live in a consumer society, practise our consumer sovereignty, and surround our-selves with consumer-led design. But the consumer's power is more often than not illusory: 'the consumer' needs more than compliments and political rhetoric on her or his side. S/he also needs genuine consumer protection and legislation (such as objective pan-global labelling schemes about energy consumption, materials and environmental effects), and these must be accepted as one of the salient features of a healthy society. Such a society is not a visionary ideal but, in certain northern European countries, an unremarkable everyday reality. (Let us hope that these countries retain these values in the face of their own increasing consumerist lobby.)

Consumers need access to information – and so do designers. One of the recurring frustrations felt by those designers who would genuinely like to be more 'responsible' and environmentally aware, is that information about materials, processes of production and energy consumption is difficult to find. Furthermore, it is often technically complex and so very difficult to understand and interpret. Data banks and cheap guides must be made available – if necessary, by government bodies – and they should play a facilitating role and not a profit-making one. Access to information needs to be accompanied by government legislation in order to counter the potentially calamitous environmental effects of market forces. Indeed, another role for government is in educating the public about such things as energy and

environmental impact. The successful campaigns on 'healthy eating' show that positive results can be achieved.

Indeed, design has some telling parallels with food and diet. In the 1960s the food equivalent to consumerist design was the arrival of foreign cuisine in Britain on a wide scale. The 1960s and 1970s were a time of new-found variety and novelty in food, with relatively little interest in healthy eating. In the 1980s there was increasing knowledge about the relationship between diet and health and a greater awareness of the bad effects of certain foods, patterns of eating, and modes of preparation. Meanwhile, specific health scares, such as those concerning salmonella and irradiation, contributed to the politicization of food. They highlighted the way in which vested interests maintained power and control over the production of food – a phenomenon which had already come to the public's attention through publicity about 'butter mountains' and other wasteful symptoms of over-production. The exposure of the use of 'slurry' in fast-foods shocked many consumers, and it is far from misleading to draw analogies between the low-grade slurry of some fast-foods and the low-grade qualities of impulse-orientated market-ing-led design. Both appear to satisfy, but may be said to provide the illusion rather than the substance of satisfaction; a renewed longing arises soon after the act of consumption. However, this is not to deny that we may all have the need for 'fast-food' on occasions; it is as a *system* that it is unsatisfactory and damaging.

The tendency of governments to withhold information about viruses and other food-related dangers, and their unwillingness to legislate for change, give the impression that their interests are most closely allied to the producers, rather than the consumers, of food. This has led opposition parties to call for a radically revised Ministry of Food, which would better balance the interests of producers and consumers, or even a ministry for consumer affairs or protection which would act as a lobby of all government departments whenever the real and longer term interests of consumers were not being properly and fully considered. Either a fully-fledged Ministry of Consumer Affairs or a redefined Design Council could play this role in relation to design. Yet, under the political wing of the Department of Trade and Industry with its espousal of the enterprise culture, the Design Council – as I have argued elsewhere – has moved further away from this oppor-tunity.[26]

Such changes will only result from a political initiative, but the necessity for this change has, I hope, been demonstrated by *Design For Society*. As the editor of *The Ethical Consumer* pointed out, 'Individuals can only begin to control events around them when they know who is doing what, when and why',[27] and this would be the objective of a radical and questioning consumer-protection body, whether specialist or all-embracing. It is

interesting to speculate on what the term 'consumer-led design' could mean in the context of a society that promoted consumer affairs and protection. Knowledge about products and their environmental effects, and their social and political implications, could lead consumers to demand ideologically sound, responsible, Green, non-stereotyping and socially liberating products. It could also lead to less consumption and even some anti-consumption – a wonderfully ironic twist in the meaning of 'consumer-led design'. A consumer-led design movement could, in other words, be radical and socially progressive rather than reactionary and socially divisive. Whether the Right would be so willing to trumpet the values of 'consumer-led design' if so-called sovereignty and choice were replaced by anti-consumerist and socially reforming principles is a moot point.

As I argued in the first chapter, the type of design discussed positively in this book should not be dismissed as just a symptom of an updated rationalism in which every act of consumption is fundamentally sensible and dispassionate. Just as we enjoy – psychologically, even need – variety, treats and some indulgences in food, so too in design. But, just as a diet of indulgences would soon lead to personal illness, so a diet of fun and extravagance in design can cause social and environmental illness. The fundamental point is that in both diet and design, fun and imagination are a vital *ingredient* of good health. Far from being boringly sensible, a radical design approach could, in the words of Ezio Manzini, director of design at the Domus Academy, be part of 'a culture that is capable of making products generated by attention to detail, love for the life of things in their relationship with men [and women] and the environment; subtle and profound expressions of human wit, creativity and even wisdom.'[28]

In his book *The New Vision*, in 1939, the artist and designer László Moholy-Nagy declared that, 'Not the product, but man, is the end in view'.[29] This was a statement which I quoted with approval at the end of *Pop Design: From Modernism to Mod* in 1987. It now seems to me inadequate, not only in its gender specificity – although Moholy-Nagy did not intend exclusion – but because it implies that the ultimate aim of design is *people*. This humanist value is not inclusive enough, even when the word 'society' replaces 'man'. In the post-humanist world we must seek a total, global, ecological balance in which humans are but one – albeit vital – ingredient. Such inclusiveness and interconnectedness does not make for easy and attractive sloganizing, but we have entered an age in design in which the memorable and seductive slogan (and its three-dimensional equivalent) has to be replaced by informed and intelligent thought and action. Designers – and consumers – can no longer plead innocence or amorality.

References

Introduction

1. Peter Booth and Andy Stockley, 'Growing Pains', *Design* (September 1990), p. 34.
2. Jeremy Myerson, 'Designing for Public Good', *DesignWeek* (27 July 1990), p. 13.
3. F. H. K. Henrion, 'Good Design from Small Packages', *The Designer* (November/December 1987), p. 16.
4. Rebecca Eliahoo, 'Designer Ethics', *Creative Review* (March 1984), p. 44.
5. Editorial, *Blueprint* (May 1990), p. 9.
6. John Wood, 'The Socially Responsible Designer', *Design* (July 1990), p. 9.
7. David Chipperfield, 'On the Dangers of Consumerism', *Design* (July 1991), p. 7.
8. Michael Wolff, 'Comment', *Design* (November 1990), p. 9.
9. Alan Page, 'New Terms', *Creative Review* (November 1990), p. 59.
10. Ashoke Chatterjee, 'In Search of an Ethic', *Integrity*, no. 344 (April 1988), p. 24.
11. Romesh Thapar, 'Identity in Modernisation', keynote address in *Design For Development*, UNIDO-ICSID conference proceedings (1979, n.p.).
12. John Thackara, *Design After Modernism* (London, 1988), pp. 11–12.
13. Rosy Martin, 'Feminist Design: A Contradiction', *Feminist Arts News* (December 1985), p. 26.
14. Richard Hamilton, 'Popular Culture and Personal Responsibility' (1960) in *Collected Words* (London, 1982), p. 151.

1 Consumer-led Design

1. Anni Albers, 'Economic Living' (1924) in Frank Whitford, ed., *The Bauhaus* (London, 1984), p. 210.
2. Walter Gropius, 'Principles of Bauhaus Production' (1926) in Ulrich Conrads, ed., *Programs and Manifestoes on Twentieth Century Architecture* (London, 1970), p. 95.
3. Ibid., p. 96.
4. J. M. Richards, 'Towards a Rational Aesthetic', *Architectural Review* (December 1935), p. 137.
5. Marcel Breuer, 'Metal Furniture' (1927) in Tim and Charlotte Benton with Dennis Sharp, eds, *Form and Function* (London, 1980), p. 226.
6. Gropius, in Conrads, op. cit., p. 95.
7. Marcel Breuer, 'Metal Furniture and Modern Accommodation' (1928) in *50 Years Bauhaus*, exhibition catalogue: Royal Academy of Arts, London (London, 1968), p. 109.
8. Ibid., p. 109.
9. Marcel Breuer, 'The House Interior' (1931) in Christopher Wilk, *Marcel Breuer: Furniture and Interiors* (London, 1981), p. 186.
10. Gropius, op. cit., p. 95.
11. Ernst Kallai, 'Ten Years of Bauhaus' (1930) in Benton, Benton and Sharp, op. cit., p. 173.
12. Roy Sheldon and Egmont Arens, *Consumer Engineering: A New Technique for Prosperity* (New York, 1932), pp. 61–2.
13. Sheldon and Martha Cheney, *Art and the Machine* (New York, 1936), p. 119.
14. William Acker (1938), quoted in Jeffrey Meikle, *Twentieth Century Limited: Industrial Design in America, 1925–1939* (Philadelphia, 1979), p. 72.
15. Raymond Loewy in a letter to *The Times*, 19 November 1945.
16. Sheldon and Arens, op. cit., p. 54.
17. Ibid., p. 54.
18. Ibid., pp. 64–5.
19. Ibid., p. 65.
20. Harley J. Earl, 'What Goes Into Automobile Designing?', *American Fabrics*, no. 32 (1955), p. 32.
21. Eric Larrabee, 'The Great Love Affair', *Industrial Design*, no. 5 (1955), p. 98.
22. George Nelson 'Obsolescence', *Industrial Design*, no. 6 (1956), p. 88.

23. Ibid., p. 82.
24. Harley J. Earl quoted in J. F.
 McCullough, 'Design Review – Cars '59',
 Industrial Design, no. 2 (1959), p. 79.
25. Earl, 'What Goes Into Automobile
 Designing', op. cit., p. 78.
26. J. Gordon Lippincott, *Design for Business*
 (Chicago, 1947), p. 14.
27. Ibid., p. 12.
28. Ibid., p. 13.
29. Ibid., p. 16.
30. Ibid., p. 16.
31. Ibid., p. 2.
32. Henry Dreyfuss, 'The Industrial Designer
 and the Businessman', *Harvard Business
 Review* (November 1950), p. 77.
33. McCullough, op. cit., p. 79.
34. Terence Conran, quoted in William Kay,
 Battle for the High Street (London, 1987),
 p. 27.
35. Terence Conran, quoted in Polly Devlin,
 'The Furniture Designer who became a
 Reluctant Businessman', *House and
 Garden* (November 1964), p. 78.
36. Terence Conran, quoted in Arthur
 Marwick, *British Society Since 1945*
 (London, 1982), p. 143.
37. Terence Conran, quoted in Francis
 Wheen, *The Sixties* (London, 1982),
 p. 170.
38. Terence Conran, 'Design and the
 Building of Storehouse', in Peter Gorb,
 Design Talks! (London, 1988), p. 242.
39. Guy Fortesque, quoted in John Hewitt,
 'Good Design in the Market Place: The
 Rise of Habitat Man', *Oxford Art Journal*,
 x/2 (1987), p. 40.
40. Theodore Levitt, 'Marketing Myopia',
 Harvard Business Review (July–August
 1960), p. 51.
41. Ibid., p. 45.
42. Ibid., p. 45.
43. Ibid., p. 56.
44. Ibid., p. 50.
45. Conran in Gorb, op. cit., p. 244.
46. Conran, 'The Advancement of Design
 Awareness', in Gorb, op. cit., p. 140.
47. John Butcher, 'Design and the National
 Interest: 1' in Gorb, op. cit., p. 218.
48. National Economic Development Council,
 Design for Corporate Culture report
 (London, 1987), p. 75.
49. anon., 'Swiss Role', *The Designer* (January
 1987), p. 6.
50. Jeremy Myerson, 'Swatch's Time Lord',
 DesignWeek (10 October 1986), p. 17.
51. Theodore Levitt, *The Marketing
 Imagination* (New York, 1986), p. 25.
52. See Stan Rapp and Tom Collins, *The
 Great Marketing Turnabout* (London,
 1990), p. 21.
53. Henley Centre report, 'Planning for
 Social Change', quoted in *DesignWeek* (31
 March 1989), p. 5.
54. Ross Electronics, prospectus, 1987,
 p. 7.
55. Ibid., p. 8.
56. Graham Thomson, quoted in *DesignWeek*
 (24 October 1986), p. 18.
57. Lois Love, 'A Sound Approach', *Design
 Selection* (March–April 1986), p. 53.
58. Thomson, op. cit., p. 19.
59. See *Which?* (September 1986), pp. 413–
 17.
60. Colin Campbell, *The Romantic Ethic and
 the Spirit of Modern Consumerism* (Oxford,
 1987), p. 60.
61. Ibid., p. 60.
62. Ibid., p. 61.
63. Ibid., p. 37.
64. Ibid., p. 37.
65. Ibid., p. 37.
66. Ibid., p. 86.
67. Ibid., p. 89.
68. Paul Walton and Caroline Palmer, 'After
 the Chip', *Design* (June 1985), p. 37.
69. National Economic Development Council,
 op. cit., p. 74.
70. Ibid., p. 76.
71. Lippincott, op. cit., p. 23.
72. Richard Hoggart, *The Uses of Literacy*
 (London, 1957), p. 340.
73. Ibid., p. 345.
74. Raymond Williams, quoted in Anthony
 Hartley, 'The Intellectuals of England',
 The Spectator (4 May 1962), p. 581.
75. Ibid., p. 580.
76. Nikolaus Pevsner, 'Postscript' in Michael
 Farr, *Design in British Industry*
 (Cambridge, 1955), pp. 317–18.
77. Anne Inglis, 'Keeping Watch on
 Watchpeople', *DesignWeek* (13 May 1988),
 p. 53.
78. Campbell, op. cit., p. 90.
79. Diane Hill, 'Feu Sans Frontières',
 DesignWeek (14 July 1989), p. 21.
80. See *DesignWeek* (4 August 1989), p. 10.
81. Jeremy Myerson, 'Three Cheers for

Honesty', *DesignWeek* (8 September 1989), p. 13.

82. Michael Peters, 'Face to Face', *Creative Review* (November 1986), pp. 55–6.

83. J. Gordon Lippincott, 'The Yearly Model Change Must Go', *Product Engineering* (13 June 1960), p. 24.

84. Bruce Nussbaum, 'Smart Design: Quality is the New Style', *Business Week* (11 April 1988), p. 106.

85. Lippincott, *Design for Business*, op. cit., p. 17.

86. Jeffrey Meikle, *Design in the Contemporary World*, a paper prepared from the proceedings of the Stanford Design Forum, 1988 (Stanford Design Forum, 1988), p. 42.

2 Green Design

1. Stephen Bayley, 'On Green Design', *Design* (April 1991), p. 52.

2. Ibid., p. 52.

3. Hasan Ozbekham, quoted in anon., 'Technology: good servant or errant monster?', *Design* (October 1969), p. 56.

4. Editorial, 'A Choice of Tomorrow', *Design* (May 1969), p. 25.

5. Brand New Product Limited, report in *The Green Consumer?* (London, 1988), p. 59.

6. Ibid., p. 59.

7. Ibid., p. 60.

8. Ibid., p. 60.

9. Ibid., p. 46.

10. Ibid., p. 42.

11. Anita Roddick, quoted in Graham Vickers, 'Pampering the British Body', *DesignWeek* (21 August 1987), p. 18.

12. Anita Roddick, quoted in Robert Waterhouse, 'Painting by Numbers', *Design* (August 1985), p. 48.

13. Quoted in John Elkington, Tom Burke and Julia Hailes, *Green Pages: The Business of Saving the World* (London, 1988), p. 23.

14. John Button, *Green Pages: A Directory of Natural Products, Services, Resources and Ideas* (London, 1988), p. 152.

15. Jonathon Porritt, *Seeing Green: The Politics of Ecology Explained* (Oxford, 1984), p. 44.

16. Ibid., p. 44.

17. Ibid., pp. 195–6.

18. The Simple Living Collective, quoted in Porritt, op. cit., p. 198.

19. Elkington, Burke, and Hailes, op. cit., pp. 22–3.

20. Button, op. cit., p. 229.

21. Sara Parkin, quoted in Lewis Chester, 'Green is Also the Colour of Money', *The Sunday Correspondent Magazine*, 24 September 1989, p. 28.

22. Roddick, quoted in Vickers, op. cit., p. 18.

23. Sandy Irvine, 'Consuming Fashions?: The Limits of Green Consumerism', *The Ecologist*, XIX/3 (1989), p. 88.

24. Dorothy MacKenzie, typescript of a lecture at the Design Museum, 26 September 1989. I am indebted to Dorothy MacKenzie for sending me a copy of this text.

25. Sandy Irvine and Alec Ponton, *A Green Manifesto: Policies for a Green Future* (London, 1988), p. 68.

26. Richard North, *The Real Cost* (London, 1986), pp 174–5.

27. Chris Cox, Association of Woodusers Against Rainforest Exploitation (AWARE), information pack, 1989, p. 195.

28. Peter Howard, quoted in John Welsh, 'Green Awakening', *Designers' Journal* (November 1988), p. 18.

29. Victor Papanek, quoted in Alastair Hay and Geoff Wright, *Once is Not Enough: A Recycling Policy for Friends of the Earth* (London, 1989), p. 13.

30. Cathy Lauzon, quoted in anon., 'Big Mac Bans Foam Pack', *DesignWeek* (23 November 1990), p. 4.

31. Dorothy Mackenzie, quoted in anon. 'Big Mac Bans Foam Pack', *DesignWeek* (23 November 1990), p. 4.

32. Roddick quoted in Vickers, op. cit., p. 18.

33. Hay and Wright, op. cit., p. 16.

34. See letter from Sylvia Katz, *DesignWeek* (10 March 1989), p. 11.

35. Adrian Judd, 'Conspicuous Consumption', *Creative Review* (April 1987), p. 39.

36. See Paula Hubert, 'How Design could Green Up its Act', *DesignWeek* (1 March 1991), p. 9.

37. Niels Peter Flint, quoted in Gaynor Williams, 'Coming up for air', *DesignWeek* (2 June 1989), p. 16.

38. Ibid., p. 16.

39. Alan Mitchell and Liz Levy, 'Green About Green', *Marketing* (14 September 1989), p. 28.

40. See *DesignWeek* (11 September 1992), p. 17.
41. Stuart Baron, quoted in *DesignWeek* (26 May 1989), p. 3.
42. Simone Aylward, quoted in *DesignWeek* (18 November 1988), p. 6.
43. Paul Jenkins, quoted in *DesignWeek* (25 August 1989), p. 5.

3 **Responsible Design and Ethical Consuming**

1. Michael Middleton, 'The Wider Issues at Stake', *The Designer* (February 1970), p. 1.
2. The French Group, 'The Environmental Witch Hunt' (1970) in Reyner Banham, ed., *The Aspen Papers* (London, 1974), p. 210.
3. Ibid., p. 209.
4. See James Meller, ed., *The Buckminster Fuller Reader* (London, 1972), p. 36.
5. Ibid., p. 376.
6. See Martin Pawley, *Garbage Housing* (London, 1975), pp. 17–34.
7. Victor Papanek, *Design for the Real World* (London, 1974), p. 9.
8. Ibid., p. 292.
9. Ibid., p. 10.
10. Victor Papanek, *Design for the Real World* (London, 1984; rev. ed.), p. 352.
11. Ibid., p. 247.
12. Ibid., p. 234.
13. Ibid., p. 241.
14. Ibid., p. 242.
15. Ibid., p. 243.
16. Ibid., p. 244.
17. Ibid., p. 245.
18. Ibid., p. 246.
19. Ibid., p. 247.
20. Ibid., p. xi.
21. Ibid., p. 68.
22. Ibid., p. 69.
23. Ibid., p. 188.
24. Ibid., p. 252.
25. Ibid., p. 62.
26. Ibid., p. 62.
27. Ibid., p. ix.
28. Stephen Bayley, ed., *The Conran Directory of Design* (London, 1985), p. 202.
29. Mike Cooley, 'After the Lucas Plan', in Collective Design/Projects, eds, *Very Nice Work If You Can Get It: the Socially Useful Production Debate* (Spokesman, Nottingham, 1985), pp. 19–20.

30. George McRobie, *Small is Possible* (London, 1985), pp. 92–3.
31. Ibid., pp. 97–8.
32. See H. Wainwright and D. Elliott, *The Lucas Plan: A New Trade Unionism in the Making?* (London, 1982).
33. Ruth Schwartz Cowan, 'How the Refrigerator Got Its Hum' in Donald MacKenzie and Judy Wajcman, eds, *The Social Shaping of Technology* (Milton Keynes, 1985), pp. 215–16.
34. Ibid., p. 215.
35. Papanek (1984 edition), op. cit., p. 252.
36. Phillip Cooke, 'Worker Co-operatives in Wales: A Framework for Socially Useful Production?', in Collective Design/Projects, op. cit., p. 89.
37. Collective Design/Projects, op. cit., p. 201.
38. James Woudhuysen, 'A British View of Swedish Design', *Svensk Form*, exhibition catalogue: Victoria and Albert Museum, London (London, 1981), p. 3.
39. Ashoke Chatterjee, 'Design in India: A Challenge of Identity', paper, November 1988, p. 13.
40. Ibid., p. 3.
41. See Marilyn Carr, *The AT Reader: Theory and Practice in Appropriate Technology* (Intermediate Technology Publications Ltd., London, 1985), pp. 8–9.
42. Papanek (1984 edition), p. 85.
43. Quoted in *The Merlin Research Bulletin*, no. 4 (May 1990), p. 1.
44. Traidcraft PLC, company prospectus, 1990, p. 6.
45. Ibid., p. 1.
46. Ibid., p. 3.
47. Editorial, *The Ethical Consumer*, no. 6 (February/March 1990), p. 2.
48. For a critical attack on the methodology used by *The New Consumer*, see *The Ethical Consumer*, no. 17 (December 1991/ January 1992), pp. 1–2, 23–4.
49. 'Green Consumerism', *The Ethical Consumer*, no. 4 (September/October 1989), p. 13.
50. 'Ethics and the Consumer', *The Ethical Consumer*, no. 1 (March 1989), p. 7.
51. Editorial, *The Ethical Consumer*, no. 3 (July/August 1989), p. 1.
52. Editorial, *The Ethical Consumer*, no. 12 (February/March 1991), p. 1.
53. Ibid., p. 1.

54. Letter in *The Ethical Consumer*, no. 9 (August/September 1990), p. 26.
55. Chartered Society of Designers, press release, dated May 1989.
56. Chartered Society of Designers, code of practice, 1989, paragraph 5.
57. Jan Burney, 'Screwing the Designer', *Interiors Quarterly*, no. 9 (1989), p. 16.

4 Feminist Perspectives

1. For a definition of patriarchy in relation to design, see Cheryl Buckley, 'Made in Patriarchy: Toward a Feminist Analysis of Women and Design', *Design Issues*, III/2 (1987), pp. 3–14.
2. Phil Goodall and Erica Matlow, editorial, *Feminist Arts News* (December 1985), p. 3.
3. Buckley, op. cit., p. 10.
4. Ibid., p. 13.
5. Ibid., p. 6.
6. Ibid., p. 6.
7. Ibid., p. 9.
8. Rosy Martin, 'Feminist Design: A Contradiction', *Feminist Arts News* (December 1985), p. 25.
9. Margaret Bruce and Jenny Lewis, 'Divided By Design?: Gender and the Labour Process in the Design Industry', paper presented at the conference on 'The Organisation and Control of the Labour Process', held at UMIST, Manchester, March 1989, p. 14. I am indebted to the author for a copy of her paper.
10. Phil Goodall, 'Design and Gender', *Block*, no. 9 (1983), p. 54.
11. Cynthia Cockburn, 'The Material of Male Power' in Donald MacKenzie and Judy Wajcman, eds, *The Social Shaping of Technology* (Milton Keynes, 1985), p. 139.
12. Ibid., p. 129.
13. See Ruth Schwartz Cowan, *More Work for Mother: The Ironies of Household Technology from the Open Hearth to the Microwave* (London, 1983), and Caroline Davidson, *A Woman's Work is Never Done: A History of Housework in The British Isles, 1650–1950* (London, 1982).
14. See Ann Oakley, *Housework* (London, 1974), p. 7.
15. Ibid., p. 6.
16. Ruth Schwartz Cowan, 'The Industrial Revolution in the Home' in MacKenzie and Wajcman, op. cit., p. 194.
17. Goodall, op. cit., p. 53.
18. Judy Attfield, 'Feminist Designs on Design History', *Feminist Arts News* (December 1985), p. 23.
19. Karen Lyons in notes to the author, May 1988.
20. See Ettore Sottsass, *A Sensorial Technology*, Pidgeon slide-tape lecture, series 11, no. 8401 (London, 1984).
21. See Julian Gibb, 'Soft: An Appeal to Common Senses', *Design* (January 1985), pp. 27–9.
22. Martin, op. cit., p. 24.
23. Margaret Bruce, 'The Forgotten Dimension: Women, Design and Manufacture', *Feminist Arts News* (December 1985), p. 7.
24. Margaret Bruce, 'A Missing Link: Women and Industrial Design', *Design Studies* (July 1985), p. 155.
25. Bruce and Lewis, op. cit., p. 29.
26. Ibid., p. 30–31.
27. Ibid., p. 35.
28. Bruce, 'A Missing Link', op. cit., p. 150.
29. Jos Boys and Rodney Fitch, 'Face to Face', *Creative Review* (July 1986), p. 28.
30. Ibid., p. 28.
31. Ibid., p. 29.
32. Ibid., p. 29.
33. Ibid., p. 29.
34. Ibid., p. 29.
35. Ibid., p. 29.
36. Ibid., p. 29.
37. Ibid., p. 29.
38. Bruce, 'A Missing Link', op. cit., p. 154.
39. Ibid., p. 154.
40. Goodall and Matlow, op. cit., p. 3.
41. Ibid., p. 3.
42. Martin, op. cit., p. 26.
43. Sue Cavanagh, *Shoppers' Crèches: Guidelines for Childcare Facilities in Public Places*, Women's Design Service (London, 1988), p. 5.
44. Julie Jaspert, Sue Cavanagh and Jane Debono, *Thinking of Small Children: Access, Provision and Play*, Women's Design Service et al. (London, 1988), p. 24.
45. Jaspert, Cavanagh and Debono point out that the word 'carer' is inclusive and accommodates relatives, family friends, childminders, nannies and au pairs.
46. Cavanagh, op. cit., p. 26.
47. Ibid., p. 3.

48. See, for example, 'Women and the Built Environment', *WEB*, issue 11, n.d., p. 3.
49. Goodall, op. cit., p. 60.
50. Matrix, *Making Space: Women and the Man Made Environment* (London, 1984), p. 55.
51. Ibid., p. 135.
52. Ibid., p. 123.
53. Vron Ware, *Women's Safety on Housing Estates*, Women's Design Service (London, 1988), p. 24.
54. Martin, op. cit., p. 26.
55. Ibid., p. 26.

5 The Way Forward?

1. Kenneth Adams, 'Changing British Attitudes', *Royal Society of Arts Journal* (November 1990), p. 832.
2. Fredric Jameson, 'The Cultural Logic of Late Capitalism' (1984) in *Postmodernism, or, The Cultural Logic of Late Capitalism* (London, 1992), p. 4.
3. Colin Campbell, *The Romantic Ethic and the Spirit of Modern Consumerism* (Oxford, 1987), p. 39.
4. Editorial, *The Ethical Consumer*, no. 1 (March 1989), p. 1.
5. Margaret Bruce and Jenny Lewis, 'Divided By Design?: Gender and the Labour Process in the Design Industry', paper presented at the conference on 'The Organisation and Control of the Labour Process', held at UMIST, Manchester, March 1989, p. 5.
6. See letter in *DesignWeek* (21 December 1990), p. 10.
7. David Carter, quoted in Rebecca Eliahoo, 'Designer Ethics', *Creative Review* (March 1984), p. 47.
8. As reported by Dr Elizabeth Nelson, 'Marketing in 1992 and Beyond', *Royal Society of Arts Journal* (April 1989), p. 296.
9. John Wood, 'The Socially Responsible Designer', *Design* (July 1990), p. 9.
10. John Butcher, 'Design and the National Interest: 1' in Peter Gorb, ed., *Design Talks!* (London, 1988), p. 218.
11. Ibid., p. 218.
12. Ibid., p. 218.
13. Ibid., p. 221.
14. Ibid., p. 218.
15. Ibid., p. 223.
16. Gordon Russell, 'What is Good Design?', *Design* (January 1949), p. 2.
17. Michael Farr, *Design in British Industry* (Cambridge, 1955), p. 288.
18. Ibid., p. 289.
19. Ibid., p. xxxvi.
20. Reyner Banham, 'H.M. Fashion House', *New Statesman* (27 January 1961), p. 151.
21. Herbert J. Gans, 'Design and the Consumer: A View of the Sociology and Culture of "Good Design"' in Kathryn B. Hiesinger and George H. Marcus, eds, *Design Since 1945* (London, 1983), pp. 33–4.
22. Paul Reilly, 'The Challenge of Pop', *Architectural Review* (October 1967), p. 256.
23. See Nigel Whiteley, *Pop Design: Modernism to Mod* (London, 1987), pp. 227–9.
24. Report on portable stereo radio-cassette players in *The Ethical Consumer*, no. 8 (June/July 1990), p. 9.
25. Richard Hamilton, 'Popular Culture and Personal Responsibility' (1960), in *Collected Words* (London, 1982), p. 151.
26. See Nigel Whiteley, 'Design in Enterprise Culture: Design for Whose Profit?' in Russell Keat and Nicholas Abercrombie, eds, *Enterprise Culture* (London, 1990), pp. 186–205.
27. Report on 'Green Consumerism', *The Ethical Consumer*, no. 4 (September/October 1989), p. 13.
28. Ezio Manzini, 'The New Frontiers', *Design* (September 1990), p. 9.
29. Laszlo Moholy-Nagy, *The New Vision* (London, 1939), p. 14.

Select Bibliography

Anscombe, Isabelle, *A Woman's Touch: Women in Design from 1860 to the Present Day*, London, 1984.

Armi, C. Edson, *The Art of American Car Design: The Profession and Personalities*, Philadelphia, 1988.

Attfield, Judy, and Kirkham, Pat, eds, *A View From the Interior: Feminism, Women and Design*, London, 1989.

Baker, Michael, *Market Development: A Comprehensive Survey*, London, 1983.

Banham, Reyner, ed., *The Aspen Papers*, London, 1974.

– *Design By Choice*, London, 1981.

– *Theory and Design in the First Machine Age*, London, 1960.

Bayley, Stephen, *Commerce and Culture: From Pre-Industrial Art to Post-Industrial Value*, exhibition catalogue: The Design Museum, London, 1989.

– *Harley Earl*, London, 1990.

– *In Good Shape*, London, 1979.

– *Taste: An Exhibition About Values in Design*, exhibition catalogue: The Conran Foundation, London, 1983.

Beaud, Michel, *A History of Capitalism, 1500–1980*, London, 1984.

Bell, Daniel, *The Cultural Contradictions of Capitalism*, London, 1976.

Benton, Tim and Benton, Charlotte, with Sharp, Dennis, eds, *Form and Function*, London, 1980.

Berman, Marshall, *All That is Solid Melts Into Air: The Experience of Modernity*, London, 1983.

Bernsen, Jens, *Design: The Problem Comes First*, Danish Design Council, n.d.

– *Why Design?*, The Design Council, London, 1989.

Bourdieu, Pierre, *Distinction: A Social Critique of the Judgement of Taste*, London, 1984.

Boyle, Godfrey, and Harper, Peter, eds, *Radical Technology*, London, 1976.

Boyne, Roy, and Rattanski, Ali, eds, *Postmodernism and Society*, London, 1990.

Brand New Product Limited, *The Green Consumer?*, report, London, 1988.

Burall, Paul, *Green Design*, London, 1991.

Button, John, *Green Pages: A Directory of Natural Products, Services, Resources and Ideas*, London, 1988.

Campbell, Colin, *The Romantic Ethic and the Spirit of Modern Consumerism*, Oxford, 1987.

Carr, Marilyn, *The AT Reader: Theory and Practice in Appropriate Technology*, Intermediate Technology Publications Ltd, London, 1985.

Carson, Rachel, *Silent Spring*, London, 1965.

Cheney, Sheldon and Cheney, Martha, *Art and the Machine*, New York, 1936.

Collective Design/Projects, eds, *Very Nice Work If You Can Get It: The Socially Useful Production Debate*, Spokesman, Nottingham, 1985.

Collins, Michael, *Towards Post-Modernism: Design Since 1851*, The British Museum, London, 1987.

Conrads, Ulrich, ed., *Programs and Manifestoes on Twentieth Century Architecture*, London, 1970.

Cowan, Ruth Schwartz, *More Work for Mother: The Ironies of Household Technology from the Open Hearth to the Microwave*, London, 1983.

Cross, Nigel, Elliott, David, and Roy, Robin, eds, *Man-Made Futures: Readings in Society, Technology and Design*, London, 1974.

Davidoff, Leonore and Hall, Catherine, 'The Architecture of Public and Private Life' in A. Sutcliffe and D. Fraser, eds, *Towards A Pursuit of Urban History*, London, 1982.

Davidson, Caroline, *A Woman's Work is Never Done: A History of Housework in the British Isles, 1650–1950*, London, 1982.

Design Council, *Design and the Economy: the Role of Design and Innovation in the Prosperity of Industrial Companies*, Design Council, London, 1983.

– *Royal Designers on Design: A Selection of Addresses by Royal Designers for Industry*, London, 1986.

Department of Trade and Industry, *Design to Win: A Chief Executive's Handbook*, DTI, London, 1989.

Dickson, David, *Alternative Technology and the Politics of Technical Change*, London, 1974.

Elkington, John, Burke, Tom, and Hailes, Julia, *Green Pages: The Business of Saving the World*, London, 1988.

Elkington, John, and Hailes, Julia, *The Green Consumer Guide*, London, 1988.

Evans, Bill, *About Turn: The Alternative Use of Defence Workers' Skills*, London, 1986.

Farr, Michael, *Design in British Industry*, Cambridge, 1955.

Featherstone, Mike, *Consumer Culture and Postmodernism*, London, 1991.

Fitch, Rodney, and Knobel, Lance, *Fitch on Retail Design*, London, 1990.

Forty, Adrian, *Objects of Desire: Design and Society, 1750–1980*, London, 1986.

Foster, Hal, ed., *Postmodern Culture*, London, 1983.

Fuller, R. Buckminster, and Marks, Robert, *The Dymaxion World of Buckminster Fuller*, New York, 1973.

Gans, Herbert J., *The Levittowners: Ways of Life and Politics in a New Surburban Community*, London, 1967.

Gardner, Carl, and Sheppard, Julie, *Consuming Passion: The Rise of Retail Culture*, London, 1989.

Gloag, John, ed., *Design in Modern Life*, London, 1934.

Gorb, Peter, ed., *Design Talks!*, London, 1988.

Gorz, André, *Ecology as Politics*, London, 1987.

Green, William R., *The Retail Store: Design and Construction*, New York, 1991.

Greenhalgh, Paul, ed., *Modernism in Design*, London, 1990.

Hamilton, Richard, *Collected Words*, London, 1982.

Harris, Jennifer, Hyde, Sarah, and Smith, Greg, *1966 and All That: Design and the Consumer in Britain, 1960–1969*, London, 1986.

Harvey, David, *The Condition of Postmodernity*, Oxford, 1989.

Haug, W. F., *Critique of Commodity Aesthetics: Appearance, Sexuality and Advertising in Capitalist Society*, Cambridge, 1986.

Heskett, John, *Industrial Design*, London, 1980.

Hewison, Robert, *Too Much: Art and Society in the Sixties, 1960–75*, London, 1986.

Hiesinger, Kathryn B., and Marcus, George H., eds, *Design Since 1945*, London, 1983.

Hoesterey, Ingeborg, ed., *Zeitgeist in Babel: the Postmodernist Controversy*, Indiana, 1991.

Huygen, Frederique, *British Design: Image and Identity*, London, 1989.

Irvine, Sandy, and Ponton, Alec, *A Green Manifesto: Policies for a Green Future*, London, 1988.

Jameson, Fredric, *Postmodernism, or, The Cultural Logic of Late Capitalism*, London, 1992.

Jensen, Robert, and Conway, Patricia, *Ornamentalism: The New Decorativeness in Art and Design*, London, 1982.

Jodard, Paul, *Raymond Loewy: Most Advanced Yet Acceptable*, London, 1992.

Kay, William, *Battle for the High Street*, London, 1987.

Keat, Russell, and Abercrombie, Nicholas, eds, *Enterprise Culture*, London, 1990.

Klein, Bernat, *Design Matters*, London, 1976.

Levitt, Theodore, *Innovation in Marketing*, London, 1962.

– *The Marketing Imagination*, New York, 1986.

Lewis, David L., *The Automobile and American Culture*, University of Michigan, 1983.

Lippincott, J. Gordon, *Design for Business*, Chicago, 1947.

Lorenz, Christopher, *The Design Dimension: The New Competitive Weapon for Business*, Oxford, 1986.

McAlhone, Beryl, ed., *Directors on Design*, SIAD Design Management Seminars, 4 volumes, The

Design Council, London, 1985.

McDermott, Catherine, *Street Style: British Design in the 80s*, London, 1987.

McKendrick, N., Brewer, Y., and Plumb, J.H., *The Birth of a Consumer Society*, London, 1982.

MacKenzie, Donald, and Wajcman, Judy, eds, *The Social Shaping of Technology*, Milton Keynes, 1985.

MacKenzie, Dorothy, *Green Design: Design for the Environment*, London, 1991.

McRobie, George, *Small is Possible*, London, 1985.

Malos, Ellen, ed., *The Politics of Housework*, London, 1982.

Mamiya, Christin J., *Pop Art and Consumer Culture: American Super Market*, Austin, 1992.

Mandel, E., *Late Capitalism*, London, 1975.

Manley, Deborah, ed., *New Design for Old*, exhibition catalogue: Victoria and Albert Museum, London, 1986.

Marwick, Arthur, *British Society Since 1945*, London, 1982.

Matrix, *Making Space: Women and the Man-Made Environment*, London, 1984.

Meikle, Jeffrey, *Twentieth Century Limited: Industrial Design in America, 1925–1939*, Philadelphia, 1979.

Meller, James, ed., *The Buckminster Fuller Reader*, London, 1972.

Meyers, William, *The Image Makers*, London, 1985.

Moholy-Nagy, László, *The New Vision*, London, 1939.

Nader, Ralph, *Unsafe at Any Speed: The Designed-In Dangers of the American Automobile*, New York, 1966.

National Economic Development Council, *Design for Corporate Culture*, report, London, 1987.

North, Richard, *The Real Cost*, London, 1986.

Oakley, Ann, *Housework*, London, 1974.

Packard, Vance, *The Hidden Persuaders*, New York, 1957.

– *The Status Seekers*, New York, 1959.

– *The Waste Makers*, New York, 1960.

Papanek, Victor, *Design for the Real World*, London, 1972; rev. ed. 1984.

Pawley, Martin, *Buckminster Fuller*, London, 1990.

– *Garbage Housing*, London, 1975.

Pevsner, Nikolaus, *Industrial Art in England*, Cambridge, 1937.

Phillips, Barty, *Conran and the Habitat Story*, London, 1984.

Pilditch, James, *Winning Ways: How 'Winning' Companies Create the Products We All Want to Buy*, London, 1987.

Porritt, Jonathon, *Seeing Green: the Politics of Ecology Explained*, Oxford, 1984.

Pulos, Arthur J., *American Design Ethic: A History of Industrial Design*, Cambridge, Mass., 1983.

– *The American Design Adventure*, Cambridge, Mass., 1988.

Rapp, Stan, and Collins, Tom, *The Great Marketing Turnabout*, London, 1990.

Reich, Charles A., *The Greening of America*, 1972.

Roberts, Marion, *Living in a Man-Made World: Gender Assumptions in Modern Housing Design*, London, 1991.

Royal Academy of Arts, *50 Years Bauhaus*, exhibition catalogue, London, 1968.

Russell, Dale, *Colour in Industrial Design*, London, 1991.

Rybczynski, Witold, *Paper Heroes: A Review of Appropriate Technology*, New York, 1980.

Schönberger, Angela, ed., *Raymond Loewy: Pioneer of American Industrial Design*, Munich, 1991.

Schumacher, E. F., *Small is Beautiful: A Study of Economics as if People Mattered*, London, 1974.

Sharp, Dennis, ed., *The Rationalists*, London, 1978.

Sheldon, Roy, and Arens, Egmont, *Consumer Engineering: A New Technique for Prosperity*, New York, 1932.

Sparke, Penny, *An Introduction to Design and Culture in the Twentieth Century*, London, 1986.

– *Consultant Design: The History and Practice of the Designer in Industry*, London, 1983.

Stanford Design Forum, *Design in the Contemporary World*, Stanford, 1988.

Sudjic, Deyan, *Cult Objects*, London, 1985.

Thackara, John, ed., *Design After Modernism*, London, 1988.

Timberlake, Lloyd, *Only One Earth*, London, 1987.

Vickers, Graham, *Style in Industrial Design*, London, 1991.

Victoria and Albert Museum, *Svensk Form*, exhibition catalogue, London, 1981.

Wainwright, H., and Elliott, D., *The Lucas Plan: A New Trade Unionism in the Making?*, London, 1982.

Wates, Nick, and Knevitt, Charles, *Community Architecture: How People are Creating their Own Environment*, London, 1987.

Ward, Barbara, and Dubos, René, *Only One Earth: The Care and Maintenance of a Small Planet*, London, 1972.

Wheen, Francis, *The Sixties*, London, 1982.

Whiteley, Nigel, *Pop Design: Modernism to Mod*, London, 1987.

Whitford, Frank, *The Bauhaus*, London, 1984.

Wilk, Christopher, *Marcel Breuer: Furniture and Interiors*, London, 1981.

Williams, Raymond, *The Long Revolution*, London, 1961.

Wilson, Elizabeth, *The Sphinx in the City: Urban Life, the Control of Disorder, and Women*, London, 1991.

Wingler, Hans, ed., *Bauhaus*, Cambridge, Mass., 1978.

Index